HANDBOOK OF THE ART COLLECTION

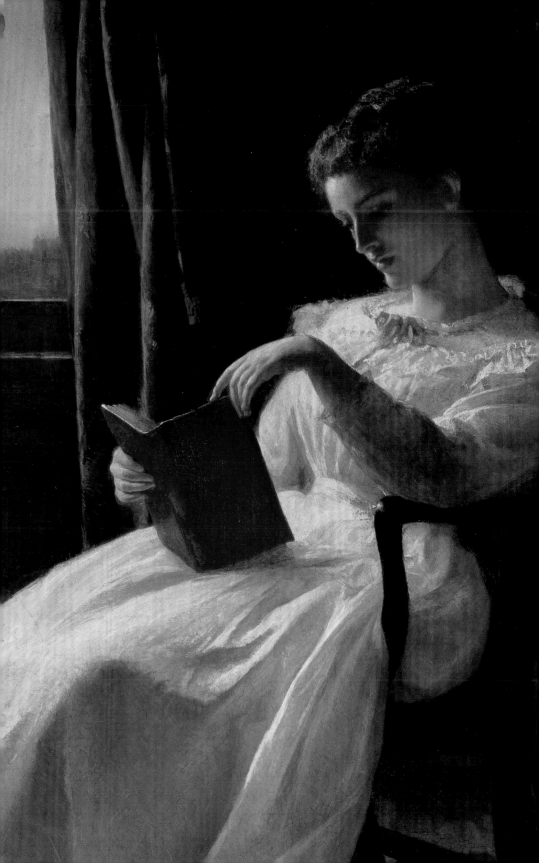

THE ST. JOHNSBURY ATHENÆUM

HANDBOOK OF THE ART COLLECTION

MARK D. MITCHELL

ST. JOHNSBURY · VERMONT

Distributed by University Press of New England

Hanover and

FRONTISPIECE: George Cochran Lambdin, *Girl Reading* (detail), 1872, oil on canvas, 29 x 25 inches, Gift of Horace Fairbanks.

Edited by Elizabeth J. Moodey

Photography by Robert C. Jenks, Jenks Studio of Photography
St. Johnsbury, Vermont (except as noted on p. 151)

Designed and printed by The Stinehour Press
Lunenburg, Vermont

Library of Congress Control Number: 2005926822

ISBN 1-58465-565-8

CONTENTS

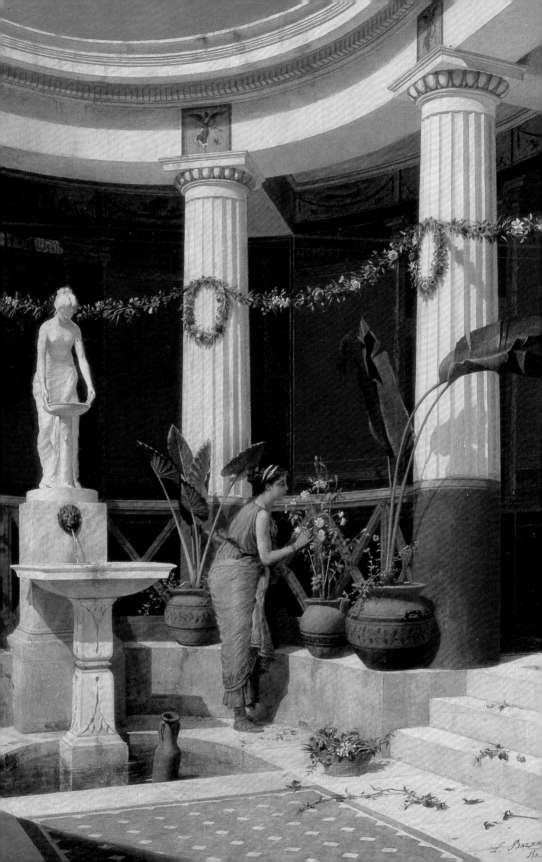

ACKNOWLEDGEMENTS

THIS COLLECTION HANDBOOK has been a team effort in every sense. I would like to extend my heartfelt thanks to the many colleagues, supporters, and friends who have helped to produce the book so that it may become a lasting resource for the many different audiences who visit the St. Johnsbury Athenæum and enjoy its art collection.

At the Athenæum, every member of the staff has offered enthusiastic support for the project. Lorna Higgs, the Athenæum's steadfast Administrative Director, has been a cheerful partner in the project from the start. She is truly an inspiration. The handbook owes its inception to the current and former members of the Athenæum's Collection Committee, including David Weinstein, Anne Brown, and Jeff Gold, who have participated actively in the undertaking. I am grateful to them for entrusting me with this important project.

The project could not have proceeded without generous support from the following sources: Philip K. Meyer in memory of Jan and Jane Meyer; The Alma Gibbs Donchian Foundation; and a special gift in honor of renowned artist, teacher, and conservator Frank Mason and his student Ben Long.

At The Stinehour Press, Paul Hoffmann and John Stinehour have contributed their finest efforts to the design and quality of the printing. Robert C. Jenks at the Jenks Studio of Photography has worked tirelessly to produce high-quality images of the collection. Editor Elizabeth J. Moodey, a wonderful colleague and friend, beautifully refined the text. At University Press of New England, Ellen Wicklum has been an enthusiastic advocate for the project, encouraging a partnership that will make this handbook available to audiences throughout the country. The participation of area teachers Deborah Thornton and Lorraine Sprout has been essential to the Resources for Teachers section among the appendices, which we hope will become a useful reference for their colleagues in the St. Johnsbury area in the years to come.

Most of all, I would like to thank my wife Becca for her love and support. She has been an invaluable and active contributor to this project, offering advice and helping to write the Resources for Teachers from her experience as a museum educator.

MARK D. MITCHELL

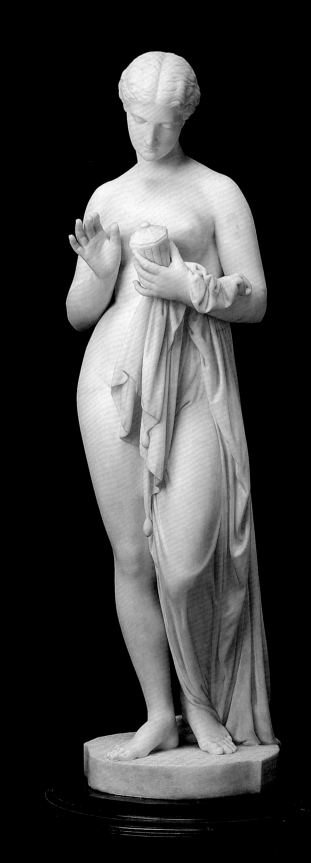

WELCOME

WELCOME TO THE ST. JOHNSBURY ATHENÆUM! Whether you're standing in the Art Gallery, planning your visit, or have already come and gone, this handbook offers a range of resources to enhance your experience and help you learn more about the collection.

Please take your time and enjoy the art at your own pace. The handbook is designed to complement a wide array of different experiences in the gallery, not to be read cover to cover. Whether you're here with family or friends, traveling to St. Johnsbury for the first time, or a frequent visitor, you'll find information and tips to help you enjoy the art.

Have a wonderful visit.

A VISITOR'S GUIDE TO
LOOKING AT ART

O NE OF ART'S VIRTUES is its ability to inspire different experiences in different viewers, or even in the same viewer at different times. You can return to the same work of art again and again and never appreciate it the same way twice. Similarly, your friends and family will have different perspectives on a work from yours. If you visit the Athenæum in a group, take the time to listen to others' viewpoints, ask them about how they arrived at their conclusions about particular works, and value their contributions to your understanding of the art and its history, even if you disagree. You'll learn a great deal about yourself and the people with whom you're visiting, not to mention the art itself.

Art has many different contexts and each inflects our understanding. A period collection like the Athenæum's—assembled and displayed for the St. Johnsbury community during America's Centennial era—is particularly interesting because of the thought that went into building the collection as a whole. Consistent with the collection's historical integrity, the Gallery is installed in the Salon style with paintings hung closely together and high on the wall, as they were displayed during the period. As you visit the Athenæum, consider some of these other contexts as well:

 • **Stylistic:** How does the artist use a particular manner of painting or sculpting to convey meaning?
 • **Aesthetic:** Is the work beautiful? What makes it successful or unsuccessful to your eye?
 • **Historical:** In what year and region was the piece created? What else was happening socially or culturally that may have influenced the artist's choices of subject and style?
 • **Biographical:** Where was the artist (or sitter) in her or his life when she or he created this object? What influence might that have had upon the work?
 • **Thematic:** Can you find other works that depict a similar subject? How do the differences and similarities between the works affect their meanings?

Ultimately, we see art through our modern eyes. We are conditioned by the world that we live in and our personal experiences and expectations. At age twelve, our appreciation of art and the meaning that we derive from it is different from what we appreciate at age seventy. As much as age, the same may be said of our gender, social class, faith, or any other identification. Being aware of the personal considerations that we bring with us when we look at a work of art greatly deepens our ability to appreciate different cultures and eras.

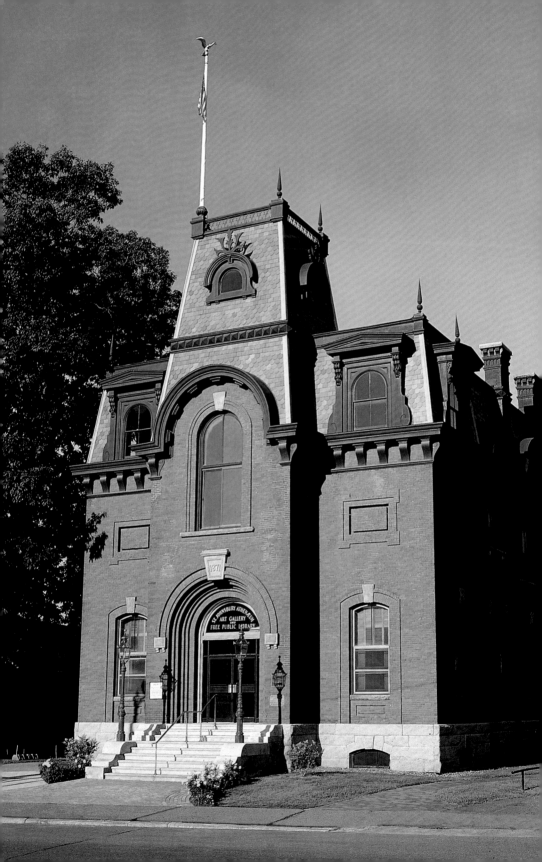

THE LENS OF HISTORY:
AN ART COLLECTION FOR
ST. JOHNSBURY

AMERICA'S CENTENNIAL IN 1876 provoked intense self-reflection in this country. Coming little more than a decade after the end of the Civil War in 1865, the Centennial celebration offered Americans a chance to consider their nation's future even as it encouraged serious scrutiny of the past. This was the climate in which industrialist Horace Fairbanks (1820–1888, fig. 1) founded the St. Johnsbury Athenæum, a combination of public library, art museum, and lecture hall. Situated at the crossroads of major roadways, waterways, and railways, the northern Vermont community of St. Johnsbury was considered a model company town during the nineteenth century, producing high-quality platform scales that were in demand around the world. Enriched by their thriving business, the Fairbanks family supported steady improvements in the town, investing in schools, churches, and public institutions such as the Athenæum. Their civic initiatives left an enduring stamp on the town and laid the foundation for its future growth and cultural development.

This essay introduces the history of the Athenæum's art collection through a history of the region and its people. Horace Fairbanks and his family assembled the bulk of the collection with St. Johnsbury in mind. They recognized the cultural limitations of living in a rural area and sought to offset them by bringing a premier collection of literature (through the library) and art (through the gallery) to their community. The exceptional quality of the collections demonstrates the Fairbanks' aspirations for St. Johnsbury as the nation approached its second century. The extent of their success may be measured by the visitors that the Athenæum's Gallery continues to attract from around the world. Unforeseen, however, was the further consolidation of the nation's industrial centers during the later nineteenth and early twentieth centuries. This process eventually left the town of St. Johnsbury behind but preserved its landmarks intact, making it home to the country's oldest art gallery still in its original form.

ST. JOHNSBURY AND ITS ATHENÆUM

The northern reaches of Vermont and New Hampshire have a long and rich cultural tradition that influences their distinctive identity to the present day. The Green and White Mountains, home to St. Johnsbury's extended community, have inspired a steady stream of the nation's most accomplished artists since the early nineteenth century (fig. 2). Over the

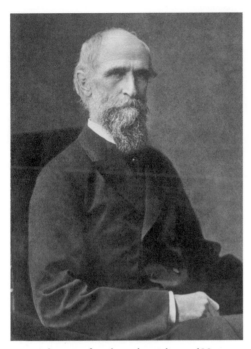

FIG. 1. Athenæum founder, industrialist, and Vermont Governor Horace Fairbanks (1820–1888).

two hundred years since the town's charter was granted in 1786, the St. Johnsbury region has reinvented itself successively as an agricultural, industrial, and tourist center. The roads, rails, and waterways that once delivered Fairbanks scales around the world now attract leaf peepers, hikers, and skiers to the region, reversing the historic flow of travel, but steadily increasing national awareness of the region's natural and cultural offerings.

By the time northern Vermont was settled by the British during the eighteenth century, the area had provided seasonal hunting and agricultural territory for nomadic bands of Western Abenaki Indians and their ancestors for approximately eleven thousand years. The French preceded the British in the area, beginning with Samuel de Champlain's exploration of Vermont's northwestern region in 1609, but the French influence was more economic and religious than territorial. Sensing the more imperial ambitions of the British settlers who arrived during the eighteenth century, many Abenaki aligned themselves with the French in opposition to British incursions. Over two centuries after being driven from their lands and into hiding by the British and later the Americans, Abenaki Indians are reasserting their presence and independent cultural identity in contemporary Vermont.

The town of St. Johnsbury, named in honor of French author and agronomist Michel Guillaume Jean de Crèvecoeur (1735–1813), who wrote under the name J. Hector St. John, traces its origin to the early days of American independence. Despite competing claims to the region by the colonies of New York and New Hampshire in the years preceding the Revolution, the first recorded settlement was not established on the town's current site until 1786. Within months, Governor Thomas Chittenden granted the town's charter and a slow trickle of arrivals swelled the fledgling population over the winter months until a group of seventeen inhabitants, led by Revolutionary War veteran Jonathan Arnold, arrived the following spring. Arnold became St. Johnsbury's most prominent citizen during the town's early years, establishing its first mills and roads to connect it with the surrounding villages. By the time of Arnold's early death in 1793, St. Johnsbury had grown nearly ten times in population, developed a local government, and gained a place among the young state's leading communities. From its inception, St. Johnsbury was planned as a center of learning. As in many early New England towns, space was set aside by the town's

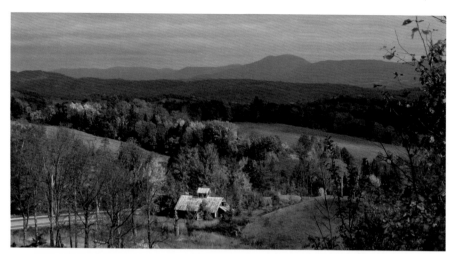

FIG. 2. The Green Mountains have attracted artists to Vermont's Northeast Kingdom since the early nineteenth century. Today, their brilliant fall colors attract tourists from around the world.

charter for civic purposes, including education. St. Johnsbury, however, exceeded convention by calling for the creation of "a seminary or college" as well as "a county grammar school."

Although unique in the details of its history, St. Johnsbury's development during the nineteenth century echoed that of New England as a whole. Rapid industrialization after the War of 1812 allowed the region to become the nation's leading economic and cultural force. Despite its long and deep winters, St. Johnsbury's physical geography facilitated its rapid industrial ascendancy. Sited at the confluence of the Passumpsic, Sleepers, and Moose Rivers, the town was amply furnished with water power for its early saw and grist mills as well as potential trade routes. Heavily forested during the late eighteenth century, the region was initially well suited to the production of potash, used in fertilizer. Once cleared, agriculture developed as the area's primary economic engine, particularly in the growth of hemp for textiles. The expansion of the latter industry proved fateful for the fortunes of the Fairbanks family as well as for St. Johnsbury.

When Joseph Fairbanks first moved his family to St. Johnsbury from Brimfield, Massachusetts in 1815, he must have recognized the town's potential. Buying a mill on a branch of the Sleepers River, Fairbanks partnered with his three sons, Erastus, Thaddeus, and Joseph P., in a series of enterprises, including a carriage shop, grist mill, hemp processing company, and ironworks. Joseph's middle son, Thaddeus, was endowed with an innovative streak and a mechanical genius that led him to recognize the need for and then to invent a reliable platform scale for weighing large bales of hemp in 1830. The brothers had formed E. & T. Fairbanks and Company in 1824 as a small iron foundry, but eventually turned to the production of Thaddeus' scales. With Erastus' leadership and management skills, the Fairbanks scale later set the worldwide standard of excellence, with distribution from England to China, during the mid-century. Thaddeus, meanwhile, continued to refine the

manufacturing process as the business reportedly doubled in volume every three years during the period 1842–57, employing over a thousand workers by 1860.

Given the extent of their influence on St. Johnsbury through their business, the Fairbanks family's leading role in community life is unsurprising. Erastus, in particular, cultivated a paternal image (his portrait by Charles Chaplin hangs in the Athenæum's Reference Room), encouraging workers and their families to look upon him "as a father." Aware of the discontentment and protests of workers in larger urban areas, Erastus presented himself as a benevolent leader, paying his employees at elevated rates with benefits that met or exceeded those at comparable businesses in the region. The family actively supported local charities and organizations promoting educational, spiritual, and physical well-being in the community, and modeled the standards of professional and personal behavior to which they held their workers. Along with his brothers, Erastus founded the St. Johnsbury Academy in 1842 and their company paid all of the school's expenses for its first forty years of operation. (The Academy serves today as St. Johnsbury's public high school as well as a boarding school.) Erastus was popular enough, both professionally and civically, that he was elected to the state legislature for three consecutive terms beginning in 1836. He later served twice as governor of Vermont, first in 1852 and again in 1860. It would not be the last time that a member of the family led the state, a reflection of the breadth of recognition and respect that the Fairbanks family earned far beyond St. Johnsbury.

Scales were not only St. Johnsbury's chief product, but they also provided an apt (and often invoked) metaphor for the value system that the Fairbanks family practiced. As E. & T. Fairbanks and Company came to exemplify the ideal of fairness in trade through the high quality of their scales that regulated commerce around the world, its leaders extended the company's ethos to its labor practices as well. The company demanded uncompromising excellence from its skilled workers, and provided equitable wages and respect in return. Workers were paid by the piece, rather than an hourly wage, and could therefore set their own hours. Unlike the largely unskilled laborers in the factories of most urban American centers, the St. Johnsbury workforce was highly skilled and largely constituted of native-born Vermonters who shared the cultural and religious background of their managers. Vermonters take great pride in their egalitarianism, and the Fairbanks Scale Works extended that outlook to every aspect of the business, a practice from which the company benefited in the loyalty and industry of its employees.

Erastus Fairbanks' oldest surviving son Horace, founder of the Athenæum, was born in 1820. He joined the family business in 1843 as a clerk and slowly added to his responsibilities until he took over the company upon his father's death in 1864. He retained the position until his own death in 1888. Horace's tenure at E. & T. Fairbanks and Company encompassed virtually the full length of the company's rise from local firm to international industry. He helped to consolidate St. Johnsbury's economic development by his steadfast pursuit of a rail line linking the Connecticut River with Lake Champlain, completed in 1877. He shared his father's commitment to St. Johnsbury and undertook a series of major initiatives that enhanced quality of life in town, not the least of which was the opening of the Athenæum in 1871. Though Horace preferred to serve his community through private initiatives rather than public service, he was elected governor in 1876 (despite declining his party's nomination), the very year of America's Centennial.

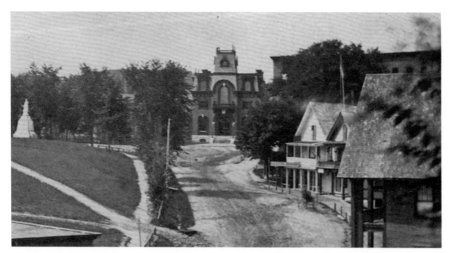

FIG. 3. The Athenæum stands at the top of Eastern Avenue, occupying a key intersection in the center of St. Johnsbury.

The Centennial of the signing of the Declaration of Independence in 1776 was a profoundly ambivalent moment in American history. The changes in American culture wrought by the Civil War are difficult to overestimate. The loss of life alone, over 600,000 killed, approximates the total number of deaths in every other American war combined. The war emancipated four million African-American slaves and transformed the Northern economy into an industrial power even as it left the South in ruins. Reconstruction, the period of rebuilding and reconciliation that immediately followed the war, lasted over a decade from the war's end in 1865 until 1877. It was no coincidence that preparations for the grand Centennial Exposition in Philadelphia began in 1866, just after the war's end, and spanned the length of Reconstruction. Notably, Horace Fairbanks began his development of the Athenæum in 1866 as well.

The Centennial Exposition was as much about America's industrial coming of age as it was about the nation's history. Such international fairs, initiated by the British in 1851, offered manufacturers, artists, and scientists alike the opportunity to exhibit their work and compete with their peers both domestic and international. (E. & T. Fairbanks and Company exhibited 194 scales at the Centennial.) Nearly nine million people visited the Exposition, making it one of the most important shared cultural reference points in the nation's history. Enormous temporary exhibition halls were erected on a 385-acre tract in Philadelphia's Fairmount Park to house the wide array of materials on display. The same artists whose works are on display in the Athenæum's Art Gallery exhibited at the Centennial, not far from the building in which the Fairbanks scales were on view. Such an encyclopedic mixture of displays seems hard to imagine today, but the sections deliberately juxtaposed national accomplishments within different areas of creative, cultural, and economic endeavor.

The Centennial marked a new beginning for the United States as a contributor to the world economy. Finally emerging from the shadow of the British, America was able to dis-

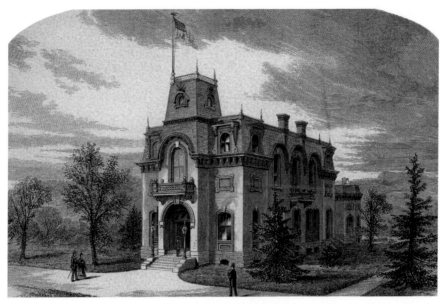

FIG. 4. Engraved frontispiece to the Athenæum's first published library catalogue in 1875 showing the original Second Empire Baroque design.

play its productions and garner recognition for the quality and ingenuity of its goods. Retrospectively, the U.S. Department of Treasury's Bureau of Statistics noted that the Centennial Exposition had an appreciable impact on the balance of American trade with foreign countries, reversing it in favor of the United States for the first time in the nation's history. Ironically, America's ability to compete with other industrialized countries in 1876 was the direct result of its massive industrial buildup during the Civil War. As Americans, including Horace Fairbanks, looked ahead to a future of competition with the world's leading powers, they could not ignore their recent past and the shaky foundation of their newly vibrant economy.

The opening of the Athenæum in 1871 at the center of St. Johnsbury (fig. 3) reflected the maturation of both national and local economies after the war. As the town prospered, the intellectual and cultural aspirations of the community grew as well. Fairbanks spent much of his time at the company's offices in large cities, particularly in New York and Europe, and witnessed the quality and breadth of cultural offerings there. Although he did not attend university, Fairbanks was committed to education and lifelong self-improvement through literature and art. College education was relatively common among the wealthy in America during the mid-nineteenth century, but not prevalent, and it tended to prepare students for lives of scholarship, rather than business. The latter was learned firsthand, and Fairbanks apparently received outstanding training from his family. Self-improvement, however, was a leading tenet of nineteenth-century American culture. Public schools and libraries burgeoned during the period, promoting literacy, democracy, and social mobility.

Fairbanks' ambitious goal for St. Johnsbury's new Athenæum was clear even before the Athenæum's opening. He wanted to create a substantial library of twelve thousand volumes covering every area of study, "an ideal of completeness." To assemble such an extensive collection, Fairbanks enlisted one of America's most celebrated librarians, William F. Poole (1821–1894). Author of the first index of American periodicals in 1848, later known as *Poole's Index to Periodical Literature*, Poole had already been the head of the distinguished Boston Athenæum for over a decade by the time Fairbanks approached him for assistance. Fairbanks took considerable pride in obtaining the finest editions available of the books that Poole recommended and importing leather bindings from London when he learned that no suitable bookbinder could be found in the United States. Although no reliable estimate exists of how much money Fairbanks invested in the books that eventually filled the Athenæum's shelves, his uncompromising search for the most informed advice, the highest quality editions, and the most lavish bindings available collectively convey a more accurate sense of Fairbanks' investment in the library than a monetary figure could. The Athenæum's library was intended not only to be an outstanding library for the town, but to vie in quality with the finest libraries in the country. In the ensuing years, Fairbanks would bring a similar ambition to the challenge of assembling an art collection for the Athenæum.

Fairbanks' choice of architects for the new Athenæum was equally significant. New York-based John Davis Hatch III (around 1827–1875) was a well-respected and outspoken member of his profession during mid-century, though little record of his career remains today. Hatch worked in the new and cosmopolitan architectural aesthetic known as Second Empire Baroque that came to prominence as the quasi-official style of American government buildings, art galleries, and other public institutions after the Civil War. The style originated in France during the mid-1850s, when Louis Napoleon commissioned additions to the Louvre that could be integrated into the original Baroque structure. Characterized by strong horizontal layering, division into pavilions, steeply-pitched mansard roofs, and rich sculptural ornament, the Second Empire Baroque was a lavish revival style, one of several that came in and out of fashion during the course of the century. Fairbanks' decision had significance both because it reflected current trends in American architecture and because it suggests an awareness of the style's origin. Fairbanks might already have seen distinguished examples of the style at Washington's Corcoran Gallery (1859) or, closer to home, at the new Boston City Hall (1862–65). Hatch would have been aware of the style's origin at the Louvre, even if Fairbanks were not, and the latter would certainly have appreciated the association of St. Johnsbury's new Athenæum with the world's most important museum.

The Athenæum's building is a distilled version of the Second Empire Baroque. Although the final building is subdivided into sections, has a strong horizontal accent, and is topped by an elegant mansard roof, the building's ornamentation is understated. The Athenæum's clean, geometric lines, rich red brick, and bulky masonry foundation are typical characteristics of New England architecture that lend local flavor to Hatch's design. Moreover, the Athenæum building is far smaller than the massive city halls, train stations, and college buildings that were sprouting up around the country. A contemporary drawing of the Athenæum's façade and profile (fig. 4) shows the elegant balconies that initially graced the building, but which were removed during the mid-twentieth century when they

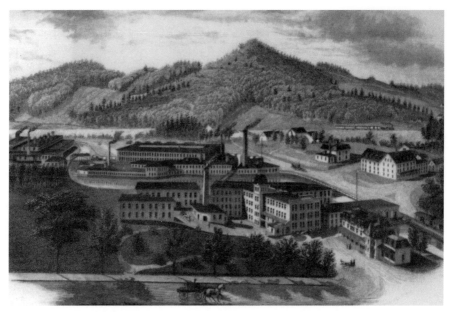

FIG. 5. The Fairbanks Scale Works around 1884, after a major fire provided the opportunity to rebuild the factory in the Athenæum's style.

proved difficult to maintain. The balconies further accentuated the sense of advancing and receding planes that characterize Baroque constructions of all eras. The Athenæum's interior reflects the lavish design typical of the style, although still understated when compared with the excesses of Hatch's European counterparts. Elaborately carved ash and walnut woodwork, ornate light fixtures, and wall colors in warm, autumnal tones extend the building's ornate exterior program to its interior as well. The Athenæum's Second Empire Baroque hybrid style was both fashionable and innovative, and had a considerable influence on later buildings erected in St. Johnsbury.

Construction of the Athenæum took three years and was directed by Lambert Packard, chief builder at the Fairbanks Scale Works. With little experience in such elaborate construction, Packard and the team of twenty craftsmen who built the Athenæum drew upon the ingenuity that had made St. Johnsbury so successful in business. Much like the development of the Fairbanks scale itself, the construction of the Athenæum called for extensive innovation on the part of its builders. The craftsmen's pride in their work as much as the designer's original drawings and the institution's cultural resources rendered the Athenæum a unique contribution to American architecture, and contributed to its designation as a National Historic Landmark by the U.S. Department of the Interior in 1996. Moreover, Packard's involvement with the Athenæum's construction had a lasting impact on the development of the town of St. Johnsbury. As an architect himself, Packard later modeled a number of town buildings on the Athenæum's version of Second Empire style.

After a devastating fire in 1876 destroyed much of the Fairbanks Scale Works, Packard also rebuilt several of the factory's structures in the style (fig. 5). Hatch's design for the Athenæum therefore became a keynote for St. Johnsbury's future development far beyond the building itself.

The Athenæum opened its doors with considerable fanfare on November 27, 1871, setting the tone for its early success within the community. One visitor remarked that there were over a hundred patrons in the library on a Saturday evening just two weeks after the opening. Six hundred residents reportedly attended each of the three inaugural lectures, which addressed the role of books in education, their innately democratic nature, and their infinite range as a source of inspiration. The lectures also highlighted the new institution's secondary function as a public lecture hall, "to be auxiliary to the educative use of the library." In the ensuing decades, the Athenæum hosted speeches by two presidents, Benjamin Harrison (in 1891, for whose visit the Athenæum was lavishly decorated, fig. 6) and William Howard Taft (in 1912), as well as visits by African explorer Henry Morton Stanley and North Pole pioneer Robert Peary, among many other distinguished guests and lecturers. The Athenæum became an important venue not just because of the care with which it was built, but because of the commitment of the community to its success. Without St. Johnsbury area residents' devoted and appreciative attendance, the Athenæum could never have become a destination on the national lecture circuit. It was as much the community's pride in the Athenæum as Fairbanks' planning that sustained its early success.

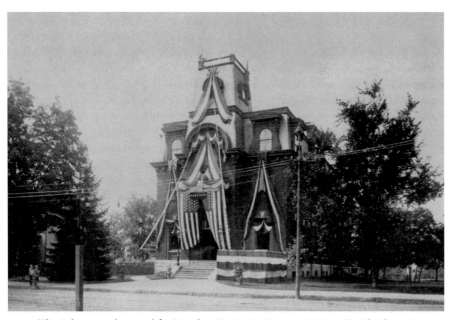

FIG. 6. The Athenæum decorated for President Benjamin Harrison's visit to St. Johnsbury in 1891.

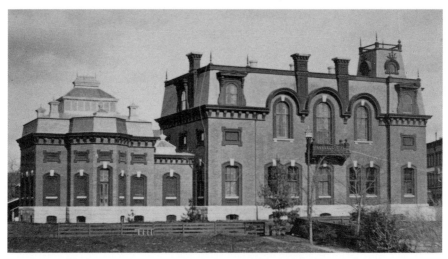

FIG. 7. The Athenæum seen from the South, showing the addition of the Art Gallery at the left, behind the original structure.

ART FOR ST. JOHNSBURY

Within nine months of the Athenæum's opening, planning was underway for Hatch to design an addition to house a permanent art gallery behind the original building (fig. 7). Fairbanks was not alone in starting a gallery during the period; most of America's leading museums were founded after the Civil War. Both New York's Metropolitan Museum of Art and Boston's Museum of Fine Arts were founded in 1870, and the Art Institute of Chicago was only founded in 1879. The opening of the Athenæum's Art Gallery in 1873, therefore, placed it among America's pioneering institutions. The new museums were created to educate the public in matters of taste and foster good industrial design. By making distinguished examples of fine art available for study, museum founders believed that they would enhance the nation's products and better compete in international markets. Taste was also aligned with virtue and refinement, prerequisites for entry into polite society. In an era characterized by grossly exploitative management practices and widespread labor unrest, business and political leaders hoped to quell protest and pacify workers by cultivating a greater sense of class mobility than actually existed. Although little record remains of Fairbanks' motives for building the Athenæum and its Gallery, his stated goals at least were more benevolent than those of his urban counterparts. From his public comments, he hoped to create a space for the quiet reflection and inspiration that he himself enjoyed.

The Athenæum's art collection is as remarkable for its eclecticism as for its exceptional strengths in key areas. Fairbanks appears to have specifically assembled his collection with the Athenæum and St. Johnsbury in mind. Like the library, the art collection offers a wide array of materials, from the classics to contemporaries, from history to fiction, and from the easily appreciated to the esoteric. Although the library was amassed with expert guid-

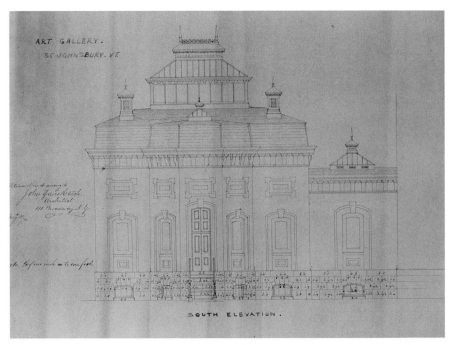

FIG. 8. South elevation drawing for the Athenæum's Art Gallery, which opened to the public in 1873.

ance, however, no evidence exists that Fairbanks consulted with an advisor as he built the art collection in the early 1870s. Instead, he preferred to work with a variety of dealers, middlemen, and the artists themselves. In later years, Fairbanks' widow contacted some of the artists with whom her husband had dealt in the 1870s, hoping to document their interactions. In the instances where the artists remembered Fairbanks, they wrote warmly of their exchanges and his visits to their studios (though they certainly would have had no incentive to speak ill of him to his widow). In several cases, the artists remembered him well because he had acquired some of their finest works. Some, such as Jervis McEntee (N-10), would occasionally borrow the works back from the Athenæum to represent them at major exhibitions. Although any overarching logic behind Fairbanks' collecting is difficult to discern, the individual areas in which he collected offer insight into his hopes for the new Art Gallery.

The Athenæum's art collection may be organized comfortably under several general rubrics: the American landscape, depictions of everyday American life, classical studies, cultural exoticism, and reproductions of Renaissance and Baroque masterworks. Although Fairbanks personally donated only about half of the approximately one hundred and twenty works that comprise the Athenæum's current holdings, many of the rest were given by his granddaughter, Theodora Willard Best, shortly after the turn of the century. Best had inherited many of the works from her grandfather's estate, and so her contribution

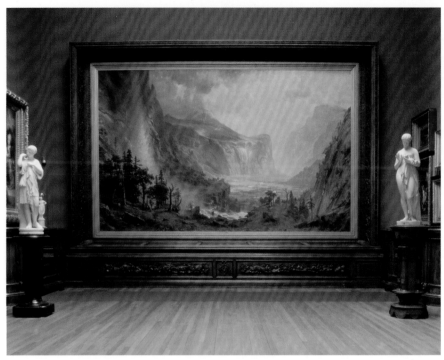

FIG. 9. View of Albert Bierstadt's *Domes of the Yosemite* installed in the Athenæum's Art Gallery.

naturally complemented the initial collection. Later donations to the Athenæum have further enriched the collection through their donors' generosity, and most similarly fit within the scope of Fairbanks' original gifts. Unlike the library, the art collection has preserved a sense of the moment in which it was created, a lasting tribute to the vision of its founder.

The Art Gallery itself is a marvel of compact gallery design and nineteenth-century art gallery theory. A large central skylight and three smaller skylights high above the South, North, and East alcoves (visible in the South Elevation drawing, fig. 8), illuminated the Gallery with natural light to show the works in what was, and still is, believed to be the richest quality of light available. The soaring height of the ceilings permitted the exhibition of large works of art, including Albert Bierstadt's enormous *Domes of the Yosemite* (w-4, fig. 9) and a copy of Anthony van Dyke's *Children of Charles I* (w-2), without reflection from the light source. The Gallery's high arches gracefully complement the natural arches of rock depicted in Bierstadt's composition. The shallow alcoves permit visitors to back up considerably to appreciate the artworks hung higher on the wall, even those hung on the side walls of the alcoves. Treatises on gallery design and installation were widely available to architects such as Hatch, and he was apparently aware of their principles. He had also learned from the initial design for the library. Difficulty with climate control in the original building led the architect to introduce a more aggressive system of both

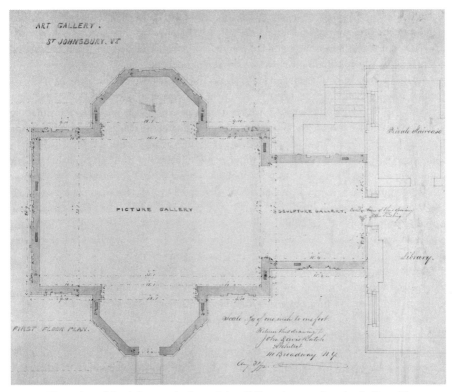

FIG. 10. Floor plan of the Athenæum's planned Art Gallery showing that the far East Alcove was designed early on as a sculpture gallery.

steam heat for winter and ventilation for summer, in order to better maintain a stable climate in the Gallery. His planning for vents concealed in the Gallery's elaborate upper moldings was an elegant and discreet solution for its day. Throughout the Gallery, Hatch's careful planning and Packard's meticulous implementation of his designs create an intimate experience of the collection for visitors.

Hatch's floor plan for the Gallery, dated August 31, 1872 (fig. 10), demonstrates a responsive adaptation of the planned spaces as the collection developed. The drawing indicates that the segment of the East Alcove closest to the library entrance was conceived early on as a "sculpture gallery," separate from the adjacent "picture gallery" with its higher ceilings. The difference in effect is appreciable, as sculptures were displayed on pedestals at eye level, whereas paintings were displayed one atop another, high on the walls in some cases. Whether because of Fairbanks' purchase of Bierstadt's *Domes* or because of the relative paucity of sculpture within his collection, Hatch's plan was apparently changed. Another alteration would be made nearly a decade after the Gallery opened to the public, with the installation of a viewing balcony for Bierstadt's painting at the eastern end of the space. The artist himself had such elevated platforms built in his studio so that his large paintings

would fill his viewers' field of vision, rather than loom above them. Whether at the artist's suggestion or someone else's, the addition of the balcony was intended to enhance the experience of the Athenæum's celebrated *Domes*. Its construction demonstrates an ongoing effort to refine the installation well after the Gallery opened.

As the importance of Bierstadt's *Domes* to the experience of the Athenæum's Art Gallery suggests, landscape painting is a primary dimension of the collection. Landscape was also the first genre of painting in which American artists were recognized for making a distinctive contribution to the history of art. Beginning in the 1820s, American landscape painters explored their new nation's scenery as a means of breaking free of European influence. Early American landscape painters, later dubbed the Hudson River School for their frequent depictions of upstate New York, portrayed the countryside with an eye toward its future settlement. The country was perceived by its citizens as a new beginning for Western civilization, which had become corrupt in Europe. America offered new opportunities to explore the landscape and live close to the earth, free from the temptations and vice of urban areas. Appropriately, the first identifiably American school of art was devoted to the celebration of the nation's unique scenery.

Representative examples of American landscape painting by the Hudson River School's second generation, including Worthington Whittredge, Sanford Gifford, Samuel Colman, and, of course, Bierstadt, constituted half of the Art Gallery's initial display. Many of these were not only representative, but major examples by America's leading painters. Whittredge's *On the Plains, Colorado* (1872, N-11) and Gifford's *The View from South Mountain, in the Catskills* (1873, S-9) bracket the two iconically American landscapes, western and eastern, and illustrate the accomplishments of recent aesthetic developments in landscape painting as the century progressed, favoring works that privilege geometric balance over narrative. Fairbanks took initiative in getting to know the artists personally and almost certainly gained insight into their work directly from the artists themselves. He joined the Century Club in New York, a social club of artists, authors, and other intellectuals that counted virtually every significant American artist among its members. He also regularly visited the artists' studios, where he purchased significant works even before they were displayed publicly. Collecting American art became an increasingly competitive activity in the wake of the Civil War, as the emerging industrial elite sought to conspicuously display their wealth in their homes. Unlike many collectors, however, who bought their art primarily through middlemen, Fairbanks was able to establish connections with the leading artists of the day that allowed him to acquire works before others even saw them.

The wake of the Civil War was, however, a tumultuous time in American art as well as culture. The landscape painters who had pioneered the professional practice of art in America and established its early institutions were seen by their younger colleagues as vestiges of the past. Like American industry, which could increasingly compete in international markets, as the Centennial Exposition would demonstrate, young American artists charted a more cosmopolitan aesthetic direction for American art in opposition to their older mentors and colleagues. Fairbanks was a contemporary of the landscape painters whose works he collected, and who had achieved leadership status in American art by the early 1870s. By building a collection of their works, Fairbanks centered the Athenæum's collection on the leading aesthetic mode of the day at its peak. The paintings celebrate an ideal

of the American landscape, however, that the war and rapid industrialization had rendered virtually obsolete. The prevailing tenor of the Athenæum's outstanding collection of landscape paintings is therefore retrospective, a selection of the highest achievements of a mature school of American art.

Fairbanks' collection of depictions of everyday American life, known as genre paintings, was more transitional in nature. Whether by coincidence because he was looking for works that would appeal to younger viewers or by design, the Athenæum's collection of genre paintings surveys the thriving Centennial-era market for scenes of childhood innocence and youthful beauty. J. G. Brown's *Hiding in the Old Oak* (1873–74, w-6), George Cochran Lambdin's *Girl Reading* (1872, e/n-5), and Chauncey Bradley Ives' *Pandora* (1875, w-12) are all superlative examples of the new mode, a sharp change in direction from the more politically inspired and satirical depictions that prevailed before the war. Fairbanks does appear to have avoided the more rough and tumble urban street urchin type—newsboys, bootblacks, and beggars, among others—that also emerged at this time. Because Fairbanks' collection was so extensive in certain types of painting, particularly landscape and genre, we may speculate, at least, that his aversion to this otherwise popular subject might reflect his desire to keep such urban miscreants from St. Johnsbury or to avoid modeling inappropriate behavior for the Athenæum's young visitors. His vision of St. Johnsbury's future was an idyllic and rural one.

Fairbanks' collections of international and historic scenes, by contrast, would have opened new worlds to the St. Johnsbury community. Although Fairbanks traveled widely for business, very few of his contemporaries traveled more than a few miles from their birthplaces during the course of their lives. Increased immigration helped to build awareness of foreign cultures, but most residents of the St. Johnsbury area would never see a foreign country firsthand. The Athenæum's collections of reproductions of some of the best-known paintings and sculpture from classical antiquity, such as the *Diana of Gabii* (w-1), and the Renaissance and Baroque eras, such as Raphael's *Madonna del Granduca* (e/s-7) and one of Rembrandt's self-portraits (e/n-8), similarly suggested the experience of visiting Europe and exploring its grand galleries. Although viewers today tend to view these reproductions as quaint or naïve, they nevertheless served an important pedagogical function in the nineteenth century when trans-Atlantic travel was both long and dangerous, as well as expensive. To these reproductions, we can add the dimensions of exoticism as represented by Louis Émile Pinel de Grandchamp's *Donkey Driver of Cairo* (n-5) and of history in Luigi Bazzani's *Pompeian Interior* (e/n-6). Within reason, Fairbanks' collecting of international and historic scenes suggests an effort to introduce the broader world to the St. Johnsbury community in an era of rapid globalization.

Each of Fairbanks' primary collecting areas conveys a different aspect of his ambition for St. Johnsbury. In the context of the Centennial era and St. Johnsbury's own rapid expansion, his collecting suggests important dynamics within the social fabric of the region. The Scale Works had outgrown its modest beginnings, and the development of the Athenæum's art collection demonstrated Fairbanks' belief that his neighbors would appreciate an outstanding gallery as much as any urban population. His great coup was bringing Bierstadt's monumental *Domes of the Yosemite* to the town, where it stands to this day as testimony to Horace Fairbanks' great ambition for the future of his community.

FIG. II. The Athenæum's Children's Room was added in 1924 and later decorated with murals by local artist Margery Eva Lang Hamilton that illustrate classic children's stories.

POSTSCRIPT

The history of the Athenæum in the twentieth century is one of virtual stasis, with a handful of notable exceptions, until a massive restoration campaign began in 1996. The most significant alterations to the building were its electrification in 1901 and the addition of a Children's Room (fig. II) in 1924, named in honor of Edward Taylor Fairbanks. Children had been a primary constituency of the Athenæum since its founding. Both in the selection of books and works of art, Fairbanks considered the interests of St. Johnsbury's young people. On the day after the library opened to the public, in an impressive ceremony as elaborate as any of the Athenæum's inaugural lectures for adults, Fairbanks along with several speakers, dignitaries, and a six-piece band welcomed area children to the Athenæum in recognition of the fact that they represented the town's future. The Children's Library remains a vital component of the Athenæum to the present day, fulfilling the Athenæum's founding commitment to early education.

As the twentieth century progressed, economies of cost and maintenance were sought in the building's upkeep as the town itself entered an extended recession. The Athenæum's massive front doors, many original fixtures, and even the soaring ceiling of the main lecture space, Athenæum Hall, were replaced or covered. Ever conscious of the future, however, administrators kept virtually every original piece of the building in storage. Beginning in

1996 with the publication of an extensive Historic Structure Report by preservation specialists Mesick Cohen Wilson Baker Architects of Albany, New York, the Athenæum underwent a systematic historic renovation and modernization that permitted the restoration of the building's original appearance. As it was with the building's original construction, area contractors, builders, and staff worked diligently to modernize the building while respecting its historic integrity. Today, thanks to their efforts, the Athenæum has been revitalized in its ability to serve the community of St. Johnsbury. Its Centennial-era mission to educate and inspire the community now reaches beyond the local area, however, an invaluable primary record of the nation's art and culture at a critical juncture in American history.

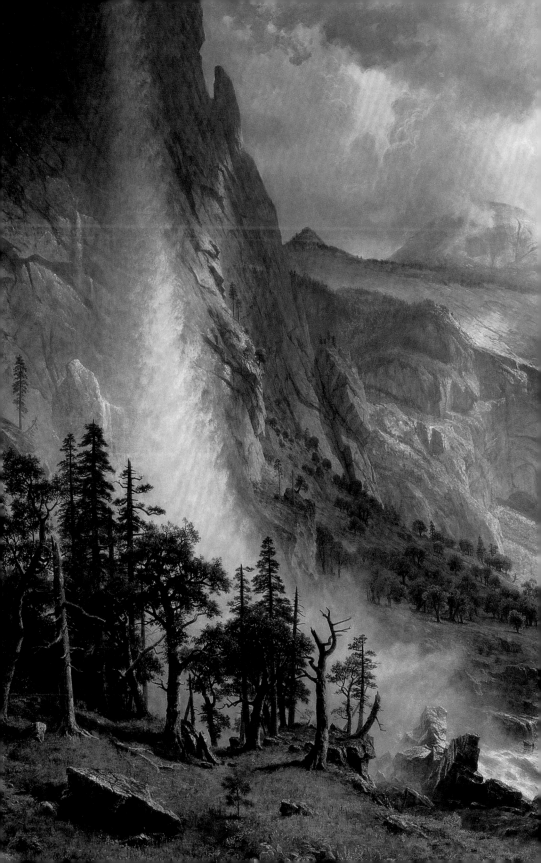

CATALOGUE OF
THE COLLECTION

For works on view in the Art Gallery, a *location number* refers to the alcove in which the work is displayed and its position on the wall (in this example, the fourth work in the West Alcove).

The *artist's information* indicates the work's creator, along with her or his birth and death dates and nationality. If the work is a reproduction, the term "after" is used to refer to the original artist.

Tour icons denote which self-guided tours this particular work may be found on.

The *object identification* gives the work's title (along with any former or alternate titles in parentheses) and the date in which it was created.

§ ‡ **W-4** Albert Bierstadt (1830–1902), German-American
The Domes of the Yosemite, 1867
Oil on canvas, 116 x 180 inches
Gift of Horace Fairbanks

The *credit line* tells how the painting or sculpture came into the collection.

The *object description* indicates the work's medium and dimensions (height before width).

EAST/NORTH SIDE
(E/N)

EAST/SOUTH SIDE
(E/S)

LIBRARY

SOUTH ALCOVE (S)

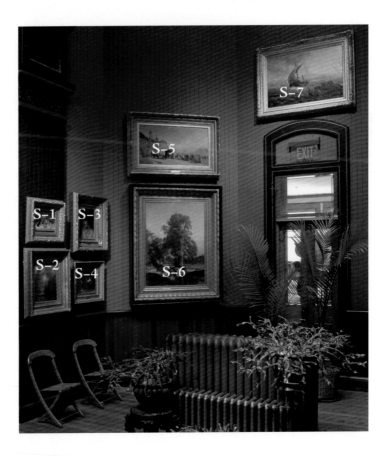

S–1 Emilie Preyer, *Fruit and Wine*

S–2 Worthington Whittredge, *Fishing*

S–3 Friedrich August von Kaulbach, *Head*

S–4 Thomas Waterman Wood, *The Argument*

S–5 A. Wordsworth Thompson, *Waiting for the Steamboat at Menaggio,
 Lake Como*

S–6 James M. Hart, *Under the Elms*

S–7 George Loring Brown, *Bay of Naples*

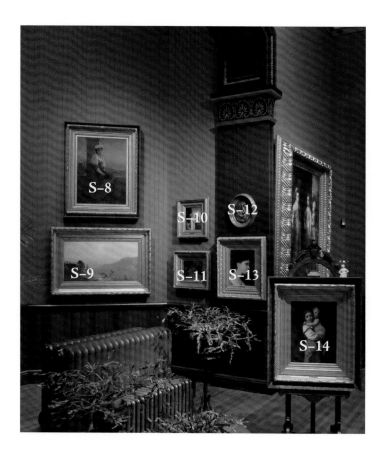

S–8 Henry A. Loop, *Idle Fancies*

S–9 Sanford R. Gifford, *The View from South Mountain, in the Catskills*

S–10 William Holbrook Beard, *Why, Puppy Looks Like Grandpa!*

S–11 William Mason Brown, *Raspberries*

S–12 Unknown artist, *Earth*

S–13 Gabriel von Max, *St. Ursula*

S–14 Adolphe William Bouguereau, *Going to the Bath*

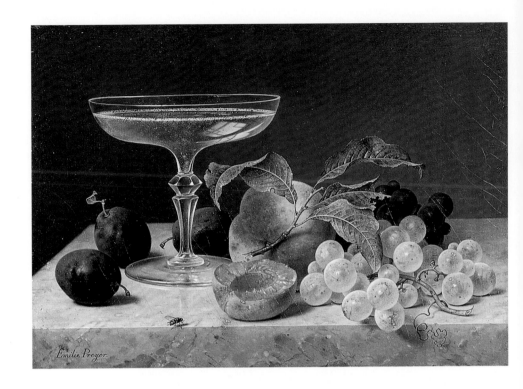

S-1 Emilie Preyer (1849–1930), German

Fruit and Wine, undated

OIL ON CANVAS, 9½ x 12½ inches

Gift of Horace Fairbanks

As the only work in the Athenæum's collection known to have been created by a woman, Emilie Preyer's *Fruit and Wine* bears witness to the often insurmountable challenges that confronted aspiring women artists during the nineteenth century. As was frequently the case for the successful few, Preyer studied art with her father, Johann Wilhelm Preyer (1803–1899), who was himself a celebrated still life painter in Düsseldorf, Germany and developed a significant following of women artists that included his daughter as well as the Burlington, Vermont-born painter Helen Searle (1834–1885).

Like her father, Emilie Preyer worked in the Dutch tradition of crisply painted, brightly colored tabletop scenes. From the known record of her paintings, exclusively still lifes, she worked in two basic sizes, of which *Fruit and Wine* is actually the larger. Moreover, with its translucent glass of champagne, richly veined marble shelf, and diverse fruits, the painting is also among her most challenging subjects with its widely varied forms, textures, colors, and effects of light. The fly, cut apricot, and decaying leaves included in the composition are symbols of life's brevity, often referred to by their Latin name, *memento mori*.

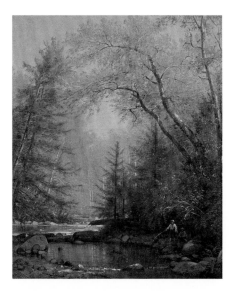 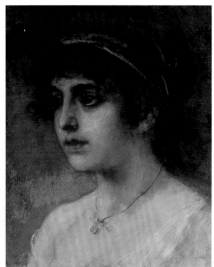

S-2 Worthington Whittredge (1820–1910), American
Fishing, around 1868–70
OIL ON CANVAS, 17 X 14 inches
Gift of the Estate of Horace Fairbanks

This intimate depiction of two figures fishing in a quiet stream has been characterized by leading Whittredge scholar Anthony Janson as "paradise regained, not on God's terms but man's." The spiritual aspect of American landscape painting, one of its cardinal traits, diminished in the wake of the Civil War and the 1859 publication of Charles Darwin's revolutionary *On the Origin of Species*. This peaceful forest interior, framed by the surrounding and overhanging trees, portrays the return to nature as respite from the demands of the urban world, rather than a spiritual pilgrimage.

S-3 Friedrich August von Kaulbach (1850–1920), German
Head, undated
OIL ON CANVAS, MOUNTED ON MASONITE, 14 X 11¼ inches
Gift of Mrs. Theodora Willard Best

Friedrich August von Kaulbach descended from a distinguished family of artists and was able to achieve recognition in his own career for his idealized depictions of women, a popular subject during the later nineteenth century. The striking blue backdrop that Kaulbach employed in this composition is a foil for the figure, pushing her forward, and reflects the artist's early interest in the portraits of the German Renaissance master Hans Holbein the Younger (1497–1543), who often used a similar approach.

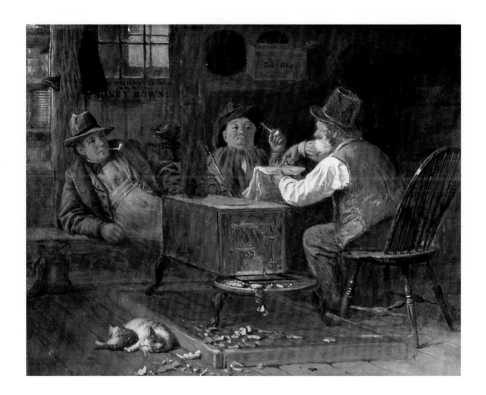

❦ S-4 Thomas Waterman Wood (1823–1903), American

The Argument, 1874

OIL ON CANVAS, 10⅝ x 13⅝ inches

Gift of Horace Fairbanks

A leading artist of his day, Thomas Waterman Wood was born in Montpelier, Vermont and maintained close ties with Vermont throughout his distinguished career. Wood's sentimental portrayals of American life captured the popular imagination and gained widespread recognition beginning in the 1860s. The themes of childhood innocence and rural life pervade his work and appealed to urban audiences nostalgic for simpler times.

The Argument revisits one of Wood's most famous compositions, *The Village Post Office*, of 1872 (in the collection of the New York State Historical Association, Cooperstown). Fairbanks probably saw the latter painting when it was exhibited at the National Academy of Design's annual exhibition in 1874 and commissioned the artist to paint this vignette from the larger composition. The appeal of the scene for Fairbanks was undoubtedly local, as both the site of Wood's composition, the Ainsworth General Store in Williamstown, Vermont, and the sitters, well-known residents of nearby Montpelier, are identified. Apparently debating a story in the day's newspaper, the figures in *The Argument* are reported to be, from left to right, Calvin Bullock, R. H. Whittier, and a Mr. Boyden.

Although the Vermont landscape often appeared as a subject in the National Academy's famous exhibitions, Vermonters themselves were rarely represented. Fairbanks seized the occasion of Wood's celebrated painting to document the state's national appeal as seen through the eyes of one of the state's most accomplished artists. In later years, Wood became a supporter of the Athenæum himself, presenting a copy of Rosa Bonheur's *Plowing in the Nivernais* (see E/S-16) to the Gallery during the 1890s.

‡ **S-5** A. Wordsworth Thompson (1840–1896), American

Waiting for the Steamboat at Menaggio, Lake Como (Steamboat-Landing at Menenazzio), 1874

OIL ON CANVAS, 20½ x 38½ inches

Gift of Mrs. Theodora Willard Best

Baltimore native Wordsworth Thompson's panoramic depiction of a small town located on Lake Como in northern Italy provides as expansive a view of the town's community as it does of the scenic landscape itself. Peasants, merchants, soldiers, musicians, and nobles mingle patiently while awaiting the ferry, providing the artist a rare opportunity to portray them at once. The brilliant blue sky and distant Alpine landscape, animated mixture of social types in the foreground, and historic buildings are carefully interwoven in Thompson's composition. Painted just four years after the unification of Italy was completed, Thompson's painting suggests the natural ease with which the people and landscape peaceably coexisted. Although the artist himself had been living in New York since completing his studies in Paris in 1868, he continued to develop his appreciation of Europe's diverse cultures and landscape during shorter trips abroad thereafter.

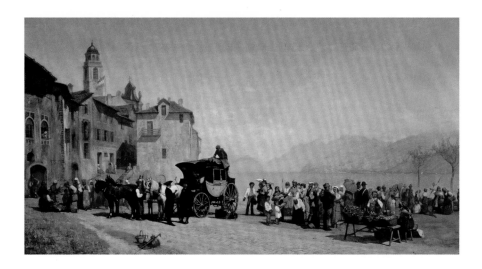

S-6 James M. Hart (1828–1901), British-American

Under the Elms, 1872

OIL ON CANVAS, 44 x 33 inches

Gift of Horace Fairbanks

James M. Hart remains a little-known figure in the history of American landscape painting, but his bucolic *Under the Elms* makes a strong case for greater attention. The work is inscribed on the back, "Afternoon / Boquet River / Essex Co. / N.Y. / Loitering in the Stream," providing a much fuller sense of the site and subject. Grand, stately elms climb gracefully upward over a peaceful stream as a herd of cattle edges across to the opposite shore. The painting pays tribute to one of America's most elegant tree species, as both the format and vantage point frame the trees themselves, rather than the scene playing out below. Such careful rendering of a single natural subject, in this case the nearest elm, offers eloquent testimony to nineteenth-century artists' search for meaning in the landscape around them through close scrutiny.

Under the Elms is characteristic of Hart's work after the Civil War. Where he favored larger-scale depictions of unexplored wilderness in his earlier work, his later paintings are often more tranquil and refined. Trained in the academic tradition in Düsseldorf, Germany during the early 1850s, Hart already enjoyed widespread popularity before the onset of Civil War in 1861. His pre-war landscapes are also marvels of specificity, delineating every leaf and rock. Not only did his subjects change during the 1860s, from wilderness to pasture, but his palette and technique transformed as well. Light-filled, idyllic compositions such as *Under the Elm* suggest an intermediate step between the detailed landscapes of the Hudson River School at mid-century and the escapism of the impressionists that came to prominence during the ensuing decades.

‡ **S-7** George Loring Brown (1814–1889), American

Bay of Naples (View of Naples from the Sea), 1853/1873

OIL ON CANVAS, 27½ x 41½ inches

Gift of Horace Fairbanks

George Loring Brown's depiction of the Bay of Naples portrays an early phase of the cataclysmic eruption of Mt. Vesuvius during ancient Roman times in 79 C.E. Like Luigi Bazzani's rendering of life in the city of Pompeii (see E/N-6) before its destruction, Brown's painting illustrates nineteenth-century fascination with the tragic event. Italy's enduring appeal for American artists such as Brown derived in no small part from its long and rich history, which fascinated to visitors from the youthful United States.

Brown's version of Vesuvius' eruption portrays an ancient quadrireme, or galley, laden with figures fleeing the disaster. The volcano's intact profile shows that the main eruption, when the peak itself exploded, has not yet occurred. The scene evokes Pliny the Younger's eyewitness description of the event and how his father had rushed off by boat to help save the people trapped in the path of destruction. Because of Pliny's historic account, such apocalyptic eruptions are known today as "Plinian," a description applied to the eruption of Mt. St. Helens in 1980.

S-8 Henry A. Loop (1831–1895), American

Idle Fancies, 1874

OIL ON CANVAS, 34½ x 27 inches

Gift of Horace Fairbanks

Known primarily as a portraitist, Henry Loop gained critical recognition for his idealized genre scenes as well. Transcending the concerns of the everyday, these compositions evoke emotion and intimate symbolic meaning rather than telling a story or portraying an individual sitter.

In *Idle Fancies*, a young Italian peasant woman waits by a fountain while her pitcher fills. Lost in contemplation, she doesn't notice that it is already overflowing. In the background, a distant landscape and sunset suggest the content of her thoughts: time's passage and faraway places.

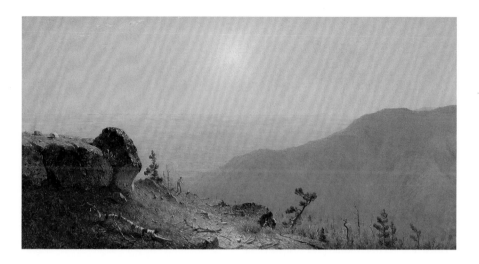

§ ℭ **S-9** Sanford R. Gifford (1823–1880), American

The View from South Mountain, in the Catskills (South Mountain, Catskills), 1873

OIL ON CANVAS, 21 X 40 inches

Gift of Horace Fairbanks

Sanford Gifford's art is notable for its radiance. Like a number of his peers working in the aesthetic mode known today as luminism, Gifford approached light and atmosphere as a medium through which to perceive the world, and he rendered their presence with great subtlety. Gentle gradations of tone and color characterize his art, and the figures and objects that inhabit his landscapes are kept to the margins so that they do not impede the fullest appreciation of the effulgent atmosphere in the distance. In *The View from South Mountain, in the Catskills*, two climbers join us on the heights to share our experience of the panoramic expanse.

New York's Catskill Mountains loom large in Gifford's art. He was raised in the nearby town of Hudson, and his experience of the Catskills therefore formed an integral part of his life and art from the very beginning. By the 1860s, Gifford had succeeded America's pioneering Hudson River School landscapist, Thomas Cole, as the Catskills' leading artistic voice. Throughout the Civil War years of the early 1860s, whenever he was on leave from his service in the army, Gifford made visits to his best-loved sites in the region, perhaps deriving comfort from their familiarity and peaceful grandeur. He first depicted this particular view during one of his wartime visits in 1863, only to revisit it ten years later in this work. This vantage obscures the famous nearby tourist hotel, the Catskill Mountain House, emphasizing our unobstructed view of the sky from the mountain's peak. The shattered limbs in the foreground remind us that nature is not always so peaceful.

Despite extensive travels throughout the world from the mid-1850s until his death in 1880, Gifford returned to the Catskills again and again. His visits undoubtedly influenced his approach to the many and diverse landscapes of the world that he visited during his life, from Europe, to the Middle East, to Alaska.

S-10 William Holbrook Beard (1824–1900), American

Why, Puppy Looks Like Grandpa!, 1874

OIL ON CANVAS, 12 X 10 inches

Gift of Horace Fairbanks

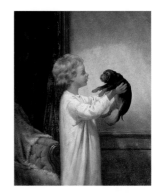

William Holbrook Beard is noted for his light humor, particularly in his depictions of animals run amok. This affectionate portrayal of a young boy remarking upon his dog's wrinkled resemblance to his grandfather is typical of Beard's work. Unusual, however, is the painting's reliance upon its title for the viewer to interpret the subject. Beard's sense of humor and dependence upon his title to convey meaning reflect the strong influence of the art of caricature on his work.

S-11 William Mason Brown (1828–1898), American

Raspberries, 1873

OIL ON CANVAS, 10 X 12 inches

Gift of Horace Fairbanks

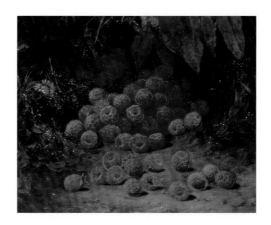

Like many American artists of the period, William Mason Brown found his niche as a still life painter during the 1860s only after trying his hand at portraiture and landscape painting. Brown's lush depictions of overturned baskets and abundant piles of ripe fruit were particularly appreciated in his day for their meticulous sensitivity to the fruits' textures and patterns.

Humble still life subjects, of which *Raspberries* is an excellent example, enjoyed immense popularity among American painters and collectors during the mid-nineteenth century. Fine color print reproductions of Brown's compositions sold widely, demonstrating their broad appeal to wealthy and middle-class collectors throughout the country. In an era when agriculture was rapidly being superseded by industry as the nation's primary economic force, however, these generous helpings of ripe fruit offered nostalgic allegories of the nation's agricultural bounty, giving no hint of the labor involved in their growth or harvest.

S–12 Unknown artist

Earth, undated

BRONZE, 12½ x 10½ inches

Gift of Horace Fairbanks

This is one of four allegorical medallions in the Athenæum's collection depicting the elements of nature: Earth, Fire, Air, and Water. Here, Earth is represented by bounty, as three winged boys, known as putti, collect a harvest of grapes. Putti have been used as symbolic figures in Western art since the antiquity. (See also N-2, E/N-10, and E/S-10.)

S–13 Gabriel von Max (1840–1915), Bohemian (Czech)

St. Ursula, undated

OIL ON CANVAS, 17½ x 14 inches

Gift of Horace Fairbanks

Within the known record of Gabriel von Max's works, religious figures are fewer in number than allegorical scenes, but they appealed similarly to the artist's interest in the relationships between a figure's physical appearance and inner state, as seen here in the figure of the fourth-century virgin martyr St. Ursula. Max was fascinated with mysticism and occultism, and his *St. Ursula* conveys a sense of his intensive study of the figure as a balance between reality and the spiritual.

Δ **S–14** Adolphe William Bouguereau (1825–1905), French

Going to the Bath, undated

OIL ON CANVAS, 21¾ x 18 inches

Gift of Mrs. Theodora Willard Best

Academic painting, the style taught in European and American academies of art, is loosely defined as a realist aesthetic centered upon close study of the human body. The once-dominant academic style developed negative connotations during the later nineteenth century that have lingered to the present. Associated with the subordination of individual creativity to standardized technique, nineteenth-century academic art has largely disappeared

from the canon of art history. Nevertheless, artists such as William Bouguereau were considered by most of their contemporaries to be the leading artistic luminaries of their time.

Bouguereau received virtually every major distinction and award available to an artist. His ascendancy lasted for most of the later century, beginning with his receipt of a second-place Rome Prize in 1850 while he was a student at the famed École des Beaux-Arts in Paris. Despite that early recognition, Bouguereau found that public commissions for grand historical compositions were too scarce to support him as an artist, so he turned to painting scenes of everyday life for his livelihood. Instead of complex narratives, his intimate depictions emphasize sentiment over narrative, so that each conveys a feeling rather than telling a story.

Going to the Bath portrays a secularized version of the Madonna and Child theme. Although the older girl is too young to be the baby's mother, their relationship accentuates familial nurturing. Before the later eighteenth century, children were viewed primarily as miniature adults, as shown in Van Dyke's portrait of *The Children of Charles I* (see w-2). Bouguereau's *Going to the Bath* illustrates the radical change in attitudes that occurred in the interim. The artist sought to elevate his subjects by smoothing and idealizing their features, transporting them beyond the mundane concerns of the everyday.

WEST ALCOVE (W)

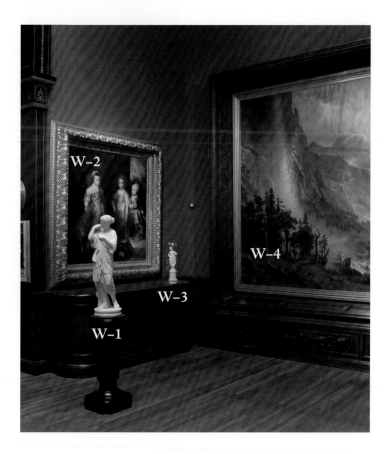

W–1 Unknown artist, *Diana of Gabii*

W–2 After Anthony van Dyke, *The Children of Charles I*

W–3 After Antonio Canova, *Dancing Girl*

W–4 Albert Bierstadt, *The Domes of the Yosemite*

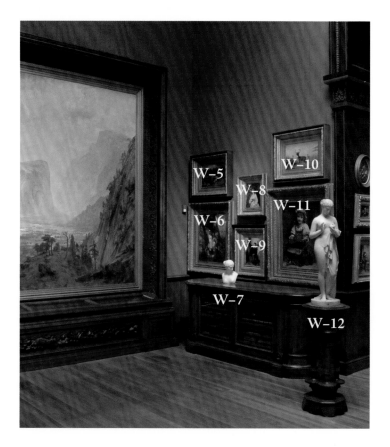

W–5 Arthur Fitzwilliam Tait, *Coming Home*

W–6 John George Brown, *Hiding in the Old Oak*

W–7 After Hiram Powers, *Bust of the "Greek Slave"*

W–8 Unknown artist, *Girl in the Wood*

W–9 Seymour Joseph Guy, *Up for Repairs*

W–10 Arthur Fitzwilliam Tait, *Deer, Early Morning on Racquette Lake
 in the Adirondacks*

W–11 Étienne Adolphe Piot, *Italian Girl with Cherries*

W–12 Chauncey Bradley Ives, *Pandora*

W-1 Unknown artist
Diana of Gabii, undated copy
MARBLE, 39 inches high
Gift of Horace Fairbanks

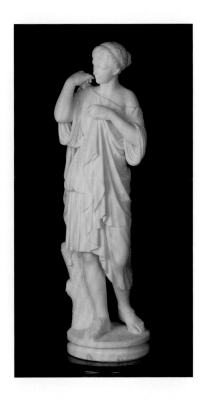

The original *Diana of Gabii,* now in the collection of the Louvre Museum in Paris, was named for the location of its excavation near Rome in 1792. Diana, known to the Greeks as Artemis, is believed to be shown here dressing for a hunt. After its discovery, the ancient Roman marble gained notice as a copy of the earlier Greek sculptor Praxiteles' rendering for the temple of Artemis Brauronia, protectress of women, on the Acropolis in Athens. Nineteenth-century critics admired the Roman *Diana* as a "perfected imitation" of the Greek model. Today, reproductions are often considered inferior by nature, lacking originality or creativity. During the eighteenth and early nineteenth centuries, however, extended discussion and disagreement surrounded the relative aesthetic merits of ancient Greek originals and their Roman copies in what became known as the Greco-Roman Debate.

The Roman *Diana* was distinguished in the eyes of nineteenth-century observers by its nobility of features and the elegance of its drapery. During the century after its discovery, this *Diana* itself generated a veritable industry of copies in an array of sizes and media, including bronze, stoneware, terracotta, and marble, that attest to the Roman sculpture's iconic power. These reproductions, often made from casts of the original, were appreciated, ironically enough, for their exact reproduction of the more interpretive Roman copy upon which they were based. By the 1880s, the Roman *Diana* had become one of the most recognized works of ancient sculpture in the world, comparable in reputation to the *Venus de Milo* (see E/S-18), though only a faint shadow of that nineteenth-century fame remains today.

△ **W-2** After Anthony van Dyke (1599–1641), Flemish
The Children of Charles I, undated copy
OIL ON CANVAS, 62 x 60 inches
Gift of Horace Fairbanks

Among the reproductions of celebrated masterworks in the Athenæum's collection, none has the scale of the copy after Anthony van Dyke's *Children of Charles I.* The work is virtually identical in size to the original painting, effectively conveying the original's grandiosity.

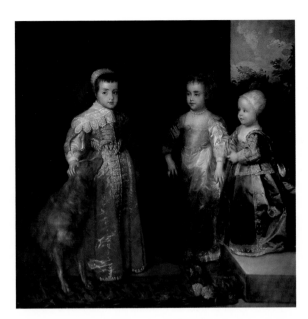
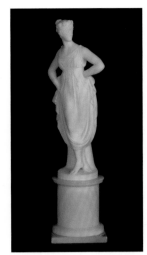

The work is celebrated in modern art history for its complex design, nuanced sensitivity to color, and balance of the competing priorities of familial intimacy and official portrait.

Van Dyke's painting (now in the collection of the Galleria Sabauda in Turin, Italy) was created in 1635 as a gift to the Queen of England's sister, Duchess Christina of Savoy, and portrays the Queen's three eldest children, Charles, Mary, and James. The King, Charles I, was reportedly angered by the painting because his children, including his immediate heir, are shown in infants' clothing, rather than more adult costume. When van Dyke revisited the subject for another commission the following year, he made certain that the children's costumes and demeanors were perceptibly older, at the expense of accuracy.

W-3 After Antonio Canova (1757–1822), Italian
Dancing Girl (Dancer with Hands on Hips), undated copy
MARBLE, 20½ inches high
Gift of the Estate of Laura H. Stone

Antonio Canova had an enduring influence upon the development of sculpture in the nineteenth century, though his stratospheric reputation declined quickly as tastes changed in favor of romanticism in the decades following his death. Canova is recognized as perhaps the quintessential sculptor of the late eighteenth-century neoclassical era; his pure white marbles embody the idealism and clarity of expression that characterize the period and its sources in ancient Greek and Roman art. Nearly four times the size of this reproduction, Canova's original *Dancer with Hands on Hips* is today in the collection of Russia's Hermitage Museum in St. Petersburg.

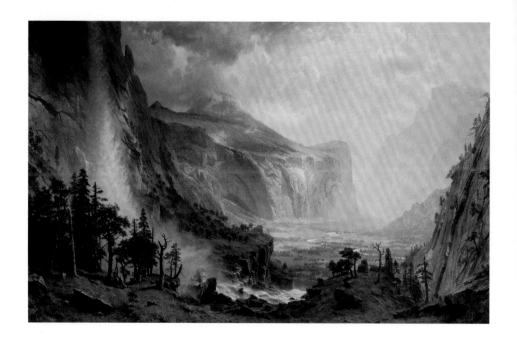

§ ‡ **W-4** Albert Bierstadt (1830–1902), German-American

The Domes of the Yosemite, 1867

OIL ON CANVAS, 116 x 180 inches

Gift of Horace Fairbanks

Albert Bierstadt's *Domes of the Yosemite* depicts one of the nation's most admired natural wonders and is, appropriate to the scale of its subject, among the artist's most ambitious compositions. The painting was created during a period of self-discovery for Americans fascinated by the western landscape and its awe-inspiring natural phenomena. Photographs and landscape paintings by artists, including Bierstadt, who traveled with government survey expeditions during the late 1850s and 1860s captivated popular audiences and inspired pioneering environmental legislation to protect the region from commercial exploitation. Abraham Lincoln officially granted the Yosemite Valley to the state of California in 1864, creating the first public land trust in American history. In an era when California remained a distant and inaccessible region for most Americans, Bierstadt's monumental painting offered viewers a compelling personal experience of its grandeur and uniqueness.

Bierstadt's beginnings foretold little of his later fame as the nation's most celebrated portrayer of the American west. Born in Germany and raised in coastal New Bedford, Massachusetts, he only began his academic training in 1853, when he traveled to Düsseldorf, Germany to study. He spent the next four years traveling through Germany, Italy, and Switzerland before returning to the United States. Conditioned by his experiences in the Alps, Bierstadt cultivated a taste for mountainous landscapes and made his first trip west

in 1859 with Frederick W. Lander's government survey party. With him, the artist brought a stereoscopic camera, which emulates human sight by taking two photographs simultaneously just inches apart, a forerunner of three-dimensional glasses. Stereoscopic landscape photography immerses the viewer in the experience of space, much like Bierstadt's magisterial *Domes of the Yosemite* would do on a vastly larger scale in the ensuing years.

Bierstadt first visited the Yosemite Valley in 1863, while on his second trip west. The author Fitz Hugh Ludlow, who was traveling with the party as well, wrote about his impression upon first entering the valley:

> We did not so much seem to be seeing from that crag of vision a new scene on the old familiar globe as a new heaven and a new earth into which the creative spirit had just been breathed. I hesitate now, as I did then, at the attempt to give my vision utterance. Never were words so beggared for an abridged translation of any Scripture of Nature.

Our vantage point in Bierstadt's *Domes of the Yosemite* is from midway up Yosemite Falls near Columbia Rock. Visitors coming to see the painting when it toured to New York, Philadelphia, and Boston received a key identifying the sites visible in the landscape and a topographical map showing the vantage point. The latter makes clear that Bierstadt dramatically compressed the valley's features to narrow the valley and juxtapose various well-known elements. The landscape's soaring features answer one another across the valley, echoing the elegant whorls of rock known as the Royal Arches at the composition's center. By emphasizing the site's vertical elements, Bierstadt was able to accentuate the scene's soaring heights, deliberately evoking the architectural forms of a medieval cathedral's central nave.

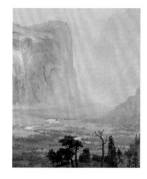

The Domes of the Yosemite fits so seamlessly into the Athenæum's Art Gallery that it is difficult to imagine it elsewhere. Nevertheless, the work was originally commissioned for the Connecticut home of financier Legrand Lockwood well before the Athenæum was founded. Lockwood was devastated by the depreciation of gold in 1869, however, and died soon thereafter in 1872. The $5,100 that the painting sold for at auction after Lockwood's death paled in comparison with the astonishing $25,000 that he originally paid Bierstadt for the work in 1867. The *Domes* was then purchased by Horace Fairbanks to be the visual centerpiece of the Athenæum's Gallery addition. Whereas the polygonal north and south alcoves maximize the wall space for exhibiting numerous smaller works, the broad, single face of the western wall offers pride of place for a single, dramatic composition. The addition of a viewing balcony on the opposite end of the Gallery in 1882 completed the Gallery's arrangement in its current form, and offers an excellent vantage from which to explore Bierstadt's composition.

Today, Bierstadt's *Domes of the Yosemite* remains the centerpiece of the Athenæum's art collection, drawing visitors from around the country and the world. Its presence in St. Johnsbury is a testament to Fairbanks' desire to make the Athenæum a center for the study of art and culture.

W-5 Arthur Fitzwilliam Tait (1819–1905), British-American

Coming Home, 1872

OIL ON CANVAS, 13½ x 21½ inches

Gift of Horace Fairbanks

Genre painters such as Arthur Fitzwilliam Tait often excelled at recounting stories in visual form. In this scene, the artist has arrayed his subjects from the upper right, where a mounted herdsman rides behind his cattle on their way home from pasture for the evening, around to the lower left where a minor drama unfolds. The lead cows have come across a group of ducks, and the ducklings' mother flaps her wings in defense of her family. Tait's animal scenes, such as this one, enjoyed great popularity with American audiences, which was only enhanced by his works' frequent reproduction and widespread sale in print form by the publishing house of Currier & Ives.

℃ W-6 John George Brown (1831–1913), British-American

Hiding in the Old Oak, 1873–74

OIL ON CANVAS, 30 x 25⅛ inches

Gift of Horace Fairbanks

J. G. Brown, as the artist is commonly known, enjoyed a long and successful career as a painter of childhood scenes. Born to a poor family in northern England, Brown enjoyed painting idyllic portraits of rural and working-class children, subjects with whom he felt a personal kinship. He imbued his subjects with hope, optimism, and plucky spirit, traits that garnered a ready and enthusiastic audience in America.

Begun in the same year that Brown turned his primary attention from rural to urban scenes, *Hiding in the Old Oak* distills the aspects of rural childhood that were the artist's

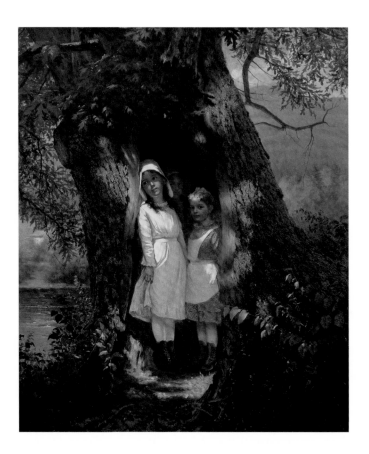

early trademarks and that justify the painting's reputation among the most popular compositions in the Athenæum's collection to the present day. Three girls, dressed in white or brightly-colored dresses and aprons have chosen the womb-like hollow of an ancient tree as their hiding place in a game of hide-and-go-seek. The leftmost figure leans back against the tree's trunk, mimicking its diagonal with her body, as she restrains her dress with her right hand to prevent it from fluttering in the breeze and giving them away. Nature, in this view, is a benevolent, protective presence in the world, aligned with the innocence of youth. An angular, skeletal branch at the composition's upper right sounds the only cautionary note of mortality.

Decades later, Brown reported to Mrs. Fairbanks that he began this composition during the summer of 1873 while in the town of Boiceville, in upstate New York. Like his landscape painter colleagues, Brown would usually travel outside of New York City during the summer in search of subjects in the rural landscape, then return to the city for the winter months to work up his studies into final compositions in the studio and exhibit the best of them in the National Academy of Design's annual exhibitions in the early spring. According to the artist, Fairbanks bought this painting directly from the Academy's annual exhibition in 1874.

W-7 Possibly Niccolò Bazzanti (1802–around 1849), Italian after Hiram Powers (1805–1873), American

Bust of the "Greek Slave" (Slave Girl), undated copy

MARBLE, 13½ inches high

Gift of Henry Fairbanks

This marble is one of the hundreds, if not thousands, of nineteenth-century reproductions of Hiram Powers' famed *Greek Slave*, a full-length standing nude first created in 1843. Its subject is a young Christian woman captured and enslaved by the Turks during the Greek War of Independence from the Ottoman Empire in 1821–32. The original sculpture achieved cult status in America during the mid-nineteenth century as an idealized rendering of faith. Powers himself wrote of the subject: "Gather all the afflictions [that the enslaved woman confronted] together and add to them the fortitude and resignation of a Christian, and no room will be left for shame." Despite the artist's effort to dress his sculpture with propriety, his *Greek Slave* met with intense controversy during its national tour. Although Americans were profoundly ambivalent about depictions of the nude, Powers' work is nevertheless recognized as one of the first to have been widely accepted and admired.

Although one art historian, Richard Wunder, has labeled this version of the sculpture a forgery, that conclusion seems inappropriate given that the work is signed by the copyist and makes no pretense of being an original composition by Powers.

W-8 Unknown artist

Girl in the Wood, undated

OIL ON CANVAS, 13½ x 11 inches

Gift of Mrs. Theodora Willard Best

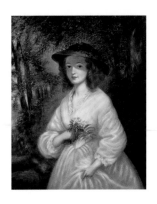

This idealized depiction of a young girl collecting a bouquet of flowers in a wooded landscape suggests a portrait, though the identity of the sitter, like that of the artist, is unknown. The girl's schematic facial features, her billowy dress, and the generic treatment of the forest background all suggest that the artist was likely a local or itinerant portraitist, for whom flattery of the sitter was often more important than accuracy.

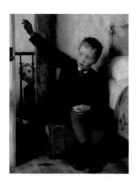 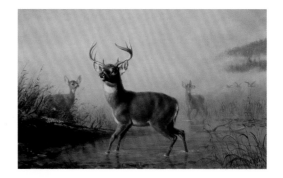

△ **W-9** Seymour Joseph Guy (1824–1910), British-American

Up for Repairs, 1875

OIL ON CANVAS, MOUNTED ON MASONITE, 15⅞ x 11⅞ inches

Gift of Horace Fairbanks

Trained in his native London before immigrating to the United States in 1854, Seymour Joseph Guy rose to prominence as a painter of children's daily life in the wake of the Civil War. In *Up for Repairs*, the artist portrays a boy who has ripped the leg of his pants and is trying to mend the damage before being discovered. Through a carefully contrived series of gestures, spaces, and expressions, Guy shows that the boy's ruse is up.

 Such levity found ready patronage in the later nineteenth century, though critics derided the artist's pandering to popular taste. As art historian Elizabeth Johns has observed, the preferred subjects of American genre painters shifted in emphasis following the Civil War, moving away from the nation's public culture and toward domestic life, of which *Up for Repairs* is a representative example.

W-10 Arthur Fitzwilliam Tait (1819–1905), British-American

Deer, Early Morning on Racquette Lake in the Adirondacks (*Deer Hunting in the Adirondacks*), 1872

OIL ON CANVAS, 21½ x 13½ inches

Gift of Horace Fairbanks

Known primarily for his hunting scenes, Arthur Fitzwilliam Tait's scene of deer wading in an inlet of New York's Raquette Lake (to use its current spelling) may well fall into that category, despite a notable absence of hunters. The stag in the foreground appears startled and looks in our direction, suggesting that the viewer may be cast in the hunter's role. The influence of Edwin Landseer, whose works Tait studied in the 1830s and early 1840s, is apparent in this tense moment, particularly when viewed in comparison with the engraved reproduction of Landseer's *Stag at Bay* on display upstairs in Athenæum Hall. Two does in the background of Tait's composition and a group of migrating geese add a sense of the hunting ground's abundance.

W-11 Étienne Adolphe Piot (1850–1910), French

Italian Girl with Cherries, undated

OIL ON CANVAS, 34 X 25 inches

Gift of Horace Fairbanks

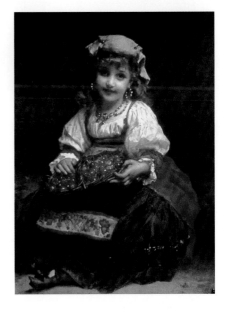

This charming portrayal of a young Italian peasant girl holding a basket of ripe cherries is typical of French genre painter Étienne Adolphe Piot's work during the 1870s. The artist, however, painted the composition in two different forms: one in which the sitter is a girl, as here, and the other in which the sitter is an attractive, engaging young woman. The difference in tone between the two types of sitter is considerable, as the latter version takes on a sexual dimension that is absent in this composition.

An unexpected discovery regarding Piot's career is his possible Confederate sympathy, no small concern in America in the wake of the Civil War. The artist painted undated portraits of Confederate Generals Robert E. Lee and Stonewall Jackson that suggest he had contacts in the South and was entrusted to create likenesses of two of its most admired military leaders. Given that Piot's *Italian Girl with Cherries* hung with pride of place in Horace Fairbanks' living room, we can only speculate that Fairbanks was unaware of any Confederate leaning.

§ **W-12** Chauncey Bradley Ives (1810–1894), American

Pandora, 1875

MARBLE, 40 inches high

Gift of Horace Fairbanks

Chauncey Bradley Ives' *Pandora* is often cited as the artist's masterwork, and it is the centerpiece of the Athenæum's sculpture collection. Ives himself summarized the classical tale of Pandora in a catalogue that accompanied its exhibition:

> Pandora was sent by Jove to Prometheus, with a jar containing all the evils of life in punishment for his stealing fire from heaven.... Pandora was charged by Jove not to open the jar, but being seized with curiosity, she cautiously raised the lid, and at once there issued forth all the ills that beset mankind in body and in soul.

Ives presents Pandora at the moment just before she succumbs to temptation. Her right

hand is raised to remove the lid, while the jar itself is tipped outward toward the world into which she will release its contents. Pandora was a significant artistic symbol during the nineteenth century, combining elements of biblical Eve and mythological Psyche to portray her as an untrustworthy messenger. As women's position in society changed over the course of the nineteenth century, imagery such as Ives' *Pandora* participated in the unfolding debate over allotted gender roles.

The year 1875 was a turning point in Ives' career. The Athenæum's half-size version of *Pandora* revisits a model that the artist first created in 1851 and reworked in 1864. By 1875, however, audience and patronage for neoclassical sculpture was on the wane, and Ives had trouble selling his works even at auction. Nevertheless, the stately grace, idealized subject, and naturalistic anatomy combine admirably in *Pandora* to provide a sense of Ives' achievement in art. The platonic, intellectual spirit of neoclassicism had a lingering influence upon American artists, particularly sculptors, working during the mid-nineteenth century. More than many of his colleagues, however, Ives retained a sense of naturalism even in his allegorical and mythological compositions such as this one. The presence of the *Pandora* in the Athenæum's

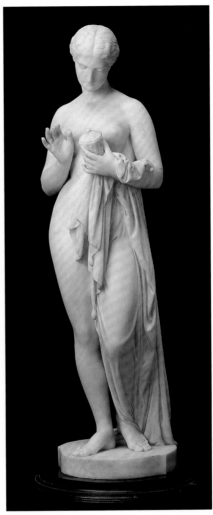

collection, nearly a quarter century after its initial creation, attests to Horace Fairbanks' recognition of the high point of American neoclassical sculpture at mid-century rather than its contemporary currency in the 1870s.

NORTH ALCOVE (N)

N–1 Eugène Joseph Verboeckhoven, *Sheep*

N–2 Unknown artist, *Water*

N–3 Alfonso Savini, Untitled

N–4 John Beaufain Irving, *The Halberdier–XVIth Century*

N–5 Louis Émile Pinel de Grandchamp, *Donkey Driver of Cairo*

N–6 Thomas Waterman Wood, *On Guard*

N–7 James M. Hart, *Landscape with Cattle*

N–8 Samuel Colman, *The Emigrant Train, Colorado*

N–9 James M. Hart, *Marine and Cattle*

N–10 Jervis McEntee, *The Woods of Asshockan, Catskills*

N–11 Worthington Whittredge, *On the Plains, Colorado*

N–12 After Andrea del Sarto, *Holy Family*

N–13 Mauritz Frederik Hendrick de Haas, *After a Storm*

N–14 Asher B. Durand, *Landscape with Rocks*

N–15 Unknown artist, *Roman Forum*

N–1 Eugène Joseph Verboeckhoven (1798–1881), Belgian
Sheep, 1875

OIL ON PANEL, 16 x 19 inches
Gift of Horace Fairbanks

Shortly after the artist's death in 1881, Eugène Verboeckhoven's portrayals of animals were characterized as "so well known in America as well as Europe that they need no description or praise." The artist's carefully delineated depictions of domestic and farm animals earned him lavish praise throughout the mid-nineteenth century until around 1860, when a more specific mode of realism came into fashion. Never one to stray from his convictions (he systematically employed the triangle of three dots after his signature to identify himself as a Freemason), Verboeckhoven continued to produce idealized pastoral and barnyard scenes until his death. By 1875, when the Athenæum's painting was completed, the artist had become a venerated elder statesman among his peers.

Verboeckhoven's reputation appears to have revolved at least partially around his active role in the Belgian Revolution of 1830. Declaring independence from the United Kingdom of the Netherlands, Belgians (like Americans of that same era) took pride in their unique national identity in both culture and art throughout the mid-century, and Verboeckhoven was among their early heroes. His distinctly agrarian subject matter highlighted Belgium's traditional agricultural economy, distinct from the rapid industrialization of the Netherlands.

N–2 Unknown artist
Water, undated

BRONZE, 12½ x 10½ inches
Gift of Horace Fairbanks

This is one of four allegorical medallions in the Athenæum's collection depicting the elements of nature: Earth, Fire, Air, and Water. Here, Water is represented by the sea, as one of three winged putti blows a conch shell while the others struggle with one of two large sea creatures. (See also S-12, E/N-10, and E/S-10.)

N-3 Alfonso Savini (1836–1908), Italian

Untitled, undated

OIL ON PANEL, 6 x 8 inches

Gift of Mrs. Theodora Willard Best

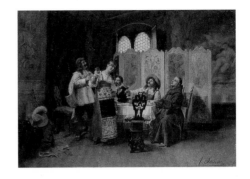

Bolognese genre painter Alfonso Savini earned an international reputation during the later nineteenth century with his humorous, sometimes irreverent portrayals of court life. In this composition, the artist portrays a group of men, one of them a monk, soliciting a young woman to join them at their table. Painted on the wall behind the men, though partially obscured from their view by a standing screen, a nude Venus suggests that the young woman's hosts may have less than honorable intentions. Despite the work's small scale, Savini successfully interweaves a complex compositional arrangement of objects and figures, nuanced character interactions, opulent costumes, and a modest dose of mature allusion, appropriate even by the stringent ethical standards of the Victorian era.

N-4 John Beaufain Irving (1826–1877), American

The Halberdier—XVIth Century, 1874

OIL ON PANEL, 14 x 10 inches

Gift of Horace Fairbanks

Halberdiers are foot soldiers named for their weapon, a long-handled poleax used against horsemen. In the modern era, the halberdier's role is largely ceremonial, most famously serving as the Pope's Vatican guard. In medieval and Renaissance times, however, halberdiers were celebrated warriors who were the primary defense against armored cavalry before the introduction of firearms.

Appropriately, John Beaufain Irving's halberdier is a man of great swagger. His brilliant red sash, bravado pose, and casual demeanor convey a sense of his proud position. Irving was well known for his historical genre scenes such as this one, though at least one of his peers, John F. Weir, criticized his compositions as overly theatrical when they were exhibited at the Centennial Exhibition in 1876.

△ **N-5** Louis Émile Pinel de Grandchamp (1831–1894), French
Donkey Driver of Cairo, undated

OIL ON PAPER MOUNTED ON PANEL, 12 15/16 x 9 ¾ inches
Gift of Horace Fairbanks

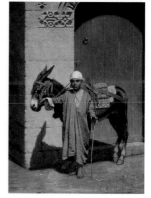

The later nineteenth century was a period of rapid change and globalization, much like the present day. Many artists shared an interest in foreign cultures, but even among them Pinel de Grandchamp was unusual, spending fifteen years exploring the Orient beginning in 1849 at the age of eighteen. Much like his peers' portrayals of urban life in the Western world, Pinel de Grandchamp here portrays a young boy at work. By depicting a child, rather than an adult, the artist engaged the curiosity and empathy of his viewers for his foreign subject without also stirring fear.

N-6 Thomas Waterman Wood (1823–1903), American
On Guard, 1874

OIL ON CANVAS, 15 ½ x 19 ½ inches
Gift of Horace Fairbanks

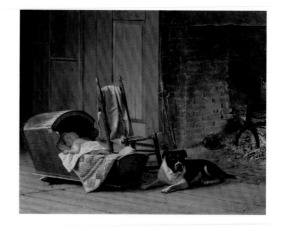

A notable attribute of Vermont-native Thomas Waterman Wood's scenes of everyday life is their legibility. As one contemporary critic characterized the artist's appeal, "he secures attention by the directness of his story." In that respect, *On Guard* is typical. A baby sleeps quietly and peacefully in its cradle under the protection of the family dog. The empty rocking chair symbolizes an absent parent in whose place the dog keeps watch. Despite the warm, glowing embers of the hearth and the dog's presence, however, questions arise that unsettle the serenity of Wood's composition: where has the baby's parent gone, and why is the dog awake and scowling? In the midst of a seemingly simple and reassuring narrative, the artist has introduced disquieting allusions that are not easily dismissed in the context of Reconstruction.

N-7 James M. Hart (1828–1901), British-American

Landscape with Cattle, 1872

OIL ON CANVAS, 20¼ x 34¼ inches

Gift of Horace Fairbanks

This quiet idyll is typical of the post-Civil War paintings of James Hart. A herd of cattle, trailing into the distance at the left, leads the viewer's eye from the foreground back to the rural village in the distance in a lyric style and nostalgic sensibility that evoke the approaches of the French Barbizon painters of mid-century. For more on James M. Hart, see also s-6.

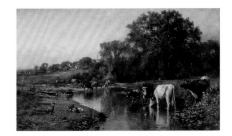

‡ ℂ **N-8** Samuel Colman (1832–1920), American

The Emigrant Train, Colorado, 1872

OIL ON CANVAS, MOUNTED ON MASONITE, 20⅛ x 40 inches

Gift of Horace Fairbanks

Samuel Colman was drawn to the exotic and experimental throughout his career. Among other initiatives, he was one of the first American painters to visit and depict southern Spain and Morocco, and he became the first president of the American Watercolor Society at its founding in 1866. He was equally quick to visit distant California in 1870, a trip that inspired a series of depictions of westward-bound wagon trains that included *The Emigrant Train, Colorado.* Given that Colman's journey came just a year after the completion of the transcontinental railroad, the arduous wagon trip must itself have seemed destined to became a vestige of the American past.

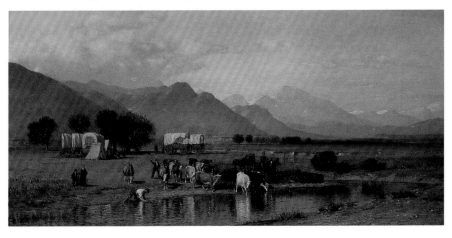

Colman depicted the westward journey as a communal endeavor, even including a woman and child in his composition. The artist also grouped the wagons at the left side of the composition to reiterate his subjects' interdependence. The emigrants water their cattle and refill their water containers in anticipation of the potentially dangerous trip through the mountains that loom in the distance. Despite the building clouds over the mountains, however, the tenor of Colman's composition remains hopeful, set as it is under a brilliant blue sky and by an abundant water supply.

N-9 James M. Hart (1828–1901), British-American
Marine and Cattle (On the North Shore), 1884
OIL ON CANVAS, 19½ x 28½ inches
Gift of Elizabeth Hills Lyman

This composition by James M. Hart illustrates how the artist's pastoral art developed during his later career. The painting's soft, tonal brushwork and expansive space almost diametrically oppose the crisp specificity of his early work. Similar to George Loring Brown's late views of Venice (E/N-4), Hart's composition suggests a landscape seen through the veil of memory rather than one recorded in situ. For more on James M. Hart, see also S-6.

N-10 Jervis McEntee (1828–1891), American
The Woods of Asshockan, Catskills, 1871
OIL ON CANVAS, 20 x 36 inches
Gift of Horace Fairbanks

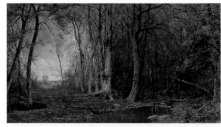

Jervis McEntee's portrayals of American autumn are distinguished from those of his contemporaries by their air of contemplative melancholy. Instead of the saturated reds, oranges, and yellows that make New England's fall foliage famous around the world and that artists such as Jasper Cropsey (see E/S-17 and *Autumn Woods* in the Reading Room) made their special study, McEntee appreciated the "graver moods" and more subtle transitions of color at the season's end. Ironically, the artist recalled the fall of 1871, when he painted this work, as one of the happiest times of his life, spent exploring the landscape near Ashokan (to use the current spelling) in the foothills of New York's Catskill Mountains, not far from his home.

The early 1870s was a period of transition in McEntee's career, as he moved from a crisp,

sharp-edged mode of realism to looser brushwork and a more tonal aesthetic. Fairbanks purchased *The Woods of Asshockan, Catskills* directly from the artist in February 1872, shortly after its completion. The artist's pride in the composition is apparent, as he later borrowed it back for inclusion in the 1878 Universal Exposition in Paris to represent his finest work.

§ ‡ **N–11** Worthington Whittredge (1820–1910), American
On the Plains, Colorado, 1872
OIL ON CANVAS, 30 x 50 inches
Gift of Horace Fairbanks

A relative latecomer to the American landscape movement, having spent much of his early career in Europe, Worthington Whittredge rapidly became its leading proponent during the 1860s, drawing American artists further in the direction of contemporary European aesthetics. His ascendance peaked in the mid-1870s with his election to the presidency of the National Academy of Design in New York. Whittredge's style is characterized by sharp focus and compositional symmetry, balancing elements of the scene like weights on a scale, rather than leading our eyes through the landscape in a narrative sequence.

Originally from Ohio, Whittredge gained a reputation for his depictions of America's western landscape. *On the Plains, Colorado* revisits what was undoubtedly the artist's most iconic work, *Crossing the Ford, Platte River, Colorado* (1868, revised in 1870). Whittredge actually returned to the site of both works in 1870, four years after his first visit in 1866, hoping to recapture his initial inspiration. *On the Plains, Colorado* portrays a tribe of Indians encamped peacefully along the shore of the Platte River, uninfluenced and unthreatened by the arrival of Euro-American settlers. Whittredge was not alone in his fascination with America's disappearing frontier. In his travels west, he participated in a rising tide of nostalgia for the mythic Old West that reached fever pitch in the early twentieth century and remains widespread today.

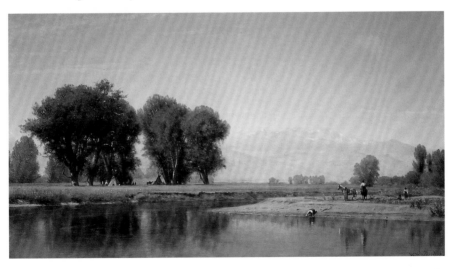

N–12 After Andrea del Sarto (1486–1530), Italian

Holy Family, undated copy

OIL ON CANVAS, 56 x 40 inches

Gift of Horace Fairbanks

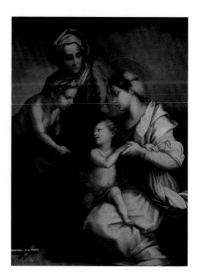

This reproduction of Andrea del Sarto's 1529 composition reflects both the subdued palette and large size of the Renaissance master's original painting, which hangs today in Florence's Pitti Palace. The scene shows Mary and Jesus at the right with the infant John the Baptist and his elderly mother, St. Elizabeth. Del Sarto painted several versions of this composition during his career, but this particular one was given special treatment by one of the artist's earliest admirers, the biographer Giorgio Vasari, for the exceptional, life-like realism in the figure of St. Elizabeth. Although del Sarto's reputation has waned since Vasari's day, the immediacy and directness of his later style had a lasting impact on Tuscan painters working in the mid-sixteenth-century mode known as mannerism.

N–13 Mauritz Frederik Hendrick de Haas (1832–1895), Dutch-American

After a Storm (Marine View—After a Storm), 1873

OIL ON CANVAS, 12 x 18 inches

Gift of Horace Fairbanks

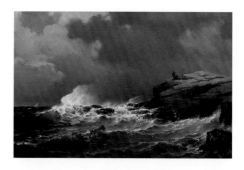

Just a few years after he painted this work, the marine painter Mauritz de Haas wrote, "I like nothing better than to paint a storm." He was fascinated by the varying colors of water and sky and made innumerable studies of both. The constant change and dramatic effects that characterize stormy weather render it a particular challenge. De Haas elaborated on his method of studying the ceaseless movement and unique properties of water: "Waves never exactly repeat themselves; but a similar wave always comes back, so that, in making studies of them, I watch the appearance of just such a wave as I wish to represent, draw it at once, and take its colour from a second wave." In this painting, the translucency of the water, rich and varied palette within the waves themselves, and dynamic sense of movement all attest to de Haas' painstaking approach to his subject.

N–14 Asher B. Durand (1796–1886), American

Landscape with Rocks, 1859

OIL ON CANVAS, 20½ x 15½ inches

Gift of Horace Fairbanks

Asher B. Durand was a pillar of American art during the mid-nineteenth century. His influence upon the direction of American landscape painting is difficult to overestimate, as he became its leader after the early death of Thomas Cole in 1848. Durand codified the principles of landscape painting for the second generation of painters of the Hudson River School in a series of letters published in the influential journal *The Crayon* in 1855. *Landscape with Rocks* is one of the earliest paintings in the Athenæum's collection. Its inclusion shows Fairbanks' awareness of the history of American landscape painting before the Civil War.

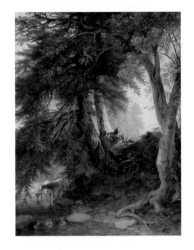

Landscape with Rocks represents one of the two main subjects for which Durand became best known: the forest interior and the expansive vista. The relatively loose paint handling in *Landscape with Rocks* has suggested to scholar David Lawall that the composition is one of the artist's "studies from nature," of which Durand painted a considerable number during the 1850s. The "studies" are characterized by an immediate response to a site, rather than a reconstituted studio composition created after the fact. Lawall has also written that the scene shown here likely depicts the landscape around Geneseo, New York, near Rochester.

N–15 Unknown artist

Roman Forum, undated

MICROMOSAIC, 12½ x 18 inches

Gift of Horace Fairbanks

This remarkable mosaic plaque documents a transitional moment in the history of modern archaeology. The view shown here, taken from the western end of Rome's ancient city center, or forum, offers a sense of the site before extensive excavations were undertaken at the turn of the twentieth century that revealed the area's lower strata as they are known today. Even the three sites featured prominently in the foreground—from left to right, the Arch of Septimius Severus, the Temple of Vespasian, and the Temple of Saturn—were relatively recent excavations, having only been cleared by the pioneering Italian archaeologist Carlo Fea in the first decades of the nineteenth century. The site was nevertheless already a significant tourist attraction, as the couple shown at the lower right suggests.

EAST ALCOVE/NORTH SIDE (E/N)

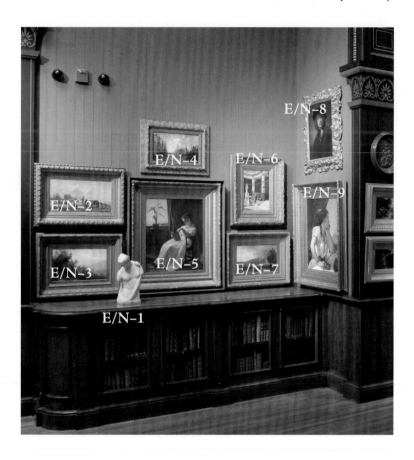

E/N–1 Unknown artist, *Psyche*

E/N–2 Ludwig Hartmann, *The Horse Market*

E/N–3 William Hart, *Autumn Morning*

E/N–4 George Loring Brown, *On the Grand Canal, Venice*

E/N–5 George Cochran Lambdin, *Girl Reading*

E/N–6 Luigi Bazzani, *Pompeian Interior*

E/N–7 William Hart, *Summer—The Passing Shower*

E/N–8 L. Gorble, after Rembrandt van Rijn, *Self-Portrait as a Young Man*

E/N–9 Pierre Olivier Joseph Coomans, *Aspasia*

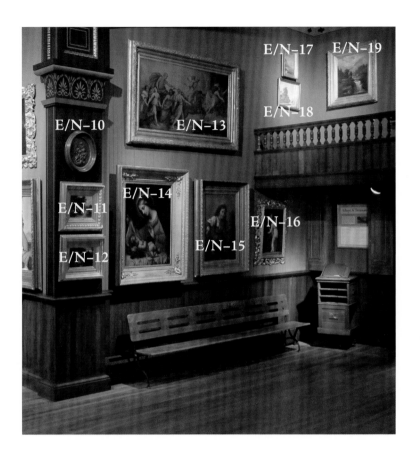

E/N–10 Unknown artist, *Air*

E/N–11 Ernst Bosch, *Peasant Scene*

E/N–12 Seymour Joseph Guy, *Red Riding Hood*

E/N–13 After Guido Reni, *Aurora*

E/N–14 Prof. Bardi, after Carlo Dolci, *Madonna and Child*

E/N–15 George Henry Hall, *Graziella*

E/N–16 After Paolo Veronese, *The Little St. John*

E/N–17 Manning Skinner, Untitled

E/N–18 Willliam Stanley Haseltine, *Traunstein, The Mill Dam*

E/N–19 Sylvester Phelps Hodgdon, *Waterfall in the Mountains*

E/N–1 Unknown artist
Psyche (Psyche of Capua; Psyche of Naples; Aphrodite), undated copy
MARBLE, 19 inches high
Gift of the Estate of Albert L. Farwell

This modern sculpture reproduces the ancient Roman *Psyche of Capua*, which is housed today in the National Archaeological Museum in Naples, Italy. The sculpture was rediscovered in 1726 in the amphitheater of nearby Capua, for which the work was subsequently named. Scholars continue to debate whether the subject is the mythological Psyche or the goddess Venus based upon the limited information that can be derived from the figure's pose and costume.

In the late antique tale of Cupid and Psyche, as recounted by Lucius Apuleius in *The Golden Ass* (2nd century C.E.), Psyche was a beautiful mortal with whom the god Cupid fell in love. Although Cupid concealed his identity from her and visited only at night, she eventually gave in to temptation and lit a lamp so that she could see him. Angered, Cupid abandoned her to her fate, but later forgave and married her after she endured a series of seemingly impossible tasks assigned by his mother, Venus. In this work, if the subject has been correctly identified, Psyche's downcast expression suggests the moment of her abandonment.

E/N–2 Ludwig Hartmann (1835–1902), German
The Horse Market, undated
OIL ON PANEL, 12 x 21½ inches
Gift of Horace Fairbanks

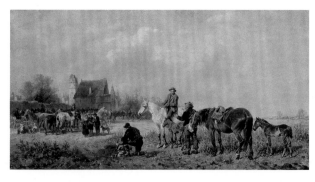

Nostalgia for simpler times was a characteristic of both European and American culture during the later nineteenth century. Ludwig Hartmann's *Horse Market* depicts a traditional German village and the informal exchanges by which farm animals had been bought and sold for centuries. The ages of the older men conversing in the foreground reflect the long history of their practice as do the town's ancient walls and medieval buildings. Hartmann excelled as a landscape and animal painter, and this composition combines his mastery of both subjects.

E/N-3 William Hart (1823–1894), British-American

Autumn Morning, 1876

OIL ON CANVAS, 12½ x 20½ inches

Gift of Horace Fairbanks

William Hart, the older brother of James M. Hart, spent most of his career in the United States. Less successful than his academically trained brother, William nevertheless achieved modest recognition during the course of his long artistic career and became the first president of the Brooklyn Academy of Design in 1865.

Hart's intimate depiction of fall in New England accentuates the cycle of nature by embellishing the vibrant fall foliage with both a fallen, skeletal tree in the lower left and a range of younger trees in the middle ground that have not yet begun to turn.

‡ **E/N-4** George Loring Brown (1814–1889), American

On the Grand Canal, Venice, 1880

OIL ON CANVAS, MOUNTED ON MASONITE, 11½ x 20 inches

Gift of Horace Fairbanks

George Loring Brown's depiction of Venice is one of three portrayals of the subject in the Athenæum's collection, a substantial holding that illustrates the subject's popularity during the later nineteenth century. Celebrated for his romanticized depictions of Italy during the mid-century, the artist did not adapt as tastes changed in the wake of the Civil War. Despite his outdated aesthetic, Brown's work remained popular, particularly in St. Johnsbury, where he received at least six commissions from various members of the Fairbanks family.

Brown's painting looks east along Venice's famed Grand Canal, toward the landmark Renaissance church of Santa Maria della Salute that crowns the composition. The coloring of the painting is significant. Brown has infused the church's white marble with the brilliant blue of the sky, creating the impression that it is an ethereal vision, rather than an earthly one. The dark palette (made darker by the artist's use of unstable medium called bitumen that deteriorates over time) of the shadowy canal below contrasts sharply with the cathedral's transcendence.

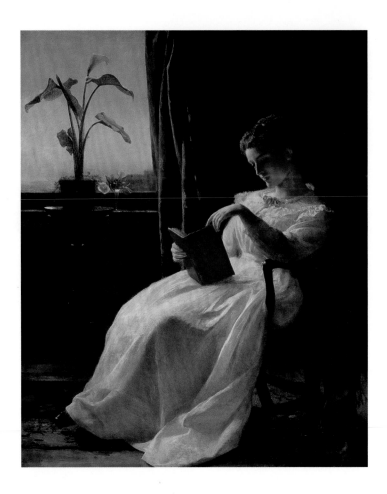

§ ❡ E/N-5 George Cochran Lambdin (1830–1896), American
Girl Reading, 1872
OIL ON CANVAS, 29½ x 25 inches
Gift of Horace Fairbanks

Among the Athenæum's masterworks, George Cochran Lambdin's *Girl Reading* stands out for its sensitivity of handling and composition, colorism, and layered symbolism. The subject, a young woman at leisure by an open window, was a common enough theme during the period, but is substantively modified and embellished in Lambdin's variant. The conventional woman-at-the-window scene symbolizes the subject's imagination traveling beyond her domestic environment into the world outside, balancing hope and frustrated longing. To that basic motif, Lambdin has added a scrupulously rendered calla lily framed by the window sill suggesting more specific and poetic meaning. The lily's undulating, unfurling leaves and pure white flower echo the girl's dress and are a metaphor for growth

and intellectual awakening. The most arresting repeated form in Lambdin's composition is the suspended arc of the lily's flower and the counterbalancing curve of the girl's left hand and finger touching the top of her book. At heart a gentle and moderately patronizing allegory of feminine youth and beauty, Lambdin's painting nevertheless conveys the potential of reading to enlighten and liberate, an outstanding moral in the context of the Athenæum.

Lambdin began his career, like many painters of the day, as a portraitist in his native Philadelphia. Trained for two years in Europe during the mid-1850s, Lambdin's mature art conveyed his awareness of contemporary stylistic developments abroad as well as the influence of earlier European, particularly Dutch, masters. By the 1870s, he had largely ceased to paint the scenes of daily life upon which he had established his reputation and concentrated instead on still life painting, particularly of the roses that grew in his garden in Germantown, Pennsylvania, outside of Philadelphia. The symbolism of flowers was much better known in the nineteenth century than it is today. Viewers would have immediately recognized the lily in Lambdin's *Girl Reading* as an embodiment of purity, a meaning that it inherited from its frequent appearance in European religious art since the Renaissance. Lambdin would have been personally familiar with that symbolic tradition from his training abroad.

E/N-6 Luigi Bazzani (1836–1927), Italian

Pompeian Interior, 1875

OIL ON PANEL, 17⅜ x 12½ inches

Gift of Horace Fairbanks

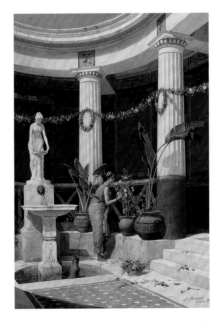

Luigi Bazzani enjoyed a long career painting re-creations of life in the ancient Roman city of Pompeii before its sudden burial in Vesuvius' eruption of 79 C.E. Excavations in the city throughout the later eighteenth and nineteenth centuries fueled a steady fascination with the ancient civilization. Bazzani's attention to historic detail was recognized in his time, as he contributed a series of fourteen illustrations to a publication by Pompeii's leading archaeologist Amedeo Maiuri.

This portrayal of a house's central courtyard incorporates the delicate, brightly painted walls and decorations of a Roman villa with a sense of the utter lack of awareness that preceded the city's destruction. Cut flowers, cast aside on the white marble in the painting's foreground, are the only overt portents of the young woman's fate.

E/N-7 William Hart (1823–1894), British-American
Summer—The Passing Shower, 1873
OIL ON CANVAS, 13 X 20 inches
Gift of Horace Fairbanks

William Hart's *Summer—The Passing Shower* offers a charming pendant for his later *Autumn Morning* (E/N-3). Here, his depiction of a sudden summer rain storm provides an opportunity to explore varying effects of light and shadow falling across the landscape. The rain does not disrupt the peacefulness of the scene, however, as the cattle in the foreground, the small pond, and the trees themselves appear undisturbed.

E/N-8 L. Gorble, after Rembrandt van Rijn (1606–1669), Dutch
Self-Portrait as a Young Man (Portrait of Himself), undated copy
OIL ON CANVAS, 23½ X 20 inches
Gift of Horace Fairbanks

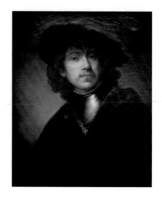

Although recent scholarship has cast doubt upon both the authenticity and date of the painting in the collection of the Uffizi Gallery in Florence upon which this copy is based, there is no argument about the signal importance of Rembrandt's self-portraits in the history of art. The artist's dozens of self-portraits, painted over the length of his career, cast him in a variety of roles. This copy, painted in the same scale as the original, portrays the young artist as a distinguished Dutch court painter and intellectual. The gold chain, granted by nobles to their

court painters, was not his own, as he was not affiliated with any court at the time of the work's completion around 1634. His beret, not in fashion at the time, had been adopted as a part of academic regalia and may symbolize the artist's self-identification as a genius. Painted in the midst of a decades-long war with Spain, Rembrandt's portrait also bears nationalistic associations. The armored collar, or gorget, that the artist wears and his direct engagement with the viewer portray two widely-publicized attributes of the Dutch people during Rembrandt's day: their military prowess and straightforwardness.

E/N–9 Pierre Olivier Joseph Coomans (1816–1889), Belgian

Aspasia, 1872

OIL ON CANVAS, 30¾ x 24¾ inches

Gift of Horace Fairbanks

The nineteenth century was an age of historic revivals. After a visit to the archaeological sites at Pompeii and Herculaneum in Italy in 1857, the Belgian academic painter Pierre Olivier Joseph Coomans joined the ranks of artists inspired by the cities' ancient mystery and grandeur. His inspiration for this painting was, in fact, a figure from classical Greek history, Aspasia, the brilliant and reportedly beautiful mistress of the ancient Athenian statesman Pericles. Also a friend of the philosopher Socrates, Aspasia was credited with much of Pericles' success as an orator and blamed for his perceived missteps in matters of state, particularly for starting the Peloponnesian War with neighboring Sparta in 431 B.C.E. The rich colors and sumptuous fabrics of Coomans' scene are illustrative of the exotic allure that ancient civilization held for artists of the nineteenth century.

E/N–10 Unknown artist

Air, undated

BRONZE, 12½ x 10½ inches

Gift of Horace Fairbanks

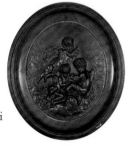

This is one of four allegorical medallions in the Athenæum's collection depicting the elements of nature: Earth, Fire, Air, and Water. Here, Air is represented by flight, as the three putti hold two small birds. (See also s-12, n-2, and e/s-10.)

E/N–11 Ernst Bosch (1834–1917), German

Peasant Scene (Shepherd and his Grandchild), undated

OIL ON PANEL, 8⅝ x 11⅜ inches

Gift of Mrs. Theodora Willard Best

Ernst Bosch's depiction of an old shepherd assisting a young girl provides an idyllic sense of peace and simplicity. Smoke rises gently from the chimney of the house just beyond the rise and the shepherd's flock pastures quietly in the middle ground under the watchful eye of the shepherd's dog. The enclosing wall of trees at the left offers some shade and a protective sense of enclosure; no threats present themselves to disturb the scene's prevailing tranquility. In an era scarred by war and social unrest, peasant scenes such as Bosch's offered reprieve from the ever-hastening pace of modern life. Very little is known of the artist himself, except that he both trained and worked primarily in Düsseldorf, Germany.

△ **E/N–12** Seymour Joseph Guy (1824–1910), British-American

Red Riding Hood, around 1866

OIL ON CANVAS, 8¹/₁₆ x 12⅛ inches

Gift of Mrs. Theodora Willard Best

The modern nursery tale of Little Red Riding Hood derives from traditional folk stories circulated in both Europe and Scandinavia. First published by the French author Charles Perrault in 1697, the story's most popular version did not acquire a happy ending until the early nineteenth century, when it was added by the German brothers Jacob and Wilhelm Grimm. In Guy's painting, Red, who does not suspect the wolf's wickedness, innocently points the way to her grandmother's house, where the wolf will set his trap.

One art historian, David Lubin, has suggested that the popularity of such depictions of vulnerable young girls, including this particular painting, reflected a conservative reassertion of women's dependence on men at a time when leaders such as suffragist Susan B. Anthony were agitating for women's rights.

E/N-13 After Guido Reni (1575–1642), Italian
Aurora, undated copy

OIL ON CANVAS, 31 x 62 inches
Gift of Mrs. Theodora Willard Best

The Italian Baroque master Guido Reni's original fresco of *Aurora* was painted in 1612–14 on commission from Cardinal Scipione Borghese to decorate a garden pavilion at his family's Quirinal Villa (now the Palazzo Rospigliosi-Pallavicini) in
Rome. Although less recognized today, the painting was widely considered among the crowning masterworks of the history of art throughout the nineteenth and early twentieth centuries.

In Reni's composition, Aurora, ancient Greek goddess of the dawn, is shown leading the chariot of her brother, the sun god Helios, through the sky, parting the clouds of night before them. Helios is surrounded by the Horae, goddesses of the seasons. The artist's luminous palette and the understated grace of his figures are among the traits for which the original painting has been celebrated since its creation.

E/N-14 Prof. Bardi, after Carlo Dolci (1616–1686), Italian
Madonna and Child, undated copy

OIL ON CANVAS, 36½ x 29½ inches
Gift of Horace Fairbanks

Like many copyists of the nineteenth century, the painter of this composition, Prof. Bardi, is unknown today. The market for painted reproductions of the works of great Renaissance and Baroque masters fostered a veritable cottage industry in Italy during the period, but injured Dolci's art historical reputation more than those of his peers, as the reproductions were sometimes mistaken for his relatively scarce originals. Nevertheless, in the Athenæum's composition Bardi captured the essential characteristics of emotional intimacy, piety, and smooth finish for which Dolci's art was celebrated in his own time.

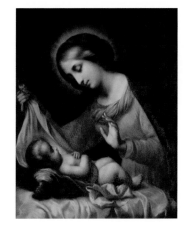

E/N–15 George Henry Hall (1825–1913), American
Graziella, 1873

OIL ON CANVAS, 33 x 25 inches
Gift of Horace Fairbanks

Hall's *Graziella* is one of several works that Fair-
banks purchased at the National Academy of
Design in New York's famed annual exhibitions.
The annuals were the most important venue for
the exhibition of contemporary American art
during the mid-nineteenth century and works
submitted for display were required not to have
been shown elsewhere beforehand. The result
was a highly anticipated cultural event to which
many artists, including Hall, sent their finest
compositions in hopes of strong sales, good
reviews, and public notice.

Hall enjoyed great popularity as a still life
painter, but his *Graziella* demonstrates his simul-
taneous interests in the human figure and exotic cultures. In an 1891 letter, the artist
recalled his sitter, whom he painted while visiting Rome in 1873: "The name of the little girl
who posed for me was Graziella, and she was exactly like the picture." Her brilliantly col-
ored peasant costume accentuates the movement of her dance.

E/N–16 After Paolo Veronese (1528–1588), Italian
The Little St. John, undated copy

OIL ON CANVAS, 24¾ x 19⅜ inches
Gift of the Estate of Albert L. Farwell

A leading figure of the Italian Renaissance in Venice, Paolo
Veronese was celebrated in his own time, as he is today, for his
rich palette and mastery of illusion. *The Little St. John* repro-
duces a single figure from Veronese's *Madonna Enthroned with
Saints* (originally painted for the sacristy of Venice's Church of
San Zaccaria around 1562) that is now in the city's Gallery of
the Accademia. In Veronese's original composition, the infant
John the Baptist is situated at the painting's visual center, lead-
ing the viewer's eye upward toward the enthroned Virgin. The
centrality and subtlety of the infant's turning figure as a space-
creating compositional device, known as a *repoussoir*, illustrates
the creative experimentation for which early critic and biographer Giorgio Vasari first
admired Veronese's work.

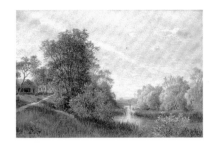

E/N-17 Manning Skinner (probably early twentieth century)
Untitled, 1896

Oil on canvas, 11¾ x 9¾ inches

This romantic rendering of a rocky coastline offers a meditation on mortality, a popular theme in nineteenth-century art. The dark palette, soaring cliff, turbulent surf, and large foreground rocks all reinforce nature's power and expressiveness.

E/N-18 William Stanley Haseltine (1835–1900), American
Traunstein, The Mill Dam, undated

OPAQUE AND TRANSPARENT WATERCOLOR ON WOVE PAPER, 14 x 20 inches

Gift of Mrs. Roger H. Plowden

Watercolor has had an irregular history in American art. The American Watercolor Society, founded in 1866 to advocate and encourage the professional use of the medium, was a relative latecomer to the field. Because watercolors are particularly sensitive to light, they are rarely displayed alongside oil paintings and sculpture, which are more durable. The presence of Haseltine's *Traunstein, The Mill Dam* in the Athenæum's collection is a reminder of the rapid growth of interest in watercolor during the 1860s and 1870s.

This painting offers an intimate portrayal of rural life in the southeastern German province of Bavaria. The tight, detailed style and unimposing subject matter characterize the influences of German, French, and English aesthetics on Haseltine, who studied in Düsseldorf and greatly admired the philosophies of the French Barbizon painters and British critic John Ruskin. An avid fisherman, Haseltine was drawn to Traunstein, where he summered during the mid-1870s, as much by its trout streams as by its scenery.

E/N-19 Sylvester Phelps Hodgdon (1830–1906), American
Waterfall in the Mountains, 1882

OIL ON CANVAS, 23½ x 18½ inches

Portrait and landscape painter Sylvester Hodgdon spent his brief artistic career, from the mid-1850s through the 1860s, in Boston. *Waterfall in the Mountains* depicts Glen Ellis Falls in New Hampshire's White Mountains, where Hodgdon painted several of his recorded landscapes during the mid-1860s.

EAST ALCOVE/SOUTH SIDE (E/S)

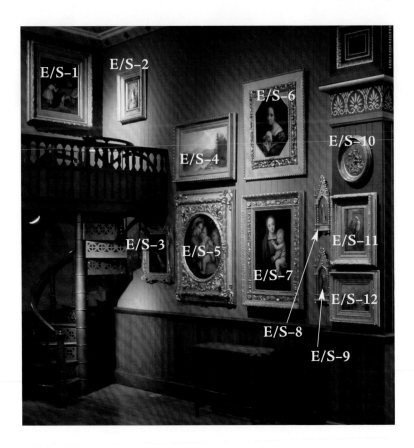

E/S–1 Lemuel Wilmarth, *On Guard*

E/S–2 After Bartolomé Esteban Murillo, *Immaculate Conception*

E/S–3 Attributed to Joseph Alexander Ames, *Portrait of Daniel Webster*

E/S–4 William Hart, *An Autumn Day*

E/S–5 After Raphael Sanzio, *Madonna della Sedia*

E/S–6 After Carlo Dolci, *St. Agnes*

E/S–7 L. Baroli, after Raphael Sanzio, *Madonna del Granduca*

E/S–8 After Fra Angelico, *Angel*

E/S–9 After Fra Angelico, *Angel*

E/S–10 Unknown artist, *Fire*

E/S–11 George Henry Yewell, *Figure*

E/S–12 Karl Josef Kuwasseg, *View of Yères, France*

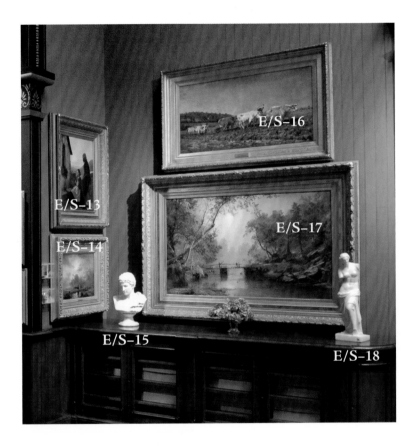

E/S–13

E/S–14

E/S–15

E/S–16

E/S–17

E/S–18

E/S–13 Julius Hübner, *Wayside Devotion*

E/S–14 Andreas Achenbach, *The Shore, Scheveningen*

E/S–15 Unknown artist, *Belvedere Antinous*

E/S–16 Thomas Waterman Wood, *Plowing in the Nivernais*

E/S–17 Jasper F. Cropsey, *Autumn on the Ramapo River—Erie Railway*

E/S–18 Unknown artist, *Venus de Milo*

E/S–1 Lemuel Wilmarth (1835–1918), American
On Guard, around 1874
OIL ON CANVAS, 26½ x 20½ inches
Gift of Mrs. Theodora Willard Best

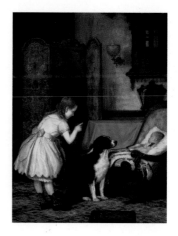

Lemuel Wilmarth was among America's most respected teachers of art during the later nineteenth century. He established his own artistic reputation upon the credentials of his European training in both Munich and Paris and his accomplishments as a genre and still life painter.

On Guard is one of two known versions of this scene; the artist gave the other, *Left in Charge*, to the National Academy of Design in New York. In both paintings, the young girl admonishes her dog to watch over her sleeping sibling. Their ornate living room is typical of the period, but Wilmarth has contrived the furniture to silhouette the dog's alert profile against a bright red tablecloth and thereby focus primary attention on the painting's genial narrative.

E/S–2 After Bartolomé Esteban Murillo (1618–1682), Spanish
Immaculate Conception, undated copy
PORCELAIN, 13 x 10½ inches
Gift of Mrs. Theodora Willard Best

The Spanish Baroque master Bartolomé Esteban Murillo painted numerous versions of the Immaculate Conception, and was known in his own lifetime as "the painter of the Conception." This painting's imagery derives from the biblical Book of Revelation: "A great and wondrous sign appeared in heaven: a woman clothed with the sun, with the moon under her feet and a crown of twelve stars on her head." Murillo's formula of a beautiful, young girl standing atop the moon and escorted by a phalanx of young angels, or *putti*, became the canonical representation at the Spanish court after he painted the first version in 1650. The Conceptions were still enormously popular twenty-eight years later, when Murillo created the work (now in the Prado Museum in Madrid) upon which this porcelain copy is based.

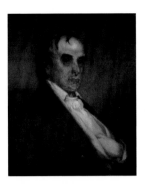

E/S-3 Attributed to Joseph Alexander Ames (1816–1872), American

Portrait of Daniel Webster, around 1853

OIL ON CANVAS, 18½ x 15½ inches

Born to a poor farming family in 1782 in Salisbury, New Hampshire, a small town north of Concord, Daniel Webster benefited from his parents' commitment to education. He attended Dartmouth College, graduating with highest honors, and later became one of America's most influential political leaders, a senator, and secretary of state. When the New Hampshire government attempted to convert Dartmouth into a state-run institution in 1816–18, Webster brought his legendary oratorical skills to bear in defending the school's autonomy before the federal Supreme Court and won, ensuring the Dartmouth's independence to the present day.

This portrait is either by the Boston portraitist Joseph Alexander Ames, one of a series that the artist produced after Webster's death in 1852, or else is a reproduction of Ames' work. It is a reduced version of a widely admired 1853 commission that Ames received from one of Webster's closest friends, Boston merchant Peter Harvey. Webster is shown as a statesman in the prime of his life, with the characteristic piercing expression for which he was known. The portrait became accepted as Webster's authoritative likeness, and was distributed through reproductive engraving.

E/S-4 William Hart (1823–1894), British-American

An Autumn Day, 1865

OIL ON CANVAS, 18 x 32½ inches

The earliest of three paintings by William Hart in the Athenæum's collection (see also E/N-3 and E/N-7), *An Autumn Day* appears to portray Whiteface Mountain in New York's Adirondack Mountains. The peaceful scene depicts the pristine American landscape with deer wading quietly in the foreground river. Whereas many of William Hart's landscapes represent the impact of man on the landscape, this painting evokes idyllic serenity.

E/S–5 After Raphael Sanzio (1483–1520), Italian
Madonna della Sedia, undated copy
OIL ON CANVAS, 28½ inches diameter
Gift of Horace Fairbanks

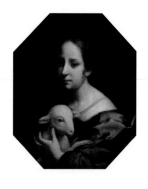

Raphael's artistic achievements at the height of the Italian Renaissance remain among the most celebrated in the history of western art. His mastery of materials and the inner peacefulness of his figures lend an exceptional eloquence to his art that is almost universally admired today.

The *Madonna della Sedia* (Madonna of the Chair), in the collection of the Pitti Palace in Florence, was painted at the peak of Raphael's career around 1514 and offers a compelling rendering of maternal intimacy. Raphael manipulated the vantage point so that we gaze upward at Mary and the infants Jesus and John the Baptist, as though on our knees. The personal engagement of the viewer with the holy figures, both through their recognition of our presence and through the deliberate suggestion that we share the space, is a hallmark of Renaissance aesthetics, humanizing the subjects while retaining a sense of their innate divinity.

E/S–6 After Carlo Dolci (1616–1686), Italian
St. Agnes, undated copy
OIL ON CANVAS, 25 x 19½ inches
Gift of Mrs. Theodora Willard Best

Carlo Dolci's portrayal of the early Roman St. Agnes includes her identifying attribute, a lamb. The lamb was also an early Christian symbol of Jesus in his sacrificial role and may have represented Agnes' devotion to him as well as her own martyrdom. She was killed at the age of thirteen for refusing marriage to a Roman prefect because she had already devoted her life to Jesus. Like many of Dolci's works, including the two others reproduced in the Athenæum's collection, *St. Agnes* centers upon the subject's head and torso bathed in a bright, dramatic light against a dark backdrop to accentuate her emotional state, a signature characteristic of Italian Baroque art.

E/S–7 L. Baroli, after Raphael Sanzio (1483–1520), Italian
Madonna del Granduca, undated copy
OIL ON CANVAS, 33 x 22 inches
Gift of Horace Fairbanks

This reproduction of one of Raphael's early masterworks conveys a sense of the delicacy and sensitivity that distinguish the original painting. The *Madonna del Granduca* (Madonna

of the Grand Duke) demonstrates the artist's early emphasis upon the Madonna's modesty. She does not meet our gaze, but instead looks downward, maintaining perfect tranquility and decorum in an age that celebrated the idealization of divine figures. Renaissance naturalism (in contrast to its nineteenth-century form) favored the appearance of humanity in portrayals of the holy family and saints, but not with individual specificity, which was the preserve of portraiture. The Virgin Mary and infant Jesus had to appear human, but still embody an ideal of flawless grace.

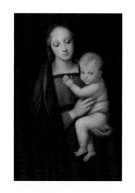

E/S-8 After Fra Angelico (around 1400–1455), Italian
Angel, undated copy
GOLD LEAF AND OIL ON PANEL, 11 x 5 inches
Gift of Mrs. Theodora Willard Best

E/S-9 After Fra Angelico (around 1400–1455), Italian
Angel, undated copy
GOLD LEAF AND OIL ON PANEL, 11 x 5 inches
Gift of Mrs. Theodora Willard Best

Fra Angelico (first known as Guido di Pietro) was a Dominican friar in Renaissance Fiesole and Florence, where he remains best known for a large group of biblical frescoes (water-based paintings created on wet plaster) that decorate the common rooms and private cells in the monastery of San Marco. The austerity and serenity of Fra Angelico's aesthetic complemented the works' function as devotional aids, inspiring rather than distracting the viewer's eye with excessive detail. Architectural frames such as those reproduced here were popular during the Renaissance, simulating the experience of a devotional space.

E/S-10 Unknown artist
Fire, undated
BRONZE, 12½ x 10½ inches
Gift of Horace Fairbanks

This is one of four allegorical medallions in the Athenæum's collection depicting the elements of nature: Earth, Fire, Air, and Water. Here, Fire is represented by conflict, as three winged putti struggle with one another and fight with bows and arrows. (See also S-12, N-2, and E/N-10.)

E/S–11 George Henry Yewell (1830–1923), American
Figure, 1866
OIL ON CANVAS, 15½ x 9½ inches
Gift of Mrs. Theodora Willard Best

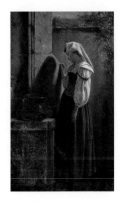

Lost in thought, George Yewell's young (probably Italian) peasant woman at a fountain seems to contemplate her fate. Her strap has fallen off her shoulder suggesting either lost innocence or listless indifference. That her pot is not even under the flow of water emphasizes her absorption in thought, rather than attention to her chore.

E/S–12 Karl Josef Kuwasseg (1802–1877), Austrian/French
View of Yères, France, undated
OIL ON CANVAS, 9½ x 12½ inches
Gift of Horace Fairbanks

Kuwasseg's idyllic portrayal of a small French town conveys a strong sense of the artist's affection for his adoptive homeland. Kuwasseg became a naturalized French citizen in 1870 and occupied much of his later career with such intimate scenes of village life brimming with vitality.

E/S–13 Julius Hübner (1842–1874), German
Wayside Devotion, 1871
OIL ON CANVAS, 28 x 24 inches
Gift of Horace Fairbanks

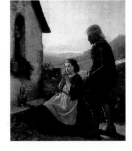

Julius Hübner's depiction of a roadside altar offers a quiet celebration of childhood piety. The two figures, perhaps grandfather and granddaughter judging by their disparate ages, have stopped to pray on their way to or from their work in the field, as the hand-held scythe and water jug resting on the altar before them suggest. The girl prays to the figures of the Virgin Mary and Jesus.

The art historian John Davis has elaborated on the appeal of this type of Catholic subject matter for Protestant artists and patrons in the United States, identifying it as a form of exoticism for those whose own religious traditions forbad such overt imagery.

E/S–14 Andreas Achenbach (1815–1910), German

The Shore, Scheveningen, 1849

OIL ON CANVAS, 17⅝ x 23½ inches

Gift of Horace Fairbanks

Achenbach was among the most famous and influential artists of his day, a distinguished reputation that has dwindled steadily since the later nineteenth century. During his own time, however, Achenbach's dramatic, luminous landscapes captivated audiences throughout Europe and the United States. During an era when many young American artists—including Albert Bierstadt and Worthington Whittredge, who are also in the Athenæum's collection—traveled abroad to complete their training in the academies of Europe, Achenbach's fame drew many aspiring landscapists to Düsseldorf to study with him.

Located on the North Sea on the outskirts of The Hague in the Netherlands, Scheveningen has become a tourist resort and retains relatively little vestige of the modest fishing community that Achenbach portrayed in 1849. Here, several boats are drawn up on the beach and women carry their baskets to retrieve the day's catch. Brilliant morning light dawns behind the looming clouds approaching from the right, balancing the hopefulness of a new day with a sense of the danger inherent in the community's reliance upon the sea. Despite its relatively small scale, Achenbach's *The Shore, Scheveningen* distills a potent sense of the sublime through its dramatic contrasts of light and dark, vibrant palette, massive cloud formations, and expansive space.

E/S–15 Unknown artist

Belvedere Antinous (Hermes), undated copy

MARBLE, 20 inches high

Gift of the Estate of Albert L. Farwell

Depictions of young men are common among ancient Roman sculptures because of the culture's twin ideals of masculinity and youth. The model for this copy is in the collection of the Vatican Museums in Rome and has been known by several names over the centuries since it was first recorded in 1543, including Hercules, Hermes (Mercury), Milo, and Theseus. The close resemblance of the *Belvedere Antinous* to a more complete sculpture bearing the winged shoes and staff symbolic of the gods' messenger Hermes has convinced some scholars of that attribution, rather than the more generic attractive, youthful type that is commonly ascribed to depictions of Antinous, the Roman Emperor Hadrian's companion. Johann Joachim Winckelmann, arguably the most important eighteenth-century scholar of classical art, greatly admired the *Antinous'* sweetness and innocence of expression, an opinion that prevailed for most of the nineteenth century.

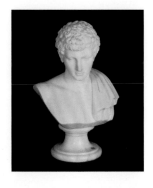

‡ **E/S–16** Thomas Waterman Wood (1823–1903), American, after Rosa Bonheur (1822–1899), French

Plowing in the Nivernais, undated copy

OIL ON CANVAS, 26 x 51 inches

Gift of Thomas Waterman Wood

Rosa Bonheur was among the most celebrated women artists of the nineteenth century, and *Plowing in the Nivernais*, which she sent to the Paris Salon of 1849, remains one of her best known compositions. Under the newly established democratic government of France's Second Republic, realist painters including Bonheur gained a new mandate to treat subjects other than the high-minded allegories and historical scenes that had previously dominated the official Salons. *Plowing in the Nivernais* captured her contemporaries' imagination and became a touchstone of critical and artistic discourse for the duration of the century, as this later copy by Thomas Waterman Wood suggests. Wood's painting is less than half the size of the original composition, yet it retains a sense of the ennobling monumentality with which Bonheur invested her laboring subjects.

One source cited for Bonheur's painting is a story by the realist author George Sand, *The Devil's Pool* (1846). The artist was reportedly listening to someone read aloud from Sand's novel as she contemplated her next work, when she heard this passage: "My attention was next caught by a fine spectacle, a truly noble subject for a painter. At the other end

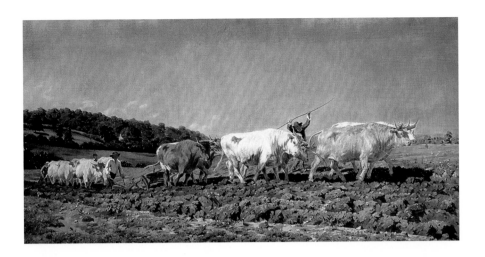

of the field a fine-looking youth was driving a magnificent team of four pairs of young oxen, through whose somber coats glanced a ruddy, glowlike flame. They had short, curly heads that belong to the wild bull, the same large, fierce eyes and jerky movements; they worked in an abrupt, nervous way that showed how they still rebelled against the yoke and goad and trembled with anger as they obeyed the authority so recently imposed...." Impressed by Sand's masterful description, Bonheur later said that she set out "to celebrate with my brush the art of tracing the furrows from which comes the bread that nourishes humanity."

§ ❡ **E/S–17** Jasper F. Cropsey (1823–1900), American

Autumn on the Ramapo River—Erie Railway, 1876

OIL ON CANVAS, 37⅛ x 63⅛ inches

Gift of Horace Fairbanks

This grand paean to the distinctive color and romantic grandeur of the American fall is among Jasper Cropsey's most ambitious compositions. When he exhibited the work at the National Academy of Design's annual exhibition in 1876, he priced it at $2,500, the highest amount that he ever listed there. The work displays autumnal brilliance in a luminous palette constituted of new, synthetic pigments introduced during the later 1850s and 1860s. Cropsey's fall scenes, of which *Autumn on the Ramapo River—Erie Railway* is in many ways a culminating example, distill the ideal of the American autumn to its essence: fiery leaves, sun-bathed scenery, peaceful rivers, and romantic experience.

Cropsey, a follower of the pioneering American landscapist Thomas Cole, was a leading exemplar of the second generation of Hudson River School painters that flourished during the 1850s and 1860s. He maintained and further explored the romantic approach to the landscape that Cole had introduced during the later 1820s. During the 1860s, Cropsey

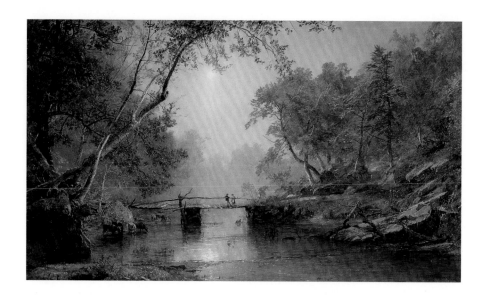

ratcheted up the color and luminosity of his compositions to accentuate their emotive effects. By 1876, the brilliance of his landscapes had reached its apogee. Shortly thereafter, the artist's career entered a steep decline as popular taste shifted in favor of the European-influenced aesthetics imported by a new generation of young artists who had returned from training abroad after the Civil War.

The reference to the Erie Railway at the end of Cropsey's title remains a mystery even today. Nostalgia may have played a role, however, as the Erie Railway, which had connected New York City and Lake Erie since 1851, went bankrupt and was sold in April of 1875, the year before Cropsey painted this composition. The Erie Railway intersected the Ramapo River near the artist's home in Warwick, New York, close to the New Jersey state line. Could Cropsey's scene represent a glimpse from the window of a train as it passed by? The painting's elevated vantage point reinforces that possibility, particularly absent any other evidence of a railroad in the composition. Notably, Cropsey, who was also an architect, designed a series of fourteen train stations for New York City's Sixth Avenue Elevated Railway in the same year that he painted this scene.

E/S–18 Unknown artist
Venus de Milo, undated copy
MARBLE, 27 inches high
Gift of the Estate of Albert L. Farwell

Venus (called Aphrodite by the Greeks), goddess of love and beauty, was a celebrated cult figure in the ancient world. The original *Venus de Milo*, of which this is a greatly reduced reproduction, is housed in the Louvre Museum in Paris and is among the most recognized

works of art in the world. Believed to have been sculpted during the second century B.C.E., she likely originally held the golden apple presented to her by the mortal Paris, who was asked to give it to the "fairest" among the goddesses Hera, Athena, and Aphrodite. The *Venus de Milo* was discovered by a peasant on the Greek island of Melos (which means "apple") in 1820 and was quickly acquired by French diplomats who presented it to their king, Louis XVIII. The sculpture soon became a symbol of French cultural aspiration during the nineteenth century, as the nation struggled to recapture the intellectual preeminence that it enjoyed before the end of Napoleon's reign in 1815.

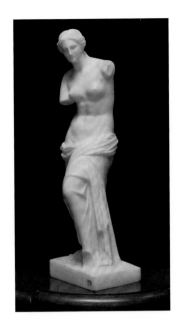

LIBRARY
First Floor

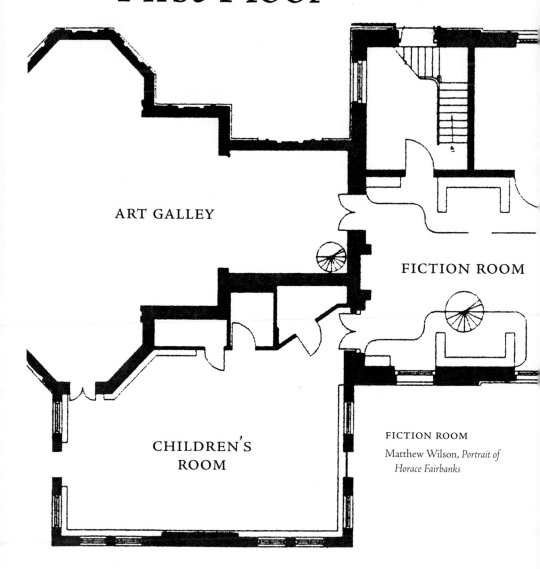

ART GALLEY

FICTION ROOM

CHILDREN'S
ROOM

FICTION ROOM

Matthew Wilson, *Portrait of Horace Fairbanks*

CHILDREN'S ROOM

Margery Eva Lang Hamilton, *The Song of Hiawatha*

Margery Eva Lang Hamilton, *Hans Brinker, or the Silver Skates*

Margery Eva Lang Hamilton, *Injun Joe and Molly Looking out over Joe's Pond*

Nathaniel Cobb, *Peace*

Margery Eva Lang Hamilton, *Heidi*

ELEVATOR VESTIBULE

Jean Massard, *Saint John de Crèvecoeur*

Richard Creifelds, *Portrait of Jonathan Arnold*

REFERENCE ROOM

Charles Joshua Chaplin, *Portrait of Erastus Fairbanks*

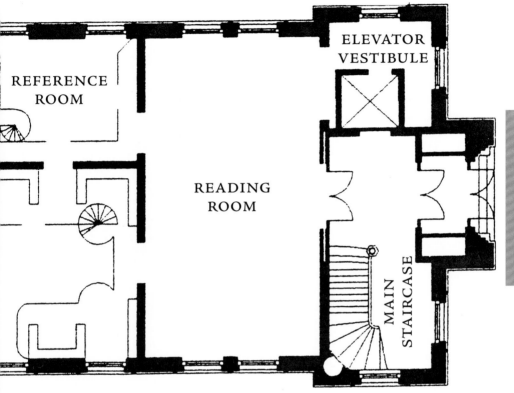

LIBRARY FIRST FLOOR

READING ROOM

Albert Bierstadt, *A Quiet Cove*

James M. Hart, *Lake Glenida*

Friedrich Johann Voltz, *The Shower*

Thomas Moran, *An Autumn Afternoon*

Jervis McEntee, *The Doge's Palace*

Lizzie Ellen Owen Wark, *Red Grain Elevator*

Félix Ziem, *Venice*

Jasper F. Cropsey, *Autumn Woods*

Mauritz Frederik Hendrick de Haas, *Sunset off the Needles*

Pierre Olivier Joseph Coomans, *Roman Women*

Jean-Baptiste Robie, *Roses*

Miguel Gonzalez, after Bartolomé Esteban Murillo, *Children of the Shell*

MAIN STAIRCASE

After Raphael Sanzio, *Sistine Madonna*

After Carlo Dolci, *Madonna*

FICTION ROOM

Matthew Wilson (1814–1892), British-American
Portrait of Horace Fairbanks, 1873–74
OIL ON CANVAS, 96 x 71 inches
Presented by the Citizens of St. Johnsbury

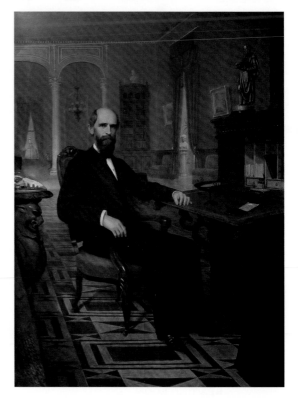

At the Athenæum's public dedication in 1871, founder Horace Fairbanks expressed his hope that the people of St. Johnsbury would make it "a favorite place of resort for patient research, reading, and study." Devoted to education, Fairbanks believed that there was no reason why St. Johnsbury should not become a crossroads of the world both literally and intellectually. His complementary initiatives in transportation and public education successfully achieved that goal in his day, transforming the town into a manufacturing and cultural center that actively engaged the world around it. (For more on Fairbanks' life, see the introductory essay, "The Lens of History.")

In this full-length portrait by New York painter Matthew Wilson, commissioned by St. Johnsbury residents to honor Fairbanks' generosity, the sitter is portrayed as a man of wide-ranging intellect. Although Fairbanks is shown in his home, Pinehurst, with several actual works of art from his collection in the background, the artist has embellished the composition's foreground with so-called "objects of virtue" to suggest the sitter's expansive intelligence. Fairbanks sits at his desk, apparently turning away from his study of an ancient bronze cup and medallion to face us. An animal skull resting on the table behind him symbolizes an interest in natural history, while the small statuette of an ancient philosopher atop his desk above him suggests both sagacity and classical education. Fairbanks is presented as the embodiment of the Athenæum's founding ideals.

CHILDREN'S ROOM

Margery Eva Lang Hamilton (1907/8–1997), American
The Song of Hiawatha, 1934
OIL ON BOARD, 31 x 82¼ inches
Funded by a grant from the Public Works of Art Project of the Civil Works Administration

This mural depicts a scene from Henry Wadsworth Longfellow's narrative poem, "The Song of Hiawatha," written in 1855. Derived from Native American legend, the poem tells the story of an Anishinabe Indian (also called Chippewa or Ojibway) of the Upper Midwest, who rises to become a leader of his tribe. Selecting a scene appropriate to her audience, the artist illustrated young Hiawatha's friend, Chibiabos, befriending the animals:

> From the hollow reeds he fashioned
> Flutes so musical and mellow,
> That the brook, the Sebowisha,
> Ceased to murmur in the woodland,
> That the wood-birds ceased from singing,
> And the squirrel, Adjidaumo,
> Ceased his chatter in the oak-tree,
> And the rabbit, the Wabasso,
> Sat upright to look and listen.

The context of Lang's commission to create the Athenæum's four murals is itself significant. After the onset of the Great Depression in 1929, Franklin Delano Roosevelt was elected President in 1932 on a platform of economic reform and relief. His aggressive series of programs, known collectively as the New Deal, included the Civil Works Administration, a precursor of the better-known Works Progress Administration. Under the Civil Works Administration, Roosevelt provided the first federal aid to the arts, much of it sponsoring artworks for public buildings and spaces throughout the country. In 1934, Margery Lang, a recent graduate of the St. Johnsbury Academy and student at the School of the Museum of Fine Arts, Boston, received one of the program's early grants to paint four murals for the Athenæum's Children's Room and used local residents as her models.

Margery Eva Lang Hamilton (1907/8–1997), American
Hans Brinker, or the Silver Skates, 1934
OIL ON CANVAS, mounted on board, 62½ x 119¼ inches
Funded by a grant from the Public Works of Art Project of the Civil Works Administration

Mary Mapes Dodge's classic 1865 children's tale of *Hans Brinker, or the Silver Skates* tells the story of a young Dutch boy who struggles with moral responsibility and caring for his family after his father is injured. Lang used students at the St. Johnsbury Academy as her models for this culminating scene, as the girls, including Hans' sister Gretel, begin a three-mile race. The race's winner would receive a coveted pair of silver skates "with silver bells and buckles."

For more information on the commission of the mural, see the above entry on *The Song of Hiawatha*.

Margery Eva Lang Hamilton (1907/8–1997), American
Injun Joe and Molly Looking out over Joe's Pond, 1934
OIL ON PANEL, 63½ x 206 inches (irregular)
Funded by a grant from the Public Works of Art Project of the Civil Works Administration

This mural is believed to portray the local legend of a St. Francis (Western Abenaki) Indian who was injured and therefore left behind by his tribe when they fled arriving settlers. Taken in by the settlers for the winter, Joe returned their kindness by warning them of impending danger, for which he was expelled from his tribe. Joe spent the rest of his days on an island in what came to be known as Joe's Pond in Danville, Vermont, until his death in 1819. In Lang's depiction, Joe and his squaw, Molly, look out from their island toward the setting sun, a common theme in nineteenth- and early twentieth-century American art symbolizing the gradual demise of Native American civilization.

For more information on the commission of the mural, see the above entry on *The Song of Hiawatha*.

Nathaniel Cobb (1839–1932), American
Peace, 1920
OIL ON CANVAS, 44½ x 69⅞ inches
Gift of the artist

This scene by Vermont native Nathan Cobb offers a somber allegory. A mother, dressed in ancient Roman attire, and her young son look out onto a desolate, ruined city. The absence of a husband or father figure adds to the work's doleful tenor. Painted in the aftermath of World War I, the scene embodies the destruction and loss that war leaves in its wake. The painting's title, *Peace*, is mournful rather than optimistic.

Margery Eva Lang Hamilton (1907/8–1997), American
Heidi, 1934
OIL ON CANVAS, 64 x 70½ inches
Funded by a grant from the Public Works of Art Project of the Civil Works Administration

Lang's choice of scenes from the Swiss author Johanna Spyri's *Heidi*, like in her *Hiawatha* mural, emphasizes themes of innocence and peace in nature. The young orphan Heidi watches over her goats in a meadow among the Alps, while her friend Peter sits nearby. In a state of unrefined, uncorrupted bliss, Heidi is shielded from the evils of the modern world by the encircling mountains.

For more information on the commission of the mural, see the above entry on *The Song of Hiawatha*.

REFERENCE ROOM

Charles Joshua Chaplin (1825–1891), French

Portrait of Erastus Fairbanks, 1847

OIL ON CANVAS, 45½ x 35 inches

Gift of Arthur F. and Phillip H. Stone

Erastus Fairbanks, father of the Athenæum's founder Horace, led the family's scale manufacturing business in St. Johnsbury for over thirty years, and is largely credited with its success. Elected governor twice, in 1852 and 1860, Fairbanks committed much of his life to public service and was a steadfast supporter of the Union as governor during the Civil War.

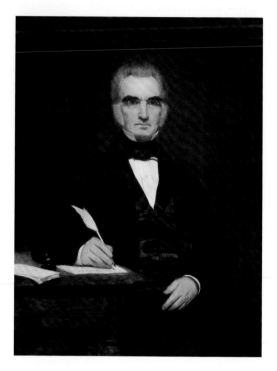

In this portrait, Fairbanks is depicted as an unassuming New England businessman, dressed well but with little taste for finery or the trappings of wealth. Painted almost ten years after Fairbanks' death, the work commemorates Fairbanks' character as well as his vision. The portraitist, French academic painter Charles Chaplin, is perhaps best remembered today for having briefly taught the impressionist Mary Cassatt.

READING ROOM

Albert Bierstadt (1830–1902), German-American
A Quiet Cove, undated

OIL ON CANVAS, 24 X 32 inches

Given in memory of Peter S. Brown, son of Peacham resident, V. Anne Brown, by family friends Jess and Tia Ravich of Pacific Palisades, California

This serene depiction of a small mountain lake bears a strong sense of sentiment, which critics and artists alike championed as an attribute of landscape painting during the mid-nineteenth century. Although their sites were usually recognizable, painters such as Albert Bierstadt (see also w-4) often strove to distill a feeling in their compositions, rather than accentuate careful detail. Great art was believed to transcend mundane reality, and convey a sense of divine presence in the world. *A Quiet Cove* is an idealized rendering, offering the viewer a sense of peace and respite in a sunny, verdant countryside. Individual details are subordinated to that principal experience.

James M. Hart (1828–1901), British-American
Lake Glenida (Village Outskirts), around 1863

OIL ON CANVAS, MOUNTED ON MASONITE, 20 X 34 inches

Gift of Mrs. Theodora Willard Best

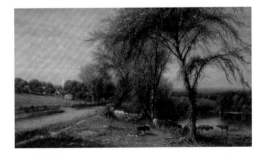

This view toward the historic town of Carmel, located in upstate New York near the border of Connecticut, looks along the water's edge of Lake Gleneida (to use its current spelling). Such pastoral scenes fit urban Americans' idyllic notions of the simplicity of rural life. Thomas Jefferson's vision of the yeoman farmer as America's model citizen lingered in the popular imagination. Also influenced by French and British painters creating similar depictions of peasant life for urban patrons in Europe during mid-century, American artists such as Hart found a ready market for such romantic scenes of country life. For more on James M. Hart, see also s-6.

Friedrich Johann Voltz (1817–1886), German
The Shower, 1879
OIL ON PANEL, 13 X 25 inches
Gift of Mrs. Theodora Willard Best

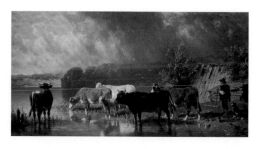

Friedrich Johann Voltz's painting of a herdsman and his dog watering their cattle attests both to the international appeal of idealized portrayals of rural life during the later nineteenth century and to the artist's success at promoting this, his signature subject. As the art market burgeoned in the later century, many American and European artists achieved modest distinction for easily recognized renderings of a particular subject, such as Verboeckhoven of sheep (see N-1) and Bazzani of Pompeii (see E/N-6), varying only the arrangements of figures and vantage point between works. In an age of industry, such a consistent product was appreciated for its stable value and accessible subject matter. Voltz created a strong, technically proficient body of work characterized by a vibrant palette, dynamic climate, and peaceable subject matter that collectively invoke the already popular aesthetics of the French Barbizon tradition of mid-century.

Thomas Moran (1837–1926), American
An Autumn Afternoon, 1878
OIL ON PANEL, 31½ X 19½ inches
Gift of Mrs. Theodora Willard Best

A pioneering landscapist of the American west whose fame rivaled even that of Albert Bierstadt (see W-4), Thomas Moran received international attention and admiration for his portrayals of the Grand Canyon and Yellowstone. His art and writings expanded awareness of the treasures of the western landscape and the need for their protection from commercial exploitation.

An Autumn Afternoon depicts a quieter, though no less expressive, phase of Moran's art. Painted at the height of Moran's acclaim as a western artist, the work could as easily depict an eastern forest interior as a western one. The scene is heavy with dark, brooding power, an effect that may result more from darkening of the artist's pigments than was his original intention.

Jervis McEntee (1828–1891), American
The Doge's Palace (Venice), undated
OIL ON CANVAS, 11¾ x 19¼ inches
Gift of Mrs. Theodora Willard Best

Already established as a respected landscape painter in America, Jervis McEntee paid his only visit to Venice while on a yearlong European sojourn in 1868–69. This view toward St. Mark's Square from the Lagoon offers one of the city's most iconic vistas in late twilight. The effect heightens Venice's evocative mood by rendering its already bright colors even more vivid while dark storm clouds brew overhead.

Lizzie Ellen Owen Wark (1869–1956), American
Red Grain Elevator, undated
OIL ON CANVAS, 11¾ x 17¾ inches
Gift of Gladys Conway

This East St. Johnsbury farmscape by local artist Lizzie Wark documents the region's living history. Early buildings are maintained and kept in use to the present day, providing the Vermont landscape with many of its distinctive sights. These particular buildings' clean geometry and rich color clearly attracted the artist to this site.

Félix Ziem (1821–1911), French
Venice, 1879
OIL ON PANEL, 20½ x 32¾ inches
Gift of Mrs. Theodora Willard Best

Félix Ziem's *Venice* exemplifies the dream-like evocations of reality for which he became famous. During his long career, the artist visited the historic city on more than twenty occasions and painted it hundreds of times. Here he portrays Venice's Lagoon, looking toward the Grand Canal with the Campanile in St. Mark's Square and the Doge's Palace visible at the right-hand side of the composition. Ziem's artistic ambition was to distill the poetic essence of the place, rather than to document the site in great detail or with immediacy, differentiating his art from that of the French impressionists.

Jasper F. Cropsey (1823–1900), American
Autumn Woods, 1876
OIL ON CANVAS, 21½ x 13½ inches
Gift of Mrs. Theodora Willard Best

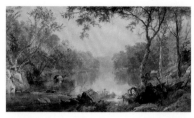

Jasper Cropsey spent much of his career paint-
ing the area around Greenwood Lake in north-
ern New Jersey. He began painting there in the mid-1840s and met his future wife there in
1847. When the artist, who was also a professional architect, eventually built his dream
home in 1867–69, he did so in neighboring Warwick, New York. For Cropsey, the area had
a rich background of personal associations and memories. *Autumn Woods* most likely
depicts Greenwood Lake, or a nearby site, and suggests a personal recollection of glorious
autumns past with its rich array of colors and effulgent sunlight.

Mauritz Frederik Hendrick de Haas (1832–1895), Dutch-American
Sunset off the Needles, 1870
OIL ON CANVAS, 27 x 45 inches
Gift of Mrs. Theodora Willard Best

Mauritz de Haas' portrayal of a single ship
navigating past a rocky coastline just as the
sun sets reminds the viewer of the perils
that accompanied life at sea during the
nineteenth century. De Haas was keenly
aware of those risks, having served as a
painter first to the Dutch Navy during the 1850s and later for the American Navy during
the Civil War after he immigrated to the United States in 1859. By 1870, when de Haas
painted *Sunset off the Needles*, steamboats had largely surpassed sailboats as the fastest
means of shipping goods, and this sunset scene may be a metaphor for the twilight of the
heroic age of sail. The rocks shown in *Sunset off the Needles* loosely resemble a well-known
formation of that name along the coast of the British Isle of Wight, located in the English
Channel. The precise location shown in de Haas' work, however, is unknown.

Pierre Olivier Joseph Coomans (1816–1889), Belgian
Roman Women (For Charity), undated
OIL ON PANEL, 21 x 16 inches
Gift of Mrs. Theodora Willard Best

Five years after he bought *Aspasia* at New York's Knoedler Gallery, Fairbanks added
another work by the artist to his collection, *Roman Women*. Unlike the private moment of
reflection in the earlier painting, *Roman Women* depicts a public exchange, as a widow and

her daughter appeal to the viewer for donations of clothing or valuables to support them. War and disease were common in ancient Rome, and the elder woman's gesture toward a small funeral vault at lower left suggests that they are appealing for aid after the death of her husband. The woman remains stoic in expression, despite her hardship, exemplifying the Roman ideal of self-containment.

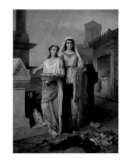

Jean-Baptiste Robie (1821–1910), Belgian
Roses, undated

OIL ON PAPER MOUNTED ON PANEL,
27 x 20 inches
Gift of Mrs. Theodora Willard Best

Jean-Baptiste Robie's lush cascade of roses in various states of maturity offers a reminder of beauty's ephemeral nature. The small buds at the top of his composition aspire upward, but as the eye traces the arrangement's downward flow, the more mature blossoms project forward and then downward, over-whelming their stems with their own profusion. That moral is subtly obscured, however, by the sheer density and coloristic brilliance of Robie's subject.

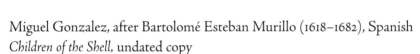

As an academic still life painter, Robie was a well-known figure in his time, garnering numerous awards and distinctions beginning as early as 1850. He spent most of his career in his native Brussels, but exhibited widely in Europe and America throughout the later century. Though little known today, Robie's works are represented in the collections of leading museums throughout Europe and America, a testament to his once pervasive reputation.

Miguel Gonzalez, after Bartolomé Esteban Murillo (1618–1682), Spanish
Children of the Shell, undated copy

OIL ON CANVAS, 25 x 29½ inches
Gift of Mrs. Theodora Willard Best

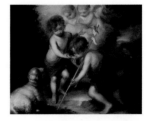

Bartolomé Esteban Murillo's depictions of children were particularly admired for their subjects' precocious gestures and for their sentimental quality. In *Children of the Shell* of 1670, now in the collection of the Prado Museum in Madrid, the infant Christ offers water to an equally young John the Baptist. By rendering the biblical figures as children, a popular trope that origi-nated in Italian art, Murillo is better able to humanize his subject and elicit the viewer's sympathy.

ELEVATOR VESTIBULE

Jean Massard (1740–1822), French
Saint John de Crèvecoeur, 1786
ENGRAVING ON PAPER, 5 x 3⅛ inches (image)
Gift of Madame de Crèvecoeur

French author and agronomist Michel Guillaume Jean de Crèvecoeur, also known by his pseudonym J. Hector St. John, contributed greatly to Europeans' understanding of nascent American culture with his celebrated *Letters from an American Farmer* of 1770–81, which he wrote while farming in upstate New York. He returned to the United States as France's consul to New York in 1783. Once Vermont had firmly established its independence from the competing claims of New Hampshire and New York (not to mention Great Britain), its early leaders, most notably Revolutionary War hero Ethan Allan, sought to rename certain towns in honor of the state's friends and allies. St. Johnsbury, formerly known as Dunmore, was renamed in de Crèvecoeur's honor in 1786.

Richard Creifelds (1853–1939), American
Portrait of Jonathan Arnold, 1898
OIL ON CANVAS, 27 x 22 inches
Gift of Lemuel Hastings Arnold

Jonathan Arnold is considered the founder of the town of St. Johnsbury, as he obtained its grant from Governor Thomas Chittenden, led one of the first groups of permanent settlers to the town's current site in 1787, and helped establish its institutions, both civic and economic. This depiction of Arnold by New York portraitist Richard Creifelds reproduces, with some embellishment, an eighteenth-century miniature (see inset) that is believed to have been created during Arnold's participation in the Continental Congress in Philadelphia in 1782–83 as a delegate from Rhode Island, which explains his wig and formal attire.

MAIN STAIRCASE

After Raphael Sanzio (1483–1520), Italian
Sistine Madonna, undated copy
OIL ON CANVAS, 41 X 31½ inches
Gift of Mrs. Theodora Willard Best

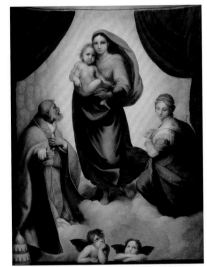

Raphael's *Sistine Madonna* was originally painted around 1512–14 for the high altar of the Church of St. Sixtus (to whom the word "Sistine" refers) in Piacenza, a town in northwestern Italy. The dramatic lighting and dynamic composition are typical of the artist's later work—a relative term given that the artist died at age thirty-seven—and convey a sense of immediacy and direct engagement with the viewer not seen earlier. The resemblance between the kneeling figure of the third-century Pope Sixtus II in Raphael's composition to his patron, Pope Julius II, may have been an intentional gesture of flattery.

After Carlo Dolci (1616–1686), Italian
Madonna, undated copy
OIL ON CANVAS, 20½ X 19 inches
Gift of Mrs. Theodora Willard Best

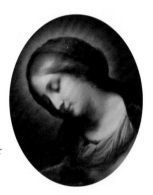

The painting reproduces a detail from the same *Madonna and Child* composition as the one found in the Art Gallery (E/N-14), but concentrates even greater attention upon the Virgin's tender expression with its oval format framing her face.

LIBRARY
Second Floor

ATHENÆUM HALL

John Crookshanks King, *John Quincy Adams*

Unknown artist, *Pasquino*

After Carlo Dolci, *The Magdalene*

Unknown artist, *Landscape*

Unknown artist, *Albert Thaddeus Fairbanks*

Matthew Wilson, *Portrait of William W. Thayer*

Thomas Lewis Atkinson, after Edwin Landseer, *The Prize Ca*

After Albert Bierstadt, *Last of the Buffalo*

Attributed to Archibald M. Willard, Untitled

Friedrich Boser, *The Young Peddler*

NOTE: Works are listed clockwise from each room's eastern or main entrance.

ELEVATOR VESTIBULE

Thomas Landseer, after Edwin Landseer, *The Stag at Bay*

Thomas Dow Jones, *Abraham Lincoln*

Évariste Vital Luminais, *Horses*

ELEVATOR
VESTIBULE

ATHENÆUM HALL

MAIN
STAIRCASE

MAIN STAIRCASE

Pàl Böhm, *Gypsies*

Henry Lerolle, *Peasant Scene*

Adolphe William Bouguereau, *Raspberry Girl*

Pierre Olivier Joseph Coomans, *Girl and Doll*

Harry van der Weyden, *Child's Head*

Adolf Eberlé, *First Shooting Lesson*

Adrien Moreau, *Spanish Wedding*

John Quincy Adams Ward, *Horace Fairbanks*

MAIN STAIRCASE

Pàl Böhm (1839–1905), Hungarian
Gypsies, undated

OIL ON PANEL, 15⅝ x 29⅞ inches

Gift of Mrs. Theodora Willard Best

Inspired by Hungary's distinctive national character, landscape, and folkways, Pàl Böhm brought the immediacy and realism of contemporary German aesthetics to bear upon the vibrant traditions of his homeland. Trained initially in Budapest and Vienna, Böhm eventually traveled to Munich in 1871, where he spent thirty years exploring peasant and gypsy subjects in his art.

Henry Lerolle (1848–1929), French
Peasant Scene, undated

OIL ON CANVAS, 21¼ x 29¾ inches

Gift of Mrs. Theodora Willard Best

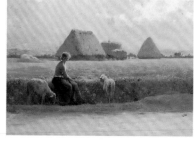

Henry Lerolle was best known as a religious painter and his prestigious public commissions included Paris' City Hall and cathedrals throughout France. The contemplative mood of his *Peasant Scene* shares a sense of introspective repose and harmony with nature that are typical of Lerolle's genre scenes, imbuing peasant life with quiet sanctity.

Adolphe William Bouguereau (1825–1905), French
Raspberry Girl, 1890

OIL ON CANVAS, 54 x 32¾ inches

Gift in memory of Barbara Ulrich Roberts, 1915–1970

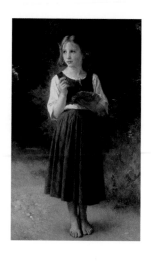

In 1888, the influential critic Clarence Cook observed that Bouguereau was among the most popular artists in America. Americans avidly collected his art during the later century. Bouguereau's interest in the simple, honest beauty of peasants appealed to Americans' wishful self-image as a nation of yeoman farmers. Caught in the midst of rapid industrialization and urbanization, rustic innocence, such as that found in Bouguereau's *Raspberry Girl*, was a popular subject.

Bouguereau had a more direct influence on American art of the later century as well, as he taught a number of Americans while an instructor at the Académie Julian in Paris. The Académie Julian was far more accessible to foreigners than the better known École des Beaux-Arts, with its stringent entry and language requirements, which few Americans could pass. Under Bouguereau's instruction, Robert Henri, Thomas Anshutz, and Cecilia Beaux, among many others, matured as artists and would later become leaders of the American art world at the turn of the twentieth century.

Pierre Olivier Joseph Coomans (1816–1889), Belgian
Girl and Doll, 1882
OIL ON CANVAS, 32 x 25¾ inches
Gift of Mrs. Theodora Willard Best

Coomans' depiction of a young girl and her doll illustrates a common theme in later nineteenth-century European and American art. Childhood and play became subjects of particular interest during the period, studied in terms of their significance to personal development and education. This little girl's mischievous streak is represented by the wallet in the foreground, presumably her father's, which she has gone through in search of materials with which to decorate her doll's hair. The scenery is also of particular note, because it offers a glimpse of the rich colors, varied fabrics and patterns, and other bric-a-brac from around the world that filled Victorian homes at about the same time that the Athenæum and its art collection were built.

Harry van der Weyden (1868–1952), American
Child's Head, undated
OIL ON CANVAS, 13 x 19 inches
Gift of Mrs. Theodora Willard Best

Very little is known about the Boston-born painter Harry van der Weyden, except that he trained in Paris and spent much of his career painting in rural areas of France and England around the turn of the century. This painting likely depicts a child from one of those two regions.

Adolf Eberlé (1843–1914), German

First Shooting Lesson, undated

OIL ON PANEL, 8 x 10 inches

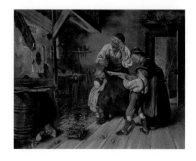

During the 1860s and 1870s, a number of success-
ful genre artists emerged from studies at the Royal
Academy in Munich to paint lighthearted scenes
of everyday life such as this one by Adolf Eberlé.
A young boy dressed in traditional Bavarian cos-
tume tries out the new crossbow that the older
man, perhaps his father or grandfather, has just built at his workbench. Wealth, the paint-
ing suggests, is not a prerequisite for happiness.

Adrien Moreau (1843–1906), French

Spanish Wedding, 1879

OIL ON CANVAS, 28 x 35½ inches

Bequest of Mrs. Theodora Willard Best

Adrien Moreau's portrayal of the lavish wedding ceremony of the Spanish nobility exem-
plifies the fascination for anecdotal genre painting among French academic painters dur-
ing the mid- and later nineteenth century. In the distant wake of the French Revolution,
artists such as Moreau clung to history, formerly considered the highest and most distin-
guished genre, as a subject for their art. Despite the loss of noble patronage during the
nineteenth century, these painters found enduring patronage among the affluent *bourgeois*
class. Moreau's wedding scene, despite its apparent extravagance, may fairly be described as
a quaint, provincial shadow of the weddings and festivities regularly hosted by Napoleon
at the beginning of the century and by Louis XVI before the Revolution of 1789. Identify-
ing the event as a Spanish wedding, rather than a French one, Moreau safely distanced
himself and his patrons from any lingering monarchism, a specter that continued to haunt
the French during mid-century.

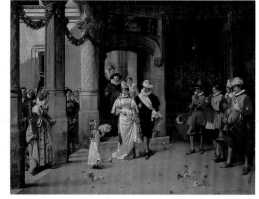

Another, nearly identical ver-
sion of the painting, entitled *The
Birthday of the Lady of the Manor*,
demonstrates how interchange-
able Moreau's titles could be to
appeal to his patrons. The paint-
ing's primary subject, in either
case, is the sweet gesture of a girl
presenting flowers to the bride as a
gift from her mother and the audi-
ence looking on from outside of
the arcade.

John Quincy Adams Ward (1830–1910), American

Horace Fairbanks, 1893

MARBLE, 26½ inches high

Gift of Mrs. Horace Fairbanks

John Quincy Adams Ward was among the nation's
leading sculptors at mid-century. As scholar Wayne
Craven has observed, Ward's sense of naturalism,
strength of design, and incisive portrayal of individ-
ual character distinguish his later portraits, such as
this one. This depiction of the Athenæum's founder
was commissioned on behalf of the institution by
Fairbanks' wife Mary, five years after her husband's
death. She reviewed photographs of studies for the
final work, making detailed suggestions to the artist
so that her husband would appear as she remem-
bered him. For more on Fairbanks' life, see the intro-
ductory essay, "The Lens of History."

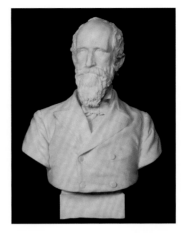

ATHENÆUM HALL

John Crookshanks King (1806–1882), British
John Quincy Adams, 1845 (cast 1863)
BRONZE, 19 inches high

In the wake of the Civil War, it would have been difficult to look back on the political career of John Quincy Adams without amazement at his foresight. As the country's sixth president, Adams favored a strong federal government over states' rights, and he later adamantly opposed the gag rule that forbad Congress from discussing slavery during the 1830s and 1840s. John Crookshanks King's depiction portrays Adams as a strong, proud figure. The original marble version of the work is displayed in the Capitol in Washington. Recognized as among King's finest works, his sculpture of Adams gained new popularity during the Civil War years in the form of replicas such as the Athenæum's cast.

Unknown artist
Pasquino (Achilles), undated copy
BRONZE, 20 inches high
Gift of the Estate of Albert L. Farwell

This detail of the head of the central figure in the ancient *Pasquino* group somewhat adapts the original composition, elevating the figure's gaze in a more dramatic upward sweep than is the case in the original. During the late eighteenth century, archaeologist Ennio Quirino Visconti persuasively argued that the *Pasquino* group depicts a scene from Homer's *Iliad* in which Menelaus, Helen's rightful husband, recovers the body of his ally Patroclus, whom Achilles had sent into battle in his place. The original Menelaus figure responds more stoically to Patroclus' death than in the Athenæum's version. (The original *Pasquino* group, one of three known ancient versions of the same subject, was, contrary to convention, named for an irreverent tailor near whose shop the sculpture was originally discovered rather than for its subject.)

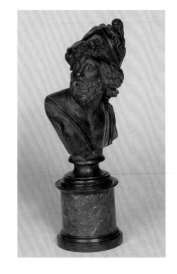

After Carlo Dolci (1616–1686), Italian
The Magdalene, undated copy
OIL ON CANVAS, 30 x 24½ inches
Gift of Mrs. Theodora Willard Best

The original version of this work was painted during the
1660s and is in the collection of the Pitti Palace in Florence,
Italy. The tenor of the painting is typical of Dolci's later
career, as his paintings became more overtly instructive in
purpose, modeling behavior for the viewer. Here, Mary
Magdalene is shown with the alabaster pot of ointment that, according to the Bible, she
used to anoint Jesus' feet in humble penitence. She looks heavenward for guidance with her
hand over her heart, a sign of the love that induced Jesus to forgive her sins.

Unknown artist
Landscape, undated
OIL ON CANVAS, 39½ x 53¾
inches

This pastoral scene incorporates a
number of the classical conventions
of ideal, poetic landscapes espoused
by the French Baroque painter
Claude Lorrain. His landscape for-
mula, including framing trees, expan-
sive atmosphere, and the narrative
element of a path leading off into the distance, became a model for the influential eigh-
teenth-century concept of the picturesque and struck a chord with many artists through-
out the nineteenth century by offering a means to order and idealize the natural world.

Unknown artist
Albert Thaddeus Fairbanks, undated
OIL ON CANVAS, 35½ x 21½ inches
Gift of Mrs. Henry Fairbanks

Albert Fairbanks was the son of Athenæum founder Horace Fair-
banks' cousin Henry. Albert died at age fifteen. This portrait was
probably painted during the sitter's lifetime as a symbol of his
family's pride, but was likely presented to the Athenæum by his
mother after his death as a tribute to his memory.

Matthew Wilson (1814–1892), British-American
Portrait of William W. Thayer, 1875
OIL ON CANVAS, 26 x 22 inches
Gift of Horace Fairbanks

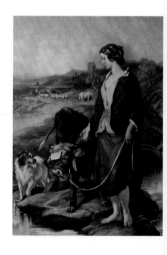

William Thayer was the Athenæum's first librarian as
well as one of its first trustees. That Fairbanks com-
missioned New York portraitist Matthew Wilson to
depict his colleague suggests that he was pleased with
his own grand portrait (now in the Fiction Room),
painted two years earlier. Thayer's portrait is far less elab-
orate than Fairbanks', but nevertheless conveys a sense of
the sitter's dignified demeanor. Under Thayer's guidance, the
Athenæum library's early years were enormously successful,
fulfilling Fairbanks' hope that the institution would become an integral part of life in the
St. Johnsbury community.

Thomas Lewis Atkinson (1817–1889/90), British,
after Edwin Landseer (1802–1873), British
The Prize Calf, 1871
ENGRAVING ON WOVE PAPER, 26 x 18½ inches (image)

Animal painter Edwin Landseer was the favorite of Queen
Victoria, and in many ways typified his era. The sentimental
subjects, including that of *The Prize Calf*, that made Land-
seer's paintings so popular during his own lifetime rendered
his work unpalatable to later critics. His mastery of animal
anatomy, however, has never been questioned, and it lends
his works a formal strength and a captivating integrity. His
paintings were enjoyed by a wide public through engraved
reproductions such as this one.

After Albert Bierstadt (1830–1902), German-American
Last of the Buffalo, 1891
PHOTOGRAVURE ON WOVE PAPER, 33 x 43 inches
Gift of Mrs. Horace Fairbanks

The original 1888 painting upon which this print is based, now in the collection of the Cor-
coran Gallery of Art in Washington, became a lightning rod of controversy when it was
rejected from a major international exhibition in Paris in 1889. The exhibition's jury cited

the work's failure to address the current state of American art, meaning the modernist aesthetics of the day. Although stylistically outdated by the late 1880s, the work's subject directly addressed contemporary concerns. Beginning in the 1870s, buffalo were being systematically destroyed by over-hunting and changes in habitat brought on by settlement and agriculture. In 1886, alarmed by the scarcity of buffalo, the chief taxidermist of the Smithsonian Institution established the first preservation movement to protect the buffalo from extinction. In his composition, Bierstadt expanded beyond the imminent extinction of the buffalo, however, tying their fate together with that of the Plains Indians. Bierstadt's vision of the western landscape in *Last of the Buffalo* differs dramatically from others in the Athenæum's collection, particularly those by Worthington Whittredge (N-11) and Samuel Colman (N-8).

Attributed to Archibald M. Willard (1836–1918), American
Untitled, undated

OIL ON CANVAS, 10 x 11¾ inches

Gift of Cornelia Taylor Fairbanks

Ohio painter Archibald Willard made a career in art with his comic scenes of young children on dog-drawn carts chasing down rabbits. His paintings of this theme developed considerable popular interest during the early 1870s and reportedly sold thousands of copies when reproduced in the newly developed mass medium of chromolithography. This painting is either by Willard or a replica of one of his compositions.

Willard is best known, however, for his depiction of a Revolutionary piper and two drummers leading the troops entitled *The Spirit of '76*, which he exhibited at the Centennial Exposition in Philadelphia in 1876. The work remains a beloved national symbol, incorporating Willard's unpretentious, unrefined realism with his flair for the dramatic.

Friedrich Boser (1809–1881), German
The Young Peddler, undated
OIL ON PANEL, 13 X 10 inches
Gift of Mrs. Theodora Willard Best

Friedrich Boser's charming depiction of a young street vendor hawking his wares adopts a popular theme in mid-nineteenth century art. Probably derived from similar themes in European Rococo art of the mid-eighteenth century, these happy, healthy young people manifest none of the cares, burdens, or chicanery of their adult peers. Boser, like many other artists working in both Europe and America, made his career of depicting a wide array of such gainfully employed youths.

ELEVATOR VESTIBULE

Thomas Landseer (1795–1880), British,
after Edwin Landseer (1802–1873), British
The Stag at Bay, 1865
ENGRAVING ON WOVE PAPER, 20½ x 36⅜ inches (image)

Edwin Landseer's painting—reproduced here in a engraving by the artist's older brother, Thomas —depicts a battle between a stag and two wolves in epic terms. The exhausted stag, its tongue lolling from the side of its mouth, rears its head as it tries to crush its enemy under foot. Meanwhile, a violent storm plays out in the background, lending emotional power to the mortal struggle. More than any other subject, Landseer's deer paintings of the 1840s and 1850s were responsible for his fame as an artist. Through the sale of reproductive engravings such as this one, Landseer became a household name.

Thomas Dow Jones (1811–1881), American
Abraham Lincoln, 1861
PLASTER, 32 inches high

The memory of Abraham Lincoln loomed large in American life during the Reconstruction era. For the most part, Vermonters, and the Fairbanks family in particular, were deeply patriotic, and the Civil War only reaffirmed their dedication to the Union. The presence of this bust of Lincoln in the Athenæum's collection is a reminder of the signal influence that the Civil War had on the nation's history.

Évariste Vital Luminais (1822–1896), French
Horses, undated
OIL ON CANVAS, 21½ x 18 inches
Gift of Mrs. Theodora Willard Best

History and national identity were closely entwined in nineteenth-century art. The French painter Évariste Vital Luminais made a career of painting imagined scenes of the ancient Gaul and Breton peoples, forebears of the modern French. In this composition, the horseman's rough tunic, helmet, and long hair identify him as an historic figure, one of the intrepid warriors whose lineage the French claimed. The dynamic diagonals of Luminais' scene are typical of his work and impart a sense of energy and vitality to his depiction of a wild horse being tamed.

SELF-GUIDED TOURS

TOUR 1 · §

Masterworks:
Highlights of the Collection

B UILT IN 1873 to display the art collection of founder Horace Fairbanks (1820–1888), the St. Johnsbury Athenæum's Art Gallery lays claim to being the oldest gallery in America still in its original form. Thanks in part to an extensive historic restoration project completed in 2003, the Art Gallery offers an outstanding opportunity to experience an American art collection as it would have been seen during the nineteenth century. This tour features several of the collection's most important works and offers questions to initiate conversation. If you have trouble finding any of the works mentioned, use the location reference number (e.g., w-4) along with the alcove diagrams in the catalogue section of this handbook or ask a volunteer for help.

As you enter the Athenæum's Art Gallery, a majestic scene of California's Yosemite Valley dominates your view. This is German immigrant painter Albert Bierstadt's *The Domes of the Yosemite* of 1867 (w-4), the centerpiece of the Athenæum's collection. The painting's vast scale is appropriate to the tremendous size of its subject and was intended to amaze audiences on the east coast who had never visited the region. Let your eye travel down into the valley, following the winding course of the Merced River, and wend your way back up the Royal Arches on the distant valley wall and the landmark profile of Half Dome at the far right. This painting is easily the most recognized work in the Athenæum's collection, and there is good reason to believe that this end of the Art Gallery was designed specifically for its display. You can walk up and examine the details of the painting, or back far away to appreciate its overall composition. If it's open, be sure to climb up to the viewing balcony, added in 1882, and experience the painting as Bierstadt himself liked to do. He had similar balconies built in his

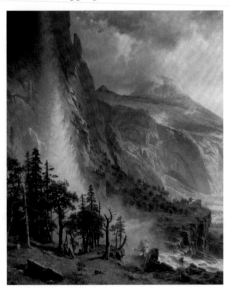

w-4

E/S-17

vast studio in upstate New York. We don't know why Fairbanks chose a monumental depiction of the Sierra Nevada Mountains as the core of an art collection displayed in the midst of Vermont's Green Mountains. What do you think his reasoning was?

If you turn to your left, you'll find a depiction of the fiery colors of fall in Jasper Cropsey's vivid *Autumn on the Ramapo River—Erie Railway* of 1876 (E/S-17). A young couple stands on a rickety bridge amid the romantic beauty of autumn foliage. The association of youthful love and the brilliance of American fall reflect the nostalgia many Americans felt toward the countryside as both urbanization and industry transformed the nation in the wake of the Civil War. Painted in the year of America's Centennial celebration, the work was among Cropsey's most ambitious compositions, as well as the highest priced at $2,500. After 1876, however, the early group of American landscape painters known collectively as the Hudson River School, of which Cropsey was a leading member, experienced a sharp decline in reputation. The famous Centennial Exposition in Philadelphia placed American and European artists in direct competition, and thereafter young artists sought to cultivate more cosmopolitan modes, such as impressionism, rather than homegrown aesthetics such as Cropsey's. The painting's title has led to considerable speculation about the subject. No train is in evidence, so perhaps the composition is intended to be a glimpse out the train's window onto a romantic interlude between country folk. How do you interpret the title?

Behind you, you'll find a depiction of a young woman reading by an open window. This is George Cochran Lambdin's *Girl Reading* of 1872 (E/N-5). Take a moment to explore this nuanced composition, the elegant contours of the lily's unfurling leaves, the natural light falling across the girl's face, and the gentle touch of her finger atop the book. The woman-by-the-window motif was very popular during the period. The subject suggests much more meaning than the immediate scene conveys. Reading a book conveys quiet contemplation and the inner life of the mind, while the adjacent window suggests a metaphor for her imagination taking wing. *Girl Reading* is both one of the most ambitious and complex compositions that Lambdin ever painted, and as such it particularly encourages

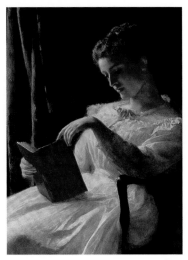

E/N-5

such speculations. Most of his works are small still life scenes of flowers that bear little meaning beyond their admirable fidelity to nature. *Girl Reading*, however, intimates a great deal about its subject, associating the girl with the purity of the lily. How are we to understand the three different types of flowers in the scene, though? Living (in the pot), cut (on the sill), and woven (in the rug), flowers abound in the scene, yet their different meanings as symbols are open to interpretation. Looking out the girl's window into the landscape, it is difficult not to imagine nineteenth-century viewers doing the same while sitting in their parlors and looking at landscape paintings by Bierstadt, Cropsey, or our next artist, Sanford Gifford. Their idealized renderings of untouched nature offered a kind of respite from the demands of the working world, a foil for the viewer's imagination and a reminder of trips to the countryside.

Sanford Gifford was fascinated by light and atmosphere. His radiant 1873 composition, *The View from South Mountain, in the Catskills* (s-9), which hangs behind you in the South Alcove, portrays a favorite scene of the artist's located near a famous resort hotel, the Catskill Mountain House. Gifford first painted the scene in the midst of the Civil War while home on leave from his service in the Union army in 1863. New York's Catskill Mountains were a

s-9

popular destination for artists and tourists alike during the nineteenth century, but for Gifford the area was also home. He was raised in neighboring Hudson, New York and knew the scenery of the region from lifelong experience. Unlike earlier painters of the Catskills, however, Gifford favored an emotive rather than a narrative format. Whereas Bierstadt's *Domes of the Yosemite*, for example, leads our eye through the scenery along a set path with a string of compositional devices, Gifford's composition focuses on basic masses of color to accentuate a feeling of peace and meditation. The rich sky absorbs our gaze, rather than leading our eye along from place to place within the scene. Mood, however, is a nuanced and personal experience. What mood does the painting invoke in you?

All of the idealism that mid-nineteenth-century American painters invested in their works was matched by their sculptor peers. Chauncey Bradley Ives' *Pandora* (w-12), the large sculpture to your right as you face Bierstadt's *Domes*, illustrates the classical tale in which a young woman opens a jar entrusted to her care and releases all of the ills of civilization. The graceful nude figure is discretely draped to maintain propriety, her rapt attention focused on the jar in her hand. The sculpture is remarkably narrative, her right hand

poised to lift the lid. The young woman's tightly bound hair and introspective expression accentuates the stoicism and restraint characteristic of the ancient Greek and Roman sculptures that inspired artists like Ives. Humanity's virtue was, in classical times, perceived to be its control over animal emotion. Balancing that idealism with a distinct element of naturalism, however, the *Pandora* is a remarkable accomplishment of mid-nineteenth-century sculpture that enjoyed long-term popularity. By the time Ives created this version of his *Pandora* figure in 1875, the original sculpture was already twenty-four years old. To your eye, is this composition more idealistic or realistic? In other words, is she more of a synthetic ideal of womanhood or a portrait of a real person?

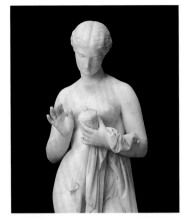

W-12

Finally, turn to your right and look for an encampment of Native Americans on the plains below the Rocky Mountains, Worthington Whittredge's *On the Plains, Colorado* (N-11). This panoramic scene of life in the West in 1872 is perhaps less realistic than it appears. Whittredge admired a number of different elements that he encountered along the shore of the Platte River, but they were not all in the same place. In his effort to create a harmonious composition, therefore, Whittredge sacrificed accurate topography. The painting is nevertheless a marvel of balance and form. His technical accomplishment in this work, recognized as among his finest, leaves little doubt as to why his peers elected him president of New York's famous National Academy of Design during the mid-1870s. Like Gifford, Whittredge treated the elements of his composition as masses of color and texture, rather then leading the viewer's eye through a narrative. The elegance of his composition derives from balancing elements at varying distances with a remarkable degree of awareness of the abstract weights of different forms. Whittredge was so interested in composition that his figures often seem to play only a secondary role in his paintings. Do you feel that Whittredge had a particular interest in representing Native American culture in this painting? Why?

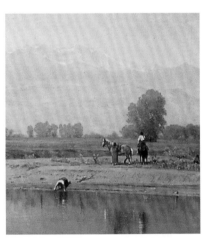

N-11

Take time now to choose a few of your own favorite works and discuss your ideas about them with your group.

TOUR 2 · Δ
ArtKids: A Visit for Families

Young people are always welcome at the Athenæum! In 1871, when the library first opened to the public, a special celebration was organized just for children. Since then, the Athenæum has steadily added programs and services expressly for young visitors and their families. This tour, *ArtKids*, is designed to encourage conversation between children and adults in the Athenæum's Art Gallery. These conversations build the visual literacy and critical thinking skills that are the foundations of lifelong enjoyment of the arts. The questions included here are just a starting point, however, and are left open-ended so that you can go wherever your imagination may take you! If you have any trouble finding the works mentioned in the text, you can use the location number (e.g., w-6) along with the alcove diagrams in the catalogue section of this handbook to find them, or just ask a volunteer for help. The volunteer also has paper and pencils that you can borrow for the activities in this tour.

GETTING STARTED

Let's start with J. G. Brown's *Hiding in the Old Oak* (w-6), which hangs to the right of Albert Bierstadt's huge painting, *The Domes of the Yosemite*. Why do you think these girls are hiding? How can you tell?

Paintings of children were very popular in America during the 1860s and 1870s, over a hundred years ago. People enjoyed them because the paintings reminded them of what it was like to be young. What do you think it would feel like to be hiding in this tree? Have you ever hidden in a place where it was hard for other people to find you? What was fun about it?

ACTIVITY! Choose one of the girls in the painting and imagine what she's thinking based on what you see. Take turns with the other people in your group saying your thoughts aloud and guessing which child each of you chose.

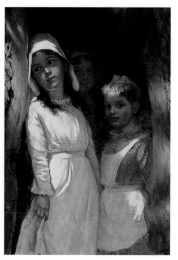

w-6

[124]

TELLING A STORY

The next painting we'll visit is also about hiding. It's Seymour Joseph Guy's *Up for Repairs* (w-9), hanging beside the painting we've just looked at. What do you think this boy is doing? How can you tell? What room do you think he's in? What do you see that makes you say that? Who could the woman in the background be?

Paintings of children during this time period often had morals or lessons to teach. How do you think the boy in this painting is feeling? What do you think the moral here is?

ACTIVITY! Either together or on your own, make up a story about why this boy is mending his clothes. What has happened? What will the woman say to him when she comes into the room? Share your story with the other people in your group.

w-9

MAKING CONNECTIONS

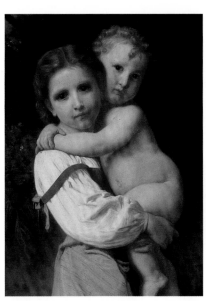

s-14

Turn around now and find the painting of a girl holding her baby brother, Adolphe William Bouguereau's *Going to the Bath* (s-14). How can you tell this girl is taking her little brother for a bath? Have you ever helped take care of a younger child? What are some of the things you did to help?

Family relationships were very important during the nineteenth century, especially in rural areas. Children often had to help their parents get all of the work done around the farm or else the family could go hungry. Do you think the children in this painting live in the city or the country? Do you think that they get along with one another? How can you tell?

ACTIVITY! Now that you've looked carefully at this painting, walk around the Art Gallery and find other images of adults or older children with babies. How are their relationships different from or similar to the one shown in this painting? Talk about what you see that makes them different or the same.

FINDING INSPIRATION

W-2

Let's turn to another painting of siblings, a copy of Anthony van Dyke's *Children of Charles I* (W-2), hanging between the painting we've just been talking about and Bierstadt's big *Domes of the Yosemite*. Why might these children be wearing clothes like these? What do you think it would feel like to wear these outfits? Are the children playful or serious? What do you see that makes you think that?

The boy at the left will one day become king of England. How does the artist show us that he's important? How do you think the relationship between these siblings is different from that of the siblings in Bouguereau's painting? Why do you think the dog looks up at the boy?

ACTIVITY! As you look at the painting, have each of the people in your group come up with three or four words that describe the children's clothing. Share your words with your group, then put them all together into a poem about the painting.

RELATING TO HISTORY

Let's take a look at another painting now, Louis Émile Pinel de Grandchamp's *Donkey Driver of Cairo* (N-5). It's a small painting of a boy with a donkey that hangs around the corner from Seymour Guy's *Up for Repairs*. How is the boy's relationship with his animal dif-

ferent from that between the children and their dog in van Dyke's painting? Do you think that this boy is having fun or working? What do you see that makes you say that? What could be on the donkey's back?

Thanks to the invention of steamships and railroads during the 1800s, artists like de Grandchamp were able to visit faraway places more easily than ever before, and they could show people back home what life was like in the places that they visited. How do you think the artist shows us where the boy is? How do you think the boy is similar to or different from children in the United States?

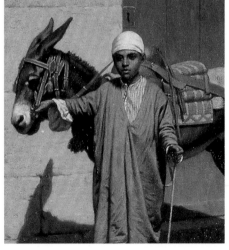

N-5

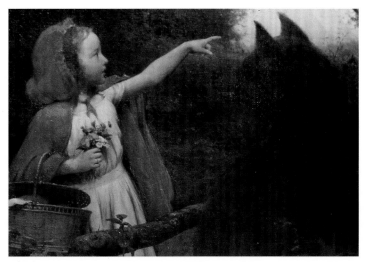

E/N-12

ACTIVITY! What kind of animal would you want to help you if you had chores to do? Look around the Art Gallery for a model or use your imagination and draw your helper. Share your drawing with your group and explain why you chose it.

USING IMAGINATION

Now turn around and walk toward the Art Gallery's entrance. On your left, look for a small painting by Seymour Joseph Guy of a girl with a large wolf (E/N-12) that hangs on the green column. Do you recognize the girl and wolf from a popular fairy tale? What part of the story could the painting illustrate? What could the girl be pointing to?

ACTIVITY! Think about your favorite story. If you were going to choose one scene from the story to illustrate it, as Guy has done in this painting, what would you choose? How would you draw it so that people could recognize what the story is? Tell the other people in your group about your idea, or draw it and then share your drawing with them.

There are a lot more paintings of children in the Art Gallery and in the Library. Find two more works to talk about with your group and think of a game of your own to play with each one. Have fun!

TOUR 3 · ‡

1876: Centennial Horizons

AFTER THE CIVIL WAR ENDED IN 1865, America entered an extended period of self-examination that culminated in the 1876 Centennial Exposition in Philadelphia. American artists increasingly looked both east, to Europe, and west, to the frontier, in search of new ideas and inspiration. Largely assembled in the midst of the Centennial era, the Athenæum's art collection bears witness to the preoccupations of the period. This tour highlights key works in the collection that illuminate that pivotal moment in America's cultural history. If you have trouble finding any of the works mentioned, use the location reference number (e.g., w-4) along with the alcove diagrams in the catalogue section of this handbook or ask a volunteer for help.

Americans were keenly aware of the western landscape's potential for economic exploitation, and artists offered audiences on the east coast innumerable portrayals of the vast western landscape to satisfy curiosity about its natural wonders. More than most of his peers, Albert Bierstadt provided a personal sense of the western landscape in his paintings. Trained in Europe, he brought the landscape aesthetic that he honed among the Italian Alps to America's Rockies. Bierstadt's monumental compositions, including *The Domes of the Yosemite* (1867, w-4), which dominates any visit to the Athenæum's Art Gallery, eloquently conveyed the incredible magnitude of the valley in a manner that audiences could experience for themselves. Viewers were effectively immersed in the scenery, filling their field of vision in a manner akin to the wide-screen televisions and movie theaters of today. Bierstadt sent paintings such as this one on tour to major cities, charging visitors admission for the opportunity to experience for themselves a landscape that very few of them would ever visit in person. In an era when black-and-white photography already offered viewers a direct transcription of nature, Bierstadt also offered glowing color and majestic scale. Try to imagine how it would feel if this were the very first time you saw a depiction of the Yosemite Valley.

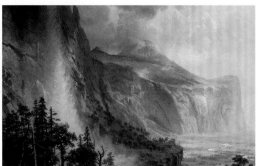

In a landmark address given in 1893, historian Frederick Jackson Turner discussed the cardinal significance of the frontier to American history and identity. "Up to our own day American history has been in a large degree the history of the colonization of the Great West," he observed. The western landscape not only

w-4

N-8

offered beautiful and breathtaking scenery, it also promised economic opportunity for Americans who found few such opportunities in the more densely populated and economically developed east. Samuel Colman's *Emigrant Train, Colorado* (1872, N-8), hanging in the alcove to your right as you face the Bierstadt, documents a westward-bound caravan of covered wagons. Colman's painting romanticizes the long journey to California, with a healthy herd of cattle, plentiful water, favorable weather, and even a woman and child. The latters' presence domesticates the scene. Colman's portrayal nevertheless retains a note of caution. Clouds gather over the distant mountains, the peaks of which are already covered in snow, suggesting that winter impends. Bravery and perseverance were considered the settlers' hallmarks, and Colman's composition accentuates the optimism of westward migration that lured Americans west throughout the later century. How do you think that Colman's painting would have reinforced east coast residents' sense of their national identity?

While Bierstadt helped to pioneer the Western landscape for American audiences, his younger colleagues increasingly followed his path in seeking professional training in Europe. More and more, however, they also chose to remain abroad as expatriates, rather than return to the United States. Among Europe's rural villages, in particular, artists such as Wordsworth Thompson found

S-5

inspiration in the persistence of folk traditions, in contrast to the rapid industrialization of urban areas. Whereas the American west offered a landscape ostensibly free of history, Europe's regional traditions provided a sense of stability in a changing world. Hanging just to the left of the door in the South Alcove, Thompson's *Waiting for the Steamboat at Menaggio, Lake Como* (1874, S-5) in northern Italy provides a detailed social panorama, as diverse as Bierstadt's landscape is grandiose. The different social classes dressed in an array of costumes mingle peaceably by the lake-side at the foot of the soaring Alps. The rich cultural history of Europe provides a remarkable counterpoint to the western United States, where Native American traditions were largely ignored by American artists. What similarities and differences do you see between Thompson's community of figures waiting for the steamboat and Colman's emigrants?

Worthington Whittredge's *On the Plains, Colorado* (1872, N-11), which hangs in the North Alcove almost directly opposite the Thompson, is, at least on its surface, an uncom-

TOURS

monly sensitive portrayal of Plains Indians. Like most Euro-American artists of the time, Whittredge had relatively little exposure to Native American culture, and depicted his subjects coexisting with the natural environment. Their encampment takes shelter in a tall stand of cottonwood trees along the Platte River. Although Whittredge made little effort to address the individuality of particular figures, he presents them as neither overtly threatening nor culturally backward. Compared with Colman's depiction of an emigrant train, there are remarkable thematic similarities, including communal interdependence and harmony with nature. Unlike the Colman, in which the site is merely a brief stopping point on a longer journey, or the Bierstadt, in which

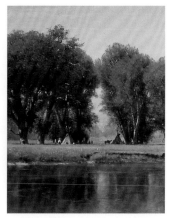

N-11

the site is unique for its incredible grandeur, Whittredge's composition treats the Colorado plain as an Edenic destination unto itself, as yet largely undisturbed by Euro-American settlements. More often, eastern audiences seem to have preferred identifiable and iconic views such as Bierstadt's, however. Not coincidentally, scenic tourism ascended to new heights during this period, and art viewers, like many tourists, derived reassurance from following recognizable, well-traveled paths. In the eyes of eastern viewers who had never visited the west, what role do you think Native Americans played in Whittredge's landscape?

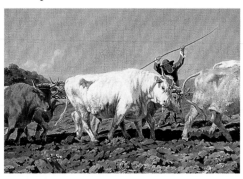

E/S-16

Another question that bears asking in nineteenth-century American art is whether the emigrants and Native Americans portrayed at the United States' western frontier resemble the European peasants who were fixtures in contemporary European and expatriate American art. Although the answer may vary from case to case, an illuminating example is offered by Thomas Waterman Wood's reproduction of Rosa Bonheur's celebrated *Plowing in the Nivernais* (undated, E/S-16), which continued to attract interest two decades after its completion in 1849. If you are facing the Whittredge, the painting hangs high on the wall diagonally behind you to your right. Bonheur painted the work as an homage to "the art of tracing the furrows from which comes the bread that nourishes humanity." The farmers guiding the giant teams are barely visible behind their muscular oxen. These are neither Colman's emigrants, nor Whittredge's Indians, but they bear resemblances to both. At peace with nature and the land they work, Bonheur's figures have elements in common with Whittredge's Indians. On the other hand, the farmers' control over their animals is

seemingly tenuous at best, comparable to the temporary respite of Colman's emigrants. Wood's admiration for the way Bonheur treated her figures may have derived from their combination of the attributes of natural harmony and human struggle with the forces of nature that animate Whittredge's and Colman's compositions respectively. How do you think the landscape itself in Bonheur's painting compares with that in Whittredge's and Colman's works?

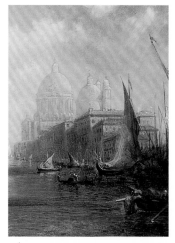

E/N-4

In the later nineteenth century, Europe's rich cultural history held considerable, vicarious interest for American artists. Very little was known or documented about America's history before modern times and the nation's cultural tradition was similarly brief. When artists such as Charles Loring Brown traveled abroad, therefore, they found great interest in landscapes that were significant to recorded history. Two works by Brown that hang in the Athenæum's Art Gallery are *On the Grand Canal, Venice* (1880, E/N-4) and *Bay of Naples* (1853/1873, S-7). The latter hangs above the door in the South Alcove and depicts the historic eruption of Italy's Mt. Vesuvius in 79 C.E. Brown's second work, which hangs to the right of the North Alcove, portrays the historic architecture of the Grand Canal in Venice. For American artists of the later nineteenth century, Venice wielded an almost magical allure. Its history and romance, evoked by Brown in the transcendent luminosity of the Renaissance Church of Santa Maria della Salute, were unlike anything in the United States and suggested an enduring link with the past. For American artists, historic European landscapes and cityscapes offered a form of exoticism. In contrast to America's own recent and violent history, Europe and the American west both offered havens from the realities of the United States during Reconstruction.

Take some time to look around the Art Gallery and think about other works in which the artists either contended with or sought refuge from the nation's recent history.

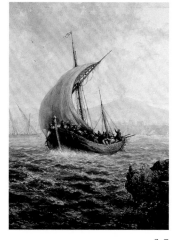

S-7

TOUR 4 · ☾

Personal Histories:
A Glimpse into Nineteenth-Century Life

AS THE ATHENÆUM'S FOUNDER, Horace Fairbanks brought together the works that formed the core of the institution's art collection, including a broad range of depictions of everyday life in different parts of the country. This tour pays particular attention to these works to provide a sense of the lives of nineteenth-century Americans. In this tour, you'll visit with local Vermonters discussing the day's news, travel to the heights of the Catskill Mountains with early tourists, and join westward migrants on their perilous trip to California in search of new opportunities. As distant as they are in time, you'll recognize aspects of modern life that have endured to the present day. If you have trouble finding any of the works mentioned, use the location reference number (e.g., E/N-5) along with the alcove diagrams in the catalogue section of this handbook or ask a volunteer for help.

Let's begin with George Cochran Lambdin's masterful *Girl Reading* (E/N-5), which hangs to your right as you enter the Art Gallery. Travel was a difficult, exhausting, and often dangerous activity during the nineteenth century. As a result, many Americans relied upon books to bring the world to them. Similarly, Fairbanks assembled the Athenæum's library and art collection to bring the world to St.

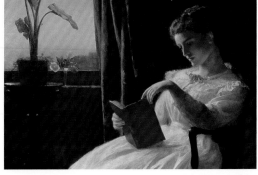

E/N-5

Johnsbury. In Lambdin's composition, an unlimited expanse of blue sky opens beyond the young woman's window. Light from the outside illuminates the woman's face as well as her book. The juxtaposition portrays the infinite opportunities that books provide. The mass production of books, particularly the introduction of dime novels during the 1860s, made reading an ever more accessible source of entertainment and escape. Based upon what you see in the painting, what type of book do you think the woman is reading?

Recreational travel to areas such as New York's Catskill Mountains, shown in Sanford Gifford's *View from South Mountain, in the Catskills* (S-9), hanging behind you and to your left, was also facilitated by the rise of the railroads. The Civil War precipitated the

development of complex rail networks throughout the northeast and midwest. Trains not only delivered raw materials to manufacturers and finished goods to market, but also carried passengers far and wide. Unlike travel by carriage, an arduous experience in an era before paved roads, the railroads made travel both more convenient and

S-9

more pleasant. Obeying strict schedules necessitated by the many trains traveling the same tracks, trains could be relied upon to bring passengers to and from their destinations in a timely manner. America experienced its first upsurge in tourism thanks to such advances in transportation. Attracted by the region's natural beauty, which had been celebrated in art by American painters since the 1820s, tourists who visited the Catskills could choose from among a group of large hotels that catered to the new industry. One of those hotels, the well-known Catskill Mountain House, was situated on a ledge just to the right of Gifford's view in this composition and is likely where the hikers shown in the foreground are staying. Gifford's painting is a veritable postcard of the hotel's majestic view. Why would collectors buy a painting that so closely approximates the view from a hotel window?

Technology also transformed local life in America's small towns during the mid-nineteenth century. With the introduction of the electromagnetic telegraph, news traveled almost instantly. No longer reliant upon mounted messengers to bring the news from afar, the distribution of newspapers and mail was also greatly enhanced by the railroads. To hear the news, however, local residents still came together at village post offices, as

S-4

depicted in Thomas Waterman Wood's *The Argument* (S-4), which hangs just behind you. This work is actually a later version of a much larger composition showing many more figures that Wood painted two years before, and titled *The Village Post Office*. In both paintings, the artist portrayed a group of identifiable Vermonters at the Ainsworth General Store in Williamstown, near Montpelier. The figures have an animated discussion of the day's news while warming themselves by the store's woodstove. This welcoming center of community life still remains intact in some New England communities, but has long since been replaced as a primary source of news and conversation.

A notable absence in the Athenæum's collection is a depiction of city life. In an era char-

TOURS

acterized by rapid urbanization, city
scenes were remarkably rare subjects in
art, so the Athenæum's collection is not
unusual. Instead, artists and their patrons
preferred romantic idealizations of rural
life such as J. G. Brown's endearing *Hiding
in the Old Oak* (w-6), which hangs just to
the right of Albert Bierstadt's vast *Domes of
the Yosemite* at the Art Gallery's west end.
Fairbanks not only exhibited such ideal-
ized visions in the Athenæum, however,
but he strove to mold the town of St.
Johnsbury similarly. Encouraging civic

w-6

engagement among the workers at his platform scale factory, St. Johnsbury's primary
industry, Fairbanks also became involved in town life himself, modeling the behavior that
he hoped his employees would practice. Brown's painting also illustrates Americans' dedi-
cation to their children during this period. Careful consideration was given in the forma-
tion of the Athenæum itself to allow for children's participation and enjoyment. As never
before in American culture, childhood development became a primary focus of national
attention, and that preoccupation was reflected in the art of the time. Why do you think
childhood became such a popular theme in the wake of the Civil War?

Idealizations of rural life were not confined to depictions of children, however. Jasper
Cropsey's expansive *Autumn on the Ramapo River—Erie Railway* (e/s-17), hanging around the
corner from Wood's *The Argument*, provides a sense of how urban audiences idealized the
simplicity and carefree qualities of life in the country. None of the works in the
Athenæum's collection were created for rural audiences. Wealthy and upper middle class
residents of America's major cities, particularly New York, formed the vast majority of the
nation's collectors. Cropsey's title, however, dispels any possibility that even this idealized
vision of rural life has escaped the influence of modernity. Like the distant train whistle

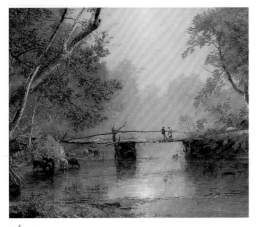

e/s-17

that interrupted Henry David
Thoreau's sojourn at Walden Pond
during the mid-1840s, the reference
to a railroad in Cropsey's title, and
not coincidentally a railroad that
intersected the Ramapo River, sug-
gests that this view may be one seen
from the window of a passing train.
If that is the case, then this view of
country romance is fleeting. Ideal-
izations of rural life abound in the
collection. How do you think nine-
teenth-century residents of St.
Johnsbury would have felt about
such generalizations?

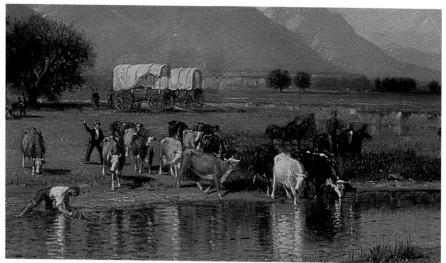

N-8

Although the completion of the transcontinental railroad was celebrated in 1869, it had relatively little immediate impact on average migrants. Samuel Colman's *Emigrant Train, Colorado* (N-8), hanging behind you to your right, was painted three years after the symbolic driving of the golden railroad spike at Promontory, Utah. The families, still traveling by covered wagon, graze their cattle and store water in anticipation of the difficult crossing of the Rocky Mountains, visible in the distance. Colman's composition reinforces the group's interdependence, as they travel together in convoy to help one another in times of trouble and cluster their wagons to protect against unseen threats. Although the sky is clear and sunny overhead, and this particular day has provided an opportunity to rest and prepare for the next part of their journey, storm clouds gather over the mountains' already snow-capped peaks. Nevertheless, the presence of a woman and child at the left-hand side of the composition shows that families are increasingly making their way westward, not just unwed men. Over two decades after the discovery of gold in California, what could make these families undertake the difficult journey?

Take a few minutes now to explore the Art Gallery and find other depictions of everyday life in nineteenth-century America. How do those works relate to the ones discussed in this tour?

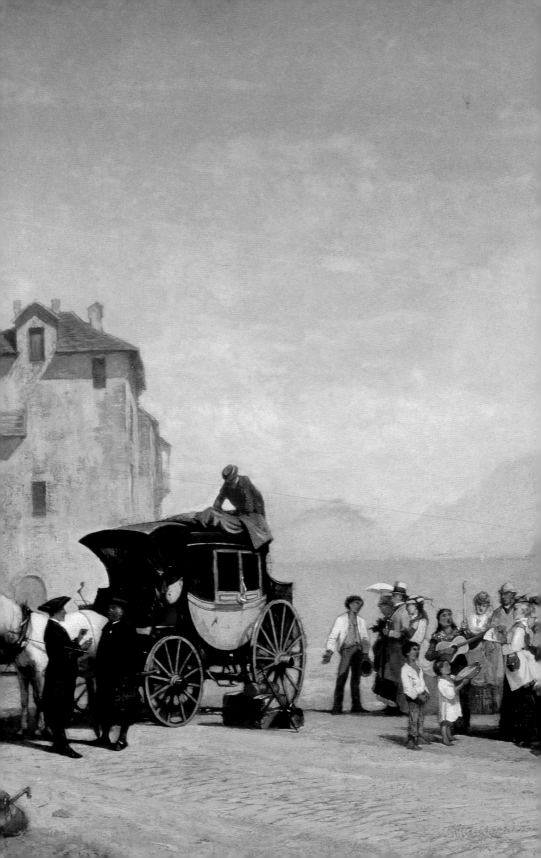

RESOURCES FOR
TEACHERS

INTRODUCTION

THIS SECTION IS DESIGNED to help teachers make the most of a class visit to the Athenæum's Art Gallery. Here, you will find the practical information to help you plan the visit, prepare your students and yourself for an enjoyable and enriching experience with art, and incorporate the visit into your curriculum.

Teaching directly from works of art is a unique experience. Informed by current museum education theory, this section provides guidelines for discussing art with your students in the gallery environment. The questions, activities, and themes outlined below prioritize the students' experience of observing and responding to art. *For that reason, emphasis is placed upon careful examination and student-centered discussion of a relatively limited number of works.* With the teacher as facilitator, students will explore the artworks collaboratively while building visual literacy and critical thinking skills. Discussion should be allowed to unfold naturally, rather than along a single, predetermined narrative track.

The information provided in this section is only a starting point. The ideas are purposely flexible and open, so that you can tailor them to your individual classroom needs. These resources are intended to be used in tandem with the information presented throughout the handbook's essay and catalogue.

PRACTICAL MATTERS

Scheduling Your Visit

Before visiting the Athenæum with your class, please call at least two to three weeks ahead to reserve a time. Reservations are on a first-come, first-served basis and may be made either by telephone at 802-748-8291 or through the Athenæum's website, http://www.stjathenaeum.org.

Arrival

Groups should be dropped off on Main Street in front of the Athenæum so that they may enter through the main door. Buses can park in the 10-minute parking spaces directly in front of the Athenæum building while unloading and then move to the municipal parking lot or farther up along Main Street to wait. Backpacks, coats, and boots may be left or hung on the racks just inside of the main entrance on the right-hand side.

Gallery Rules

Before entering the Art Gallery, please take a minute to review the rules with your class:

—*please don't touch the art, it is old and very fragile*

—*you should remain two feet away from the artworks at all times*

—*be aware of your surroundings so that you don't bump anything by accident*

—*be respectful of other Art Gallery and Library patrons by speaking softly*

—*only pencils are allowed; no pens or crayons*

—*write on the clipboards provided, not on the cabinets, shelves, or other surfaces*

—*no food, drinks, or gum*

—*no cameras or backpacks*

—*share your ideas about what you see when called upon by your teacher*

Group Size & Chaperones

The maximum number of people (students and chaperones) permitted in a group is twenty-five. Please have at least one teacher or chaperone for every ten students.

Suggested Tour Length

Plan to be in the Gallery approximately one hour, and allow extra time on either end for bathroom visits, coats, and other logistics.

Accessibility

The Athenæum is wheelchair accessible by elevator. An entrance ramp is located on the North side of the building by the parking lot.

Bathrooms

Public bathrooms are located on the basement level, which is accessed by the elevator off the main circulation room. There is also a single restroom located in the Children's Room, which is adjacent to the Art Gallery.

Lunch/Snack

Food and drink are not permitted in the Athenæum. In good weather, the Athenæum's backyard or neighboring Courthouse Park may be used for group picnics. Arnold Park, a short walk north on Main Street, is another outdoor option. Several restaurants are also located nearby. Please call or e-mail the Athenæum for recommendations appropriate for your group.

STRUCTURING YOUR CLASS VISIT

THERE ARE MANY POSSIBLE FORMATS for leading a successful class visit to the Athenæum's Art Gallery. The following framework is a suggestion for making the most use of your time with us, but can be adjusted to suit the needs of individual classes.

Exploring (5 minutes)

It is important to allow the students a few minutes to explore the art on their own before beginning discussion. It gives them a chance to spend time with a few works that call out to them and satisfy their need to discover this new space. Exploring is particularly beneficial as an introductory activity. You can also assign a goal, such as identifying a

favorite work or something that relates to the theme of your visit. Please remind students not to touch the art.

Orientation (5 minutes)

Ask the students if any of them have been to the Athenæum or to any other place like it before. "What is here?" "Why is it here?" Try to draw out the fact that the Athenæum is both a public library and art gallery. Convey that the Athenæum was a gift from Vermont Governor Horace Fairbanks; the Library opened in 1871, and the Gallery was added in 1873. Fairbanks hoped that the combined Library and Art Gallery would educate and inspire the people of St. Johnsbury and the surrounding area.

Looking (10 minutes, at intervals of 1–2 minutes)

Before starting discussion about any work of art, allow students to look at it carefully for a minute or two and begin to think about it on their own in silence. (Teachers and chaperones should participate too.)

Discussion (30 minutes)

Using the guiding questions listed below, along with some of your own questions suited to your group's goals, you will serve as the facilitator of your students' discussion. The main goal of the visit is to allow the students to respond to the works of art, not to hear you lecture about them. The focus should be on the students and their observations. As facilitator, it is your job to draw out ideas, connect observations, and encourage students to build on each other's ideas. As a general rule of thumb, you should be talking 20% of the time, and the students should be talking 80% of the time.

Sketching/Writing (10 minutes)

Each visit should incorporate a written response to the visual experience, whether it be writing or drawing. There are a few sample activities suggested in this section, but feel free to come up with other activities that suit your group's needs. The activity can come at any point during the course of your visit, not necessarily at the end. Allow time for the students to share their creations as well.

GUIDING QUESTIONS

THE FOLLOWING QUESTIONS can be used in conjunction with content-related questions and discussion. They are designed to stimulate thoughtful responses to the visual material from all members of the group. As the students respond to these questions, affirm each answer equally, link the ideas that are shared, and paraphrase their answers as an affirmation tool.

Please note: Recent research in museum education practice discourages beginning discussion by telling students the name of the work, the artist, and/or the year in which the work was created. This information narrows students' thinking, rather than opening it up, which is our objective. Leave the interpretation to the students. As facilitator, you should allow the students to explore the works together by sharing their ideas with one another. Factual information can be introduced to the discussion as needed and when appropriate to the natural flow of the conversation.

What's going on in this picture/sculpture?
This question opens the discussion and implies that there is a narrative to be found here. It discourages listing, and instead encourages students to offer descriptions and more elaborate ideas. The question draws upon the human instinct to tell stories.

What do you see that makes you say that?
This question, always used as an immediate follow-up to the first, draws the students' attention back to the image itself and encourages them to provide evidential reasoning to back up their observation.

What more can we find?
This question asks the students to look for more and implies that the looking exercise is not over. It can also serve to redirect the students if they are stuck on one particular issue or problem.

These questions are taken directly from Visual Thinking Strategies, a curriculum that uses art to teach thinking, communication skills, and visual literacy, that was created by Philip Yenawine, former director of education at the Museum of Modern Art in New York, and Abigail Housen, a developmental psychologist. They are co-founding directors of Visual Understanding in Education. (For more information, visit their website listed in the On-Line Resources section below.)

SAMPLE UNIT: COMMUNITIES AND CULTURES

Objectives
• In this lesson, students will analyze, interpret, and respond to art by identifying and discussing different kinds of communities including families, towns, friends, and tribes.
• Students will use direct observation of works of art to determine the relationships among members of a community and their interdependency.
• Using critical thinking skills, students will discuss the importance of community in each time and place depicted.

Learning Standards
VT Grade Cluster/Level Expectations: A12–14, 16, 18, 19, 21; H&SS1, 2, 4–10, 12, 13, 16, 18; W1, 5–10, 15–17
NH Curriculum Frameworks: Visual Arts 2, 4–6; Social Studies (Revised) 1.1–1.10, 2.1–2.3, 5.2, 5.4, 5.5, 6.1–6.3, 6.5–7, 7.1–3, 7.5; English Language Arts 2, 3, 5–7

Artworks for Discussion
• Wordsworth Thompson, *Waiting for the Steamboat* (1874, s-5)
• Samuel Colman, *The Emigrant Train, Colorado* (1872, n-8)
• Worthington Whittredge, *On the Plains, Colorado* (1872, n-11)
• John G. Brown, *Hiding in the Old Oak* (1873, w-6)
• After Anthony van Dyke, *The Children of Charles I* (undated, w-2)
• Thomas Waterman Wood, *The Argument* (1874, s-4)

Diagram

The following compositional elements and discussion questions are a sample of possible avenues for discussion. The questions are open-ended to encourage students to explore multiple interpretations of a single work of art.

Clouds
Cumulus clouds hover over the mountains. Do you think they are ominous or serene? What might they suggest about the emigrants' future?

Mountains
The distant mountain range could symbolize challenge and adversity for the California-bound emigrants. What else could it represent?

Plains & Sky
In Colman's composition, the vast areas of sky and earth parallel each other. What mood do you think this open landscape evokes?

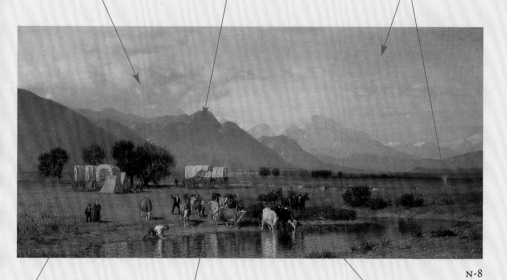

N-8

Wagons
The closely grouped wagons suggest both a tightly-knit community and the need for mutual protection. What more can they tell us about these people?

Cattle
Cows provided sources of both food and transportation. How do the people and cattle interact with each other? What might that tell you about their relationship?

Water
Drinking water was a critical resource for survival on the frontier. How does Colman suggest its importance?

Grades	Pre-Visit Activities	Gallery Activities
K–5	Talk about how your class is composed of many different communities. Have students organize themselves into groups based upon different shared traits, e.g., place of birth or favorite sport. Discuss what communities lived on the American frontier in the nineteenth century, esp. Euro- and Native American. What did the communities do differently and what did they do alike? How did they interact? Brainstorm likenesses and differences.	Ask the students to act out the roles of different figures in Samuel Colman's *The Emigrant Train, Colorado* (N-8) and Worthington Whittredge's *On the Plains, Colorado* (N-11). Encourage them to talk about what they are doing and how they contribute to the community portrayed. Encourage the students to think about the painting as a page in a storybook. Have them write down what the story is about, give the book a title, and/or draw other illustrations for it.
6–8	Ask the students to look at the local newspaper for photographs of different communities in their area. Have them choose one, read the related article, and then present what the community is and what brought them together. Have the students identify a historic community related to the curriculum and discuss that community's shared attributes.	Ask the students to write a short story from the perspective of one of the figures in one of the Artworks for Discussion. What is their figure thinking about? What kind of a day are they having? This activity may be most effective using a more complex scene, such as Samuel Colman's *The Emigrant Train, Colorado* (N-8) or Worthington Whittredge's *On the Plains, Colorado* (N-11).
9–12	Divide the class into groups and assign each group a relevant entry from this Handbook to read. Ask them to select an aspect of their work about which they would like to learn more, and then have them conduct further research on that topic. Have the students develop questions about their works that they will use to lead discussion in the Gallery.	Have the students look carefully at the works that they studied before their visit. Ask them what surprises them about the work in person and what they did not notice about it from the reproduction alone. Ask them to draw or describe the thing that most surprised them. Invite the students to imagine that they are Horace Fairbanks and to describe why they selected this particular work for the Athenæum's collection. What does it contribute to the array of works on display? How does the St. Johnsbury community benefit from the inclusion of their particular work?

| --- | --- |
| What might bring this group of people together?

How do you think these people help each other?

What kind of community are they?

Why might it be important for these people to be able to depend on each other?

What could the people in the picture be talking about? What do you see that makes you say that? | Students choose an aspect of their school community to document in photographs. After assembling their images, they can discuss them in class. Together, they can explore what the visual clues in the images are that detail and reveal life in that community (i.e., toys, seasonal clothes, weather, landmarks, etc.). Finally, students can combine the words and photographs together into a composite image of their community. |
| What do you see in this painting that tells you that the artist is depicting a community?

How has the artist shown the figures interacting with one another? | Have the students expand upon the stories that they wrote in the Gallery and add illustrations of their own. |
| How has this artist depicted a sense of community in this work? What do you see that makes you say that?

Think about the work's cultural and historical context, be it modern Italy, frontier America, nineteenth-century Vermont, or another place and time. What might that tell us about this particular community?

If you were to paint a picture of your community, what would you include? | Let the students create their own art collections. Ask them to pretend that they are the governors of Vermont and want to give their community a collection of art. What kind of art would each of them want to give to their community and why? They can visit different museums' websites (the Metropolitan Museum of Art's and National Gallery of Art's sites are great places to start) and select about ten works to use for their collections. Each student can then explain why they chose particular works. |

OTHER SUGGESTED UNITS

For more information and background on the works listed in these units, please read the individual entries in the catalogue section. The sample questions should be used in conjunction with the Guiding Questions described above.

Title & Description	Works for Discussion	Sample Questions
The Rise of American Landscape Painting a survey of major artists and ideas of early American landscape art	Sanford R. Gifford, *The View from South Mountain, in the Catskills* (1873, s-9) Albert Bierstadt, *The Domes of the Yosemite* (1867, w-4) Worthington Whittredge, *On the Plains, Colorado* (1872, n-11) Asher B. Durand, *Landscape with Rocks* (1859, n-14) Jasper F. Cropsey, *Autumn on the Ramapo River—Erie Railway* (1876, e/s-17)	What do you think each artist is celebrating about the American landscape in their paintings? How can you tell? Describe some distinctively American traits of each location. (Rugged, bountiful, colorful, vast?)
Westward Expansion explore issues of Manifest Destiny and life on the frontier	Albert Bierstadt, *The Domes of the Yosemite* (1867, w-4) Samuel Colman, *The Emigrant Train, Colorado* (1872, n-8) Worthington Whittredge, *On the Plains, Colorado* (1872, n-11) Jasper F. Cropsey, *Autumn on the Ramapo River—Erie Railway* (1876, e/s-17)	How do these artists portray westward expansion? If you had never visited the west, what would you learn from these paintings? How do the artists depict the hopes and fears of people on the frontier?

Title & Description	Works for Discussion	Sample Questions
Ancient Rome revisit life in ancient times	George Loring Brown, *Bay of Naples* (1853/1873, s-7) Unknown artist, *Diana of Gabii* (undated copy, w-1) Unknown artist, *Roman Forum* (undated, n-15) Luigi Bazzani, *Pompeian Interior* (1875, e/n-6) Pierre Olivier Joseph Coomans, *Aspasia* (1872, e/n-9) Pierre Olivier Joseph Coomans, *Roman Women* (undated, Reading Room)	How do these artists depict life in ancient times? Why do you think nineteenth-century Americans would want to collect such scenes? Do you think that these are accurate representations of life in ancient Rome? Why or why not?
The Elements of Art master the vocabulary and principles of painting and sculpture	Emilie Preyer, *Fruit and Wine* (undated, s-1) Sanford R. Gifford, *The View from South Mountain, in the Catskills* (1873, s-9) Albert Bierstadt, *The Domes of the Yosemite* (1867, w-4) Chauncey Bradley Ives, *Pandora* (1875, w-12) George Cochran Lambdin, *Girl Reading* (1872, e/n-5)	How do the artists create a sense of space/volume using modeling, light and shadow, perspective, and scale in their works? How does the artist use color, shape, line, and texture to evoke a certain mood or feeling?
The Four Seasons in Art discuss how artists paint the seasons and their symbolism	James M. Hart, *Under the Elms* (1872, s-6) Jervis McEntee, *The Woods of Asshockan, Catskills* (1871, n-10) Thomas Waterman Wood after Rosa Bonheur, *Plowing in the Nivernais* (undated copy, e/s-16) Jasper F. Cropsey, *Autumn on the Ramapo River—Erie Railway* (1876, e/s-17)	How can you tell what season is depicted in these works of art? As you walk around the Art Gallery, find and discuss other visual clues that indicate particular seasons. How do artists use certain seasons to convey mood? (Hopeful, nostalgic, carefree?)

ON-LINE RESOURCES

Visual Understanding in Education http://www.vue.org

This website introduces the Visual Thinking Strategies curriculum, which uses a learner-centered method to examine and find meaning in visual art. Employed by many museum educators and classroom teachers around the world, it effectively uses art to teach critical thinking, communication skills, and visual literacy.

Harvard University Project Zero http://pzweb.harvard.edu

Founded in 1967, Project Zero's stated mission is to help create communities of reflective, independent learners; to enhance deep understanding within disciplines; and to promote critical and creative thinking. The website offers an array of information and resources, including links to their innovative programs and partnerships, such as Project MUSE (Museums Uniting with Schools in Education).

Getty Foundation ArtsEdNet http://www.getty.edu/education

The Los Angeles-based Getty Foundation offers a number of useful resources for teachers through its website, including lesson plans, a teachers' listserv, a discussion of the basic elements of art, and a template for building your own lessons at different grade levels.

Smithsonian Institution http://www.si.edu

The Smithsonian's website offers informational and pedagogical tools for the teaching of American history and art. The Smithsonian American Art Museum and National Portrait Gallery, accessible through the main website, are particularly appropriate resources for learning more about America's artistic and cultural heritage. Another Smithsonian division, the Archives of American Art, offers on-line primary research options that will be expanded in the coming years.

FURTHER READING

The following list of selected sources is intended to offer the reader suggestions for additional study of the topics explored in this handbook.

St. Johnsbury History

Fairbanks, Edward T. *The Town of St Johnsbury VT: A Review of One Hundred Twenty-Five Years to the Anniversary Pageant 1912*. St. Johnsbury, Vt.: The Cowles Press, 1914.

Start, Edwin A. "A Model New England Village." *New England Magazine* 3 (1891): 701–718.

Yale, Allan. "Sleepers Awake! The Industrial Revolution Comes to Antebellum St. Johnsbury." *Vermont History, The Proceedings of the Vermont Historical Society* 69 suppl. (Winter 2001): 116–121.

The Centennial Era

Fahs, Alice, and Joan Waugh, eds. *The Memory of the Civil War in American Culture*. Chapel Hill: University of North Carolina Press, 2004.

Foner, Eric. *Reconstruction: America's Unfinished Revolution, 1863–1877*. New York: Harper & Row, 1988.

Giberti, Bruno. *Designing the Centennial: A History of the 1876 International Exhibition in Philadelphia*. Lexington: University Press of Kentucky, 2002.

American Architecture

Jackson, John B. *American Space: The Centennial Years, 1865–1876*. New York: Norton, 1972.

Roth, Leland M. *A Concise History of American Architecture*. New York: Harper & Row, 1979.

Nineteenth-Century American Art

Craven, Wayne. *American Art: History and Culture*. Madison, Wis.: Brown & Benchmark Publishers, 1994.

Groseclose, Barbara. *Nineteenth-Century American Art*. Oxford, England and New York: Oxford University Press, 2000.

Howat, John K., ed. *American Paradise: The World of the Hudson River School*. Exh. Cat. New York: Metropolitan Museum of Art, 1987.

Novak, Barbara. *American Painting of the Nineteenth Century: Realism, Idealism, and the American Experience*. New York: Praeger, 1969.

Truettner, William H., ed. *The West as America: Reinterpreting Images of the Frontier, 1820–1920*. Exh. Cat. Washington, D.C.: Smithsonian Institution Press, 1991.

Wilmerding, John, ed. *American Light: The Luminist Movement, 1850–1875*. Exh. Cat. Washington, D.C.: National Gallery of Art; New York: Harper & Row, 1980.

Nineteenth-Century European Art

Eisenman, Stephen F., et al. *Nineteenth-Century Art: A Critical History.* New York: Thames & Hudson, 1994.

Rosenblum, Robert, and H. W. Janson. *19th-Century Art.* New York: Abrams, 1984.

Renaissance and Baroque Art

Paoletti, John T., and Gary M. Radke. *Art in Renaissance Italy.* New York: Harry N. Abrams, 1997.

Snyder, James. *Northern Renaissance Art: Painting, Sculpture, the Graphic Arts from 1350 to 1575.* Rev. ed., Larry Silver, Henry Luttikhuizen. Upper Saddle River, N.J.: Prentice Hall, 2005.

Greek and Roman Sculpture (and Copies)

Haskell, Francis, and Nicholas Penny. *Taste and the Antique: The Lure of Classical Sculpture, 1500–1900.* New Haven, Conn.: Yale University Press, 1981.

Kleiner, Diana. *Roman Sculpture.* New Haven, Conn.: Yale University Press, 1992.

Pollitt, Jerome Jordan. *Art and Experience in Classical Greece.* Cambridge, England: Cambridge University Press, 1972.

INDEX

All photography by Robert C. Jenks,
Jenks Studio of Photography, St. Johnsbury, Vermont except as follows.

Additional photography by Jeffrey Nintzel: alcoves pp. 34, 35, 46, 47, 58, 59, 68, 69, 80, 81, and entries w-10, e/n-3, e/n-17, e/s-2, e/s-4, e/s-5, e/s-8, e/s-9, Chaplin (p. 98), Ziem (p. 101), Gonzalez (p. 103), Creifelds (p. 104), Lerolle (p. 108), and Ward (p. 111).

PRINTED AT THE STINEHOUR PRESS
IN THE NORTHEAST KINGDOM OF VERMONT

DESIGN BY PAUL HOFFMANN

CRIME SCENE

True-Life Forensic Files

Copyright © 2008 by Scholastic Inc.

All rights reserved. Published by Scholastic Inc., *Publishers since 1920.*
SCHOLASTIC and associated logos are trademarks and/or registered trademarks
of Scholastic Inc.

No part of this publication may be reproduced, stored in a retrieval system, or
transmitted in any form or by any means, electronic, mechanical, photocopying,
recording, or otherwise, without written permission of the publisher. For information
regarding permission, write to Scholastic Inc., Attention: Permissions Department,
557 Broadway, New York, NY 10012.

The material in this book originally appeared in the following titles in the Scholastic
series **24/7: Science Behind the Scenes/Forensic Files:** *Dusted and Busted: The
Science of Fingerprinting and Guilty by a Hair: Real-Life DNA Matches!*

Library of Congress Cataloging-in-Publication Data available

ISBN-13: 978-0-545-08842-8
ISBN-10: 0-545-08842-9

10 9 8 7 6 5 4 3 2 1 08 09 10 11 12

Interior design by Red Herring Design/NYC
Additional design by Kay Petronio

Printed in the U.S.A. 23
First printing, September 2008

CRIME SCENE

True-Life Forensic Files

DUSTING
AND DNA

By D. B. Beres and Anna Prokos

CONTENTS

In Chattanooga, a thief robs a local drugstore.

These cases are 100% real. Find out how fingerprint analysts solved a handful of mysteries.

17 Case #1:
The Burglar with No Prints

A burglar robs a store and appears to leave no prints behind. How does the fingerprint expert make the ID?

27 Case #2:
The Duffel Bag Murder

A gruesome crime has been committed. Can fingerprint evidence help nail the criminal?

Hikers in Tennessee get an awful shock.

In Paris, TN, a thief makes a major misstep.

37 Case #3:
The Barefoot Bandit

Can a burglar be identified from his footprint?

5

FORENSIC DOWNLOAD

← Here's even more amazing stuff about fingerprinting—right here at your fingertips.

FORENSIC 411

← Get the 411 on DNA, and find out how investigators use it to solve crimes.

DNA on a burger solves a crime in Suffolk, VA.

These stories are 100% real. Find out how investigators have used DNA to solve mysteries that seemed 100% impossible.

67
Case #4:
The Case of the Hungry Burglars

Three men eat a hamburger just before they rob a fast-food restaurant. Will the burger bite them back?

77
Case #5:
A Hair of Evidence

A woman disappears. Can a few cat hairs help solve the mystery?

Cat hair holds the key to a murder in Canada.

87
Case #6:
A Second Look at the Evidence

A man goes to jail for shooting a policeman. But did the police get the right man?

Will DNA evidence free a prisoner in Boston, MA?

FORENSIC
DOWNLOAD

DNA is in almost every cell of your body. And information about it is on every page of this section.

YELLOW PAGES

You probably already know that your fingerprints are unique. That's what makes them a great method of identification.

FORENSIC 411

Say there's been a robbery. Police arrive on the scene. One of the first things they'll do is search for fingerprints. If the thief has left a fingerprint, that could lead to a quick arrest.

In this section:

- ▶ how fingerprint analysts REALLY TALK;
- ▶ how good you are at MATCHING FINGERPRINTS;
- ▶ who usually shows up to process CRIME SCENES.

Dusted and Busted

Stop! Before you get your prints all over this book, learn the vocabulary of fingerprint analysts.

"Look, I know you think of me as just a fingerprint specialist. But I prefer to call myself an expert in dactylography."

"Dactylo" means "having to do with fingers or toes." "Graphy" means "the study of."

specialist
(SPEH-shul-ist) someone who knows a lot about something.

dactylography
(dac-ti-LOG-rah-fee) the study of fingerprints as a method of identification.

"Check out the ridges in these fingerprints. They form a pattern that looks like a little tornado!"

ridges
(RI-jez) raised lines on the tips of your fingers that create your fingerprint. The area between the ridges is called a groove.

fingerprints
(FIN-ger-prints) the pattern of skin ridges at the tips of your fingers. These patterns include arches, loops, and whorls.

"Nope, the fingerprints don't match. We're going to have to let the suspect go."

10

"I want someone to dust the whole car! There must be *some* latent prints in there!"

latent prints
(LAY-tuhnt prints) fingerprints or footprints that you can't see. When people touch stuff, the oils on their skin leave a mark. That means that every time you touch a hard, shiny surface, you're leaving an invisible fingerprint!

"I'm sure we didn't miss a spot, sir. We dusted for prints everywhere."

dusted
(DUS-ted) brushed a dark fingerprint powder on a surface as you're looking for latent prints. The dust sticks to the sweat and oils in the latent prints. That makes invisible prints visible!

Say What?

Here's other lingo fingerprint specialists might use on the job.

prints
(prints) short for *fingerprints*.

"We found **prints** all over the soda bottle."

busted
(BUS-tid) caught; found out.

"We **busted** that crook!"

partial
(PAR-shul) part of a fingerprint. It's short for *partial fingerprint*.

"Hey, did anyone notice this **partial** on the door?"

perp
(purp) a person who has committed a crime. It's short for *perpetrator*.

"The **perp** is now in jail."

process
(PRAH-ses) to gather information (such as fingerprint evidence) at a crime scene.

"Get some experts to **process** the scene!"

Instructions: Look at each partial fingerprint on the left. Then choose the matching fingerprint from the four to the right.

5

10

15

20

25

Evidence at Hand

You leave a mark almost everywhere you go.

Take a look at the ends of your fingers. You'll see small ridges made of skin. The ridges have a purpose. They help you get a better grip on stuff you pick up.

These ridges form patterns called fingerprints. Your fingerprints were formed even before you were born. They never change. And no one has fingerprints just like yours. That's why fingerprinting is such a good way of **identifying** someone.

There are several kinds of fingerprints. Here are the terms the specialists use.

▶ **LATENT PRINTS**: They're formed when you touch something and the oil or sweat on your hand leaves a print. Latent prints are mostly invisible to the naked eye. Fingerprinting dust makes them visible.

▶ **PATENT PRINTS**: These are clearly visible. They're made when you touch something like paint or blood and then touch other surfaces.

▶ **IMPRESSED PRINTS**: These are made when you touch something like gum that leaves a clear impression of your prints.

▶ **PARTIAL PRINTS**: Partials are incomplete prints.

Answers: 1 & 4, 6 & 9, 11 & 12, 16 & 19, 21 & 24

The Forensic Team

Fingerprint specialists work as part of a team to help solve crimes and identify victims.

Forensic DNA Specialists

They collect DNA from blood or body fluids left at the scene. Then they use this evidence to identify victims and suspects.

Crime Scene Investigators

They study the scene of a crime and process evidence. They often have to speak in court about what they found.

DETECTIVES OR AGENTS

They direct the crime investigation. They collect information about the crime, interview witnesses, identify suspects—and arrest them if there's enough evidence!

Trace Evidence Specialists

They collect trace evidence at the scene. That includes fibers, tire tracks, shoe prints, and more. Can this evidence lead them to a criminal?

Fingerprint Specialists

They find, photograph, and collect fingerprints at the scene. Then they compare them to prints they have on record.

Medical Examiners

They're medical doctors who investigate suspicious deaths. They try to find out when and how someone died. They often direct other members of the team.

14

TRUE-LIFE CASE FILES!

24 hours a day, 7 days
a week, 365 days a year,
fingerprint specialists
are solving mysteries.

In this section:

▶ how police caught a thief who
seemed to have NO PRINTS;

▶ how fingerprints on PLASTIC
solved a murder;

▶ why a burglar's BARE FEET
led to his arrest.

Note: These case files are true.
However, names, places, and
other details have been changed.
In addition, the photos in these
stories are to give you a picture
of what happened. They are not
from these crimes.

24/7 Science Behind the Scenes

the Scenes

Here's how fingerprint analysts get the job done.

What does it take to solve a crime? Good fingerprint analysts don't just make guesses. They're like scientists. They follow a step-by-step process.

As you read the case studies, you can follow along with them. Keep an eye out for the icons below. They'll clue you in to each step along the way.

THE QUESTION
At the beginning of a case, fingerprint analysts **identify one or two main questions** they have to answer.

THE EVIDENCE
The next step is to **gather and analyze evidence**. Fingerprint analysts collect as much information as they can. Then they study it to figure out what it means.

THE CONCLUSION
When they've studied all the data, fingerprint analysts **come to a conclusion**. Where are the fingerprints? And who left them? If they can answer those questions, they may have cracked the case.

The Burglar with No Prints

Chattanooga, Tennessee
October 15, 2005, 9:15 A.M.

A burglar robs a store and appears to leave no prints behind. How does the fingerprint expert make the ID?

Escape Artist

A thief drops in on a drugstore and leaves the scene without a trace.

Bob Moranes had a terrible surprise when he arrived at work on October 15.

Mr. Moranes was the owner of Gooch Pharmacy near Chattanooga, Tennessee. That morning, when he walked to the back of his drugstore, his heart jumped. Everything was a mess. Items from the shelves lay on the floor. Bottles were missing. The cash register was open—and empty.

Moranes called the police. As he waited for them to arrive, he went through the mess. A lot of medicine was missing.

Then he checked to see how the burglar had entered the store. The back door and the windows were locked from the inside. How had the burglar gotten in? And where had he or she gone?

When the owner of Gooch Pharmacy arrived, his drugstore was a mess.

One fall morning, the owner of a drugstore in Chattanooga, Tennessee, had a terrible shock. His store had been robbed. Would the police be able to find the thief?

Scoping the Scene

Investigators look for clues to the thief's escape.

Soon the police arrived. They wanted to figure out how the thief had gotten inside.

They found a clue in a back office. The cover to a heating **duct** in the ceiling had been removed. Ducts are the passages that allow air to move around in a building.

That's not all. In the office, a desk had been moved directly under the opening to the duct.

Where did that duct lead? The police traced it to the heating system on the roof. They found an opening next to it.

After the burglary, investigators dusted drawers and other surfaces for prints.

Now the police had a theory about how the burglar entered and left the store. He climbed into the opening on the roof. He crawled through the ducts. Then he kicked out the duct cover and dropped to the floor.

When the burglar was ready to leave, he dragged the desk across the floor. He placed it under the hole in the ceiling. He climbed onto the desk and then pulled himself through the hole.

 But who was this guy?

THE MAN WITH NO FINGERPRINTS

This guy was really determined not to leave any prints behind.

Robert James Pitts had a long history of arrests. He was tired of getting caught. In 1941 he thought of a plan. He hoped it would keep him out of jail forever.

Pitts found a doctor who was willing to perform a strange operation. The doctor removed the top layers of skin on Pitts's fingertips. Then he tried to replace it with skin from Pitts's chest.

This plan was only partly successful. Pitts didn't have any fingerprints. But the skin from his chest didn't grow on his fingertips. Pitts was left with thick scar tissue on his fingers. He had no ridges or sense of touch. And the operation didn't keep Pitts out of jail, either. About a year later, he was arrested. Police were surprised to find that their suspect had no fingerprints.

But they took prints of the middle sections of each of his fingers. They compared the prints to files from the **FBI**, and Pitts was identified.

A suspect is arrested. Even without fingerprints, that's the situation Robert James Pitts found himself in many times.

21

The Search for Clues

Investigators find no prints inside—but what about outside?

The fingerprint team arrived at the store to process the scene.

Burglars often leave prints where they enter and exit a crime scene. The investigators knew how the burglar broke into the store. So that's where the print team started. They dusted the heating system and the duct cover.

But they didn't find any prints.

They dusted the cash register. No prints.

They dusted all the boxes and bottles of medicine that were out of place. No prints.

The only clue was a few pieces of black tape. An officer had been sent to figure out how the burglar had gotten off the roof. The officer found a ladder in the back of the building.

Next to the ladder, the officer found several pieces of black tape. He picked one up and noticed a print pressed into the sticky stuff on the tape. He carefully bagged the tape as **evidence**. He sent it to the crime lab.

Would the tape help the police catch the burglar? Or would this be another dead end?

EVIDENCE

One police officer found some clues outside the drugstore. There were seven or eight wads of black tape like this one.

DON'T FORGET TO DUST

How do fingerprint analysts collect and analyze the evidence?

Photographing the Scene

Fingerprint **analysts** first make sure the crime scene has been photographed. That way, there's a record of what the scene looked like right after the crime.

Dusting for Prints

Then the specialists start to process the scene.

▶ They use a dark powder that sticks to the oil and sweat in fingerprints. That makes the fingerprints more visible.
▶ They dust anything the perp might have touched—like doors, walls, counters, and furniture.
▶ They take small stuff like weapons or tools back to the lab. They'll check those for prints, too.

Lifting the Prints

▶ When specialists find a print, they use something sticky, like tape, to **lift** the print. They may also photograph the print to scan into the computer.
▶ They stick the tape to a card and write down where and when it was lifted.
▶ Back at the lab, fingerprint specialists process all the small items for prints.

Finding a Perp

▶ If they find a good print, fingerprint specialists compare it to prints from **suspects**.
▶ Or print specialists may run the print through **AFIS**. That's a computer **database** with millions of prints.

For more about AFIS, go to page 25.

Analysts dust fingerprint powder on a counter to reveal a fingerprint.

CASE #1: THE BURGLAR WITH NO PRINTS

A Trace of Evidence

Can a few pieces of tape help catch a criminal?

Back at the crime lab, fingerprint specialist Oakley McKinney examined the bits of tape. "There were seven or eight pieces of tape," he says. "Some were wadded up or smashed. But I found three pieces with clear finger-prints."

McKinney focused on the three pieces with clear prints. He placed them on a table and put bright light on them. Then he photographed the tape. He examined the photos with a magnifying glass. Bingo! McKinney found a print. "I was pretty excited," says McKinney. "Especially since there were no other prints at the scene. This could be the evidence the police needed to make an arrest."

McKinney scanned the photos of the fingerprints into the AFIS computer system. Would AFIS give the police a lucky break?

Oakley McKinney is a fingerprint specialist. He managed to find two clear fingerprints on the black tape left at the crime scene.

FINGERPRINTS GO DIGITAL

A computer database called AFIS makes fingerprint searches faster and more thorough.

Say you're a fingerprint specialist. You go to a crime scene and manage to find some great fingerprints. You lift the prints. Then you go back to the police station. There, you have to look through thousands of prints to find a match.

Wouldn't it be great if there were an easier way?

In fact, there is. It's called AFIS. That stands for *Automated Fingerprint Identification System.* (Print specialists say it like a name—AY-fiss.)

A Database of Fingerprints

AFIS is a computer database where police can store the prints of arrested suspects. Fingerprint specialists can enter prints they've found at crime scenes into AFIS. The computer then does a search. If it finds a match, the specialist checks to make sure AFIS is right.

In 1999, the FBI made this system even more efficient. It created IAFIS. The "I" stands for *integrated*, which means "joined together." IAFIS has joined together AFIS systems from all over the country. Now fingerprint specialists can compare prints they find to millions of prints from all over the U.S.

A computer screen with the results of an AFIS search.

25

Trapped by the Tape!

Police ID the suspect. But can they find him?

AFIS compared the prints McKinney had found to millions of prints on file. It came up with a match. McKinney double-checked the computer's results. It was a **hit**! "The suspect's name was Jeffrey Snyder," says McKinney. "He lived north of town. He had a prior arrest for burglary."

The police went to Snyder's home. And Snyder tried to make another sneaky escape—out the back window! Officers tackled him in his backyard. Inside Snyder's house, they found some of the medicines from Gooch Pharmacy.

Snyder eventually confessed that he'd stolen money and medicine from the store.

He'd taped the ends of his fingers to make sure he wouldn't leave any fingerprints. But he removed the tape behind the store. He didn't realize that his fingerprints were stuck to the tape.

That mistake made the burglary charges stick!

Using the fingerprints found on the tape, police tracked down the thief. Not long after, Jeffrey Snyder was arrested.

In the next case, find out how fingerprint evidence helped investigators bag a brutal criminal.

The Duffel Bag Murder

A gruesome crime has been committed. Can fingerprint evidence help nail the criminal?

On July 15, 2000, in Crossville, Tennessee, a pair of hikers found a body in the woods. How could this murder be solved?

Trail of Terror

Two hikers are out for a nice day in the woods. Then they make a bloody discovery.

Ryan and Heather Chase loved hiking the wooded trails in Tennessee. On July 15, they were exploring an old logging road. They noticed a faded duffel bag in a ditch. Ryan unzipped the bag. Then he jumped back. "There's a body in there!" he gasped.

When the sheriff and deputies arrived, they examined the bag. They found what they thought were human body parts. They searched the scene and found several more duffel bags.

This case was big. The sheriff was going to need expert help. He called the Tennessee Bureau of Investigation (TBI).

The sheriff and his deputies found duffel bags like this one in the Tennessee woods.

Bagging the Evidence

The TBI looks for clues at the scene.

Agent Todd Dawson from the TBI arrived on the scene. He was leading the investigation.

THE QUESTION Dawson knew he had to answer two main questions. Who was the victim? And who was the killer?

THE EVIDENCE Dawson directed his agents to search the area for clues.

Agents found five large duffel bags. Each contained body parts. It looked like all the parts belonged to one body. But Dawson wasn't sure yet.

The agents checked the area where each bag was found. They looked for blood and other **trace evidence** that might have come from the killer.

The duffel bags themselves were bloody inside. However, there was no blood in the area around the bags. That suggested that the body had been cut up somewhere else.

That was one clue. To find others, Agent Dawson knew that he'd need help from **experts**. He and his deputies carefully gathered the evidence.

Investigators found five large duffel bags in a wooded area.

A Close Look at the Victim

Does the body hold any clues to the murder?

Agent Dawson and his deputies brought the evidence back to the TBI crime lab.

The body parts were removed from the duffel bags. They were sent to the office of Dr. Ralph Roberts, a medical examiner. Medical examiners are doctors in charge of investigating suspicious deaths.

Dr. Roberts would try to identify the victim. He'd also try to figure out how the victim was killed.

The victim's body parts had been wrapped in plastic before being stuffed into the duffels. Dr. Roberts unwrapped each body part.

Dr. Roberts concluded that the parts belonged to a single victim. It was a young white male. And he'd been killed by a gunshot wound to the head.

Dr. Roberts still needed to identify the victim. He called in fingerprint expert Oakley McKinney. McKinney inked the victim's fingers and pressed them to print cards. Then he took the victim's fingerprints and scanned them into AFIS.

To see a fingerprint ID card, go to page 52.

For more information about AFIS, see page 25.

THE CONCLUSION ⓘ McKinney got a break! AFIS matched the prints with 29-year-old Dale Givens.

Now that the victim had a name, Dawson began interviewing Givens's friends and family. He hoped one of them had information that might lead him to the killer. But the key piece of evidence was yet to come.

Examining the Evidence

Investigators examine the duffel bags. Are there clues?

Meanwhile, back at the crime lab, forensics experts examined the duffel bags.

Trace specialists looked carefully for evidence. Traces of hair or clothing fibers could give them more information about the victim or the killer. But they couldn't find anything useful.

DNA specialists then took samples of the blood. DNA is like a fingerprint. No two people have the same DNA. The specialists hoped to find the killer's DNA. That could help investigators track him down. But they were disappointed. All the blood came from the victim.

Then Dawson noticed something on a piece of plastic that had been wrapped around a body part. It looked like a bloody footprint.

He sent the plastic to fingerprint specialist

McKinney thought he had found a bloody thumbprint. But the print came from a toe.

McKinney for processing. McKinney found several prints. "I found what I thought was a thumbprint," he said. "But it turned out to be the print from a big toe."

TBI's database didn't contain footprints. So the toe print was no help. Was the investigation stalled?

PRINT PROCESSING PRIMER

Fingerprint specialists process fingerprints in different ways. Here's a look at how different prints are handled.

Type of Evidence: fingerprints on hard surfaces such as glass, plastic, or metal
Method: dusting or Super Glue fuming

Type of Evidence: fingerprints on soft, absorbent surfaces such as paper, cardboard, or unfinished wood
Method: use a chemical called Ninhydrin, or send to lab

Type of Evidence: bloody prints
Method: photograph, then send to lab

Type of Evidence: wet prints
Method: allow to dry, then photograph

Printed!

Will the search for a bloody fingerprint finally pay off?

McKinney refused to give up. If he found just one fingerprint, he might be able to solve the case.

McKinney went back to the bloody plastic. He found more prints. But they turned out to be from toes, too. He found a few that looked like fingerprints. But they were smeared or damaged.

McKinney had another idea. Was it possible that there were latent prints on the plastic?

McKinney decided to try a process called fuming, which makes latent prints visible. First, he cut the plastic into smaller sheets. Then he put them inside a special chamber. Fumes from heated Super Glue were released into the chamber. These fumes make invisible prints visible.

When McKinney took the sheets out of the chamber, he examined them carefully with a magnifying glass. There it was: a fingerprint.

Fuming makes invisible prints visible. The fumes from Super Glue stick to the chemicals in sweat and oil that form fingerprints. When the fumes are dry, the fingerprints turn white.

McKinney photographed the print and entered it into AFIS. He got a hit. The print belonged to a man named Joseph Parks.

"AFIS told us it was a print from a left ring finger," McKinney said.

McKinney called Agent Dawson. "I told him we had a match on the plastic print. I gave him the suspect's name." McKinney was confident he had found the killer. "When you find a fingerprint wrapped up with body parts, you can be pretty sure it's the perpetrator's," he said.

A LASTING IMPRINT

How long will a fingerprint stay at the scene of the crime?

A fingerprint can disappear immediately. Or it can last forever. It depends on where the print is and what made it, says specialist Oakley McKinney. Here's a look at some of the factors that affect the quality of a fingerprint.

Dirty hands make good prints.
If the print is made with clean hands, it's usually pretty faint. If the hands are dirty, the prints are usually better. And if the person had paint, blood, or ink on their hands, those prints will last a long time.

Fingerprints stick best to hard, smooth surfaces.
Fingerprint specialists can lift fingerprints off soft, absorbent surfaces like paper or clothing. But fingerprints left on glass or other hard, smooth surfaces last longer.

Don't leave prints out in the rain.
Sun, wind, rain, and cold can damage prints.

Bagged!

Investigators tracked Joseph Parks to Nashville, Tennessee. Police searched Parks's apartment. He had tried to scrub his place clean. But investigators still found trace evidence that linked him to the victim.

Parks was arrested. McKinney's toe print evidence came in handy. Parks's footprints matched those on the bloody plastic!

Police also questioned Parks's girlfriend. She told them that Givens had come to Parks's apartment for a drug deal. The deal went bad, and Parks killed Givens.

Eventually, the case went to court. The prosecutor showed the fingerprint that McKinney had found on the plastic. He explained that AFIS had traced the print to Joseph Parks.

Together with other evidence, the fingerprint convinced the **jury**. Parks was found guilty of murder. He is serving a life sentence.

The latent fingerprint and the bloody toe print from the plastic helped prove that Parks was guilty.

Find out how evidence from a criminal's feet also played a role in the next investigation.

36

The Barefoot Bandit

Can a burglar be identified from his footprint?

Paris, Tennessee
September 7, 1979
5:12 A.M.

Burger Break-In

A thief steals some money—and leaves a trail of footprints behind.

It was a beautiful morning when Tim McCall arrived early for work. McCall was the assistant manager of the Burger Queen in Paris, Tennessee. So he was often the first person to get to work.

As usual, McCall began to get the restaurant ready to open. It seemed like a normal day.

But then McCall noticed that the office door was open. He walked in and saw papers on the floor. The window above the desk was open. There were black footprints across the room to the door. Strangely, they were from bare feet!

In Paris, Tennessee, a burglar broke into the local Burger Queen. The only evidence left behind were some footprints. Could the Tennessee Bureau of Investigation solve this one?

McCall quickly checked the cash box. It was kept in a desk drawer. It usually contained about $100 in change. The drawer had been pried open. And the cash box was missing.

It was time to call the police.

When the assistant manager arrived at Burger Queen, he found that the office had been broken into.

Looking for Clues

Investigators find no trace of fingers, but plenty of toes.

When the police arrived, McCall showed them the crime scene.

The police investigators had one main goal. It was to figure out the identity of the burglar. They immediately began processing the scene for fingerprints and other clues.

Fingerprint specialists always look for prints where the criminals enter and exit the crime scene. At the Burger Queen, the window had been forced open. That's probably how the burglar had come in. So the officers dusted around the window and door. One officer checked

Fingerprint analysts always look for prints where criminals enter and exit the scene. Here, an analyst dusts for prints on a door.

outside the window for evidence.

They also dusted the handles of the desk drawers. Another officer gathered things the burglar might have touched. He carefully took items from the desk drawers and put them in bags. Later, he'd take them to the print lab to be checked for fingerprints.

But the search didn't turn up any fingerprints. This burglar must have been wearing gloves.

There was just one more piece of evidence—the prints from the bare feet.

The investigators had an idea where the prints came from. They thought the burglar had opened the window and climbed onto the desk. Then he had stepped on a piece of **carbon paper** on the desk. Carbon paper is covered with fine, black dust. The black dust must have stuck to the burglar's feet.

The burglar then jumped to the floor and walked across the room. As he did, he left perfect black footprints.

The thief stepped on carbon paper, which is covered with black dust. He then walked across the floor.

Carbon paper was used before there were computers. Typists used carbon paper to make copies. They placed a sheet of carbon paper between two sheets of white paper.

Police photographed the footprints on the floor. They couldn't enter the prints into a database like AFIS. But who knew? Maybe the photos of the footprints would come in handy later.

PRINT PRIVACY

Can the police look at your prints?

What if you're suspected of a crime? Can the police make you give them your fingerprints or footprints?

If you've been arrested, the answer is yes. Police are allowed to take suspects' fingerprints or footprints without their permission. But if you haven't been arrested, the answer is no. Police must get your permission before they take a fingerprint or footprint.

IF THE SHOE FITS

What can police tell from a pair of shoe prints?

Burglars rarely steal in their bare feet. A perp's shoe prints are sometimes left in dirt, mud, or snow at the scene of a crime. In that case, trace evidence experts will process the prints. They photograph them to study later.

Shoe prints can tell the police a lot. If the prints are deep, that could mean that the suspect is heavy. If the footprints are far apart, the person may have been running.

The pattern on the bottom of the shoe can also be a clue. Investigators may be able to tell what kind of shoe the suspect was wearing.

Investigators might also take samples of dirt from the crime scene. When police have a suspect, they'll test the dirt on his shoes. Is there a match?

Following the Trail

Police have a print from the Barefoot Bandit. Now they need a foot to match.

The footprint was pretty good evidence. In fact, toe prints are like fingerprints. Each person's toe prints are unique.

Still, they needed a suspect.

The police had a few leads. They wanted to question Burger Queen employees. They also wanted to talk to past employees.

In addition, they planned to question local people

who had been arrested before for burglary. The Burger Queen burglar had known not to leave fingerprints. So maybe this person had stolen before.

The police began their investigation by talking with people who had arrest records. Two local men looked suspicious. But one had a solid **alibi** for the night of the burglary.

The other suspect was a man named Lonnie Stout. Stout had been arrested several times for breaking and entering. One of these cases involved a restaurant. What's more, he lived less than a mile (1.6 km) from Burger Queen. And he had been known to walk around barefoot.

TOE NAILED

Are your toe prints unique?

Like your fingerprints, your toe prints are one-of-a-kind. A man named William Gourley learned that the hard way. In 1952, he was found guilty of trying to rob a bakery. The evidence? He had left a print of his left big toe at the scene.

That's not all. The ridges on the soles of your feet and the palms of your hands also form unique patterns. So just think of your hands and feet as permanent ID cards.

Busted Barefoot!

Police find a suspect. Will his feet match the prints?

The police drove to Lonnie Stout's house. They asked him where he had been the night of the burglary. Stout seemed nervous. Finally police asked if they could take a print impression of Stout's feet. Stout agreed and pulled off his shoes.

THE EVIDENCE

An officer rolled ink on Stout's feet. Stout then placed each foot on white paper. Police took the footprints back to the police department. There, they photographed the prints.

The police placed Stout's prints with the footprints from the crime. Then they sent the two sets of prints to the crime lab at the Tennessee Bureau of Investigation (TBI).

THE CONCLUSION

Agents at the crime lab compared the two samples. They were a perfect match.

Faced with the evidence, Stout confessed. He told police what had happened. During the burglary, he had not wanted to leave fingerprints at the scene. So he had used his socks to cover his hands!

Meanwhile, his bare feet left a trail of evidence!

The burglar had covered his hands with socks so he wouldn't leave fingerprints. But his footprints sent him to jail!

FORENSIC DOWNLOAD

Here's even more amazing stuff about fingerprinting—right here at your fingertips.

In this section:

▶ how people learned how to make INVISIBLE FINGERPRINTS visible;

▶ how fingerprinting has been IN THE NEWS;

▶ the TOOLS used by fingerprint analysts;

▶ whether fingerprinting might be in YOUR FUTURE!

1823 First Fingerprint Classification

In Europe, Johannes Purkinje created the first system for organizing fingerprints. His system divided all fingerprints into nine categories. People have been using fingerprints for identification for centuries. But Purkinje was the first to organize them.

1880 Don't Sweat It

A doctor from Scotland named Henry Faulds did a study on fingerprints. It was published in a magazine called *Nature*. What was his big discovery? Faulds discovered that sweat from fingerprints could be made visible with powders.

Key Dates in Fingerprinting

Fingerprints have left their own mark on history.

1883 Science Meets Police Work

French police official Alphonse Bertillon believed that no two people had exactly the same body measurements. He measured criminals' bodies. He used these numbers in a formula. His system, known as the Bertillon System, was used for a while to identify criminals.

1896 Creating a Fingerprinting System

British official Sir Edward Henry developed a fingerprint system in 1896. The system divided prints into arches, loops, whorls, and composites. Henry's system became the basis of the system used in much of the world today.

1902 Prints Deliver Guilty Verdict

Harry Jackson stood in Central Criminal Court in London, charged with burglary. He pleaded not guilty. But police had found an imprint of his left thumb at the crime scene. During the trial, the jury saw blow-ups of this print and of one taken from Jackson. It was the first use of fingerprint evidence in a criminal trial. Jackson was found guilty—of stealing balls from a pool table!

1903 The Wild Will West Case

Will West arrived at Fort Leavenworth Prison in Kansas. The clerk took West's Bertillon measurements. Strangely enough, another prisoner named William West had exactly the same measurements. To make it more confusing, William West looked just like Will West!

How could they tell the two men apart? Officials found that the two men's fingerprints were nothing alike! The West case helped fingerprinting replace Bertillon as the leading tool for identification.

1990s AFIS Alert

The Automated Fingerprint Identification System (AFIS) was developed, making it a lot faster to find criminals. Law enforcement agencies use AFIS to search fingerprint databases around the country.

For more about AFIS, see page 25.

47

In the News

Fingerprinting is making the headlines.

Fingerprints Help Free Man From Jail!

ROXBURY, MA— January 24, 2004

Stephan Cowans walked out of jail in Roxbury, Massachusetts, a free man. He had served six and a half years for a crime a judge now says he didn't do.

Seven years ago, Cowans had been convicted of shooting a Boston police officer. However, a new look at a fingerprint proved Cowans was innocent. In the first trial, a fingerprint expert said that a print found on a glass at the scene was Cowans's. But new forensic testing proved that the "match was a mistake," said one official.

Stephan Cowans served almost seven years in jail for a crime officials now say he did not commit.

At Cowans's first trial, an expert said Cowans's prints were found at the crime scene. This was a huge mistake.

Looking for fingerprints on rocks is like looking for a needle in a haystack.
Soon, fingerprints may be detected even on rocks!

New Spray Makes Fingerprints Stick

November 2003

Fingerprint experts have always stayed away from rough surfaces when they are dusting for prints. The best prints come from smooth surfaces. It's been impossible to get prints from rough surfaces, like bricks or stones. Until now, that is.

A new spray can help experts find fingerprints even on rough surfaces. Fingerprint expert Claude Roux says that now there's the "possibility that even rocks at outdoor crime scenes will yield valuable fingerprint evidence."

A new spray may make latent prints on rocks visible to the naked eye.

At Your Fingertips

See what kind of prints you're leaving. Then check out the tools and other stuff used by fingerprint specialists.

KINDS OF FINGERPRINTS

LOOP

There are three main categories of fingerprints. Which do you have? Have a look, but don't smudge them.

This is a **radial loop** on the thumb of someone's left hand. Radial loops open up on the opposite side from the second finger.

In **loop** fingerprints, the ridges form loops, one inside the other. See how the ridges go to the left, up, and down. That's the loop.

This is an **ulnar loop** on the thumb of someone's left hand. Ulnar loops open up on the side closest to the second finger.

Loops are the most common type of fingerprint. About 65% of people have loop fingerprints.

WHORL

About 30% of people have whorl fingerprints.

Here the loops form something called a **whorl**. As you can see, the ridges are in the shape of a circle.

This is a **central pocket loop**. It has a loop with a whorl right in the center.

This is an **accidental loop**. There's a whorl in the center.

The **double loop** has two loops.

ARCH

In **arch** fingerprints, the ridges form a single bump or wave. The ridges move up to form a little arch.

This is a **tented arch** fingerprint. The arch makes a tent shape.

Arch fingerprints are pretty rare. Only about 5% of people have them.

TOOLS AND EQUIPMENT

powder, brush, and tape Dusting is still the most popular way to find prints, so print specialists can't live without powder and a brush.

Super Glue Dusting isn't the only way to lift prints. Fumes from Super Glue make invisible prints visible, so they can be photographed. "Super Glue is one of the most valuable tools we have," says print specialist Oakley McKinney.

Ninhydrin Here's another way to lift prints. This chemical is used to get fingerprints from soft, absorbent surfaces like paper and clothing. The chemical reacts to acids in your skin, making prints show up. Ninhydrin can even develop prints made 30 years ago.

AFIS AFIS (Automated Fingerprint Identification System) is a computer program that can search through several million prints on the computer in a few minutes.

fingerprint ID card Here's the card used to record prints.

magnifier A comparison magnifier or magnifying glass is the print expert's best friend. Magnifying the print helps the examiner find all the unique details in the print.

gloves Fingerprint experts usually wear gloves. Why? They don't want to leave their own fingerprints around.

crime scope This tool uses UV light, which makes fingerprints glow. Presto!

FINDING A MATCH

Compare this AFIS print to the suspect's print.

A print specialist scanned the photo on the right into the AFIS system. The print on the left is the AFIS match.

Help Wanted: Fingerprint Analyst

How'd you like to get your hands on a job as a fingerprint analyst? Here's more information about the field.

Oakley McKinney is a special agent with the TBI.

Q How did you become a latent print specialist?

Agent McKinney: I started my career with the FBI—that's where I got my fingerprint background. I eventually moved to the Tennessee Bureau of Investigation (TBI).

Q How would you become a print expert today?

Agent McKinney: Every law enforcement agency has different requirements. The TBI takes recent college graduates, who train for two years. We require that they have 24 hours of chemistry during college. And ideally, we'd like someone who studied forensics.

Q What's your typical day like?

Agent McKinney: My day varies greatly. Here, someone is always on call to go out to a crime scene. But most days I'm in the lab. I work on 25 to 30 cases at a time. Each one is at a different point in the investigation. On some cases, I'm waiting for photos. On others, I'm comparing photos and prints. I'm entering the prints into AFIS on other cases.

Q How is your job different from the crime scene investigators we see on TV?

Agent McKinney: On TV you'll see forensic specialists interviewing witnesses or suspects. That's pretty hokey. Our job is to collect, preserve, and examine the physical evidence that's left behind. It's not investigations.

Q What kinds of cases do print specialists work on?

Agent McKinney: Most cases overall are burglaries, but we work on every crime—murder, rape, forgery, anything where a latent is available.

Q What do you like about your work?

Agent McKinney: I like figuring stuff out. I like working until I find and process a good print. It's kind of like a puzzle. And I like being part of a team that catches the bad guys.

Q What do you dislike?

Agent McKinney: To this day, I still don't like the blood and guts. But you just have to deal with it. You have to focus and be a professional and do your job.

THE STATS

Money

▶ Average yearly salary for latent print specialist in the U.S.: $47,560*

▶ Average yearly salary for latent print examiners in Canada: $41,000*

Education

▶ 4 years of college with a major in forensic science

▶ On-the-job training courses at a law enforcement agency

The Numbers

▶ Number of print specialists working in the U.S.: 10,270*

▶ Job openings for forensic scientists are expected to rise about 19 percent by 2012.

** Data is for forensic science technicians, which includes ballistics experts, trace evidence analysts, etc., as well as fingerprint examiners.*

DO YOU HAVE WHAT IT TAKES?

Take this totally unscientific quiz to see if fingerprint analysis might be a good career for you.

1 **Do you stay away from gross stuff?**

a) No. In fact, I'm really interested in how the body works.

b) I'm okay if it's not too gross.

c) I don't even like to see fake gross stuff on TV.

2 **Do you stick with a task even when it's hard?**

a) Yes, I never give up.

b) Sometimes, unless it's really boring.

c) No, when the going gets tough, I'm out of here.

3 **Do you enjoy working with computers?**

a) Definitely. I like how I can get lots of information.

b) Sometimes, but my eyes start to hurt after a while.

c) No. I never understand them.

4 **Are you concerned about justice?**

a) Yes, I want to make my area a safer place.

b) I like to watch crime shows on TV.

c) Someone else can do that.

5 **Are you good at spotting small details?**

a) Yes, I always notice everything.

b) I'm okay if I concentrate.

c) I just get the big picture.

YOUR SCORE

Give yourself 3 points for every "**a**" you chose.

Give yourself 2 points for every "**b**" you chose.

Give yourself 1 point for every "**c**" you chose.

If you got **13–15 points**, you'd probably be a good fingerprint analyst.

If you got **10–12 points**, you might be a good fingerprint analyst.

If you got **5–9 points**, you might want to look at another career!

HOW TO GET STARTED... NOW!

It's never too early to start working toward your goals.

GET AN EDUCATION

▶ Starting now, take as many science courses as you can.

▶ Start thinking about college. Look for ones that have good forensics programs.

▶ Read the newspaper. Keep up with what's going on in your community.

▶ Read anything you can find about fingerprint analysis. See the books and Web sites in the Resources section on pages 108–111.

▶ Graduate from high school!

NETWORK!

Call your local law enforcement agency. Ask for the public affairs office. Find out if you can interview a print specialist about his or her job.

GET AN INTERNSHIP

Get an internship with a law enforcement agency—in the print lab, if possible.

LEARN ABOUT OTHER JOBS IN THE FIELD

▶ **Policing:** Police officers learn to work with investigative techniques, such as fingerprinting.

▶ **Information technology:** Agencies that conduct investigations need people with strong computer skills.

All it would take is one sneeze. Your DNA would be all over this book. That's right. Your spit has DNA in it.

FORENSIC 411

That's important to police because everyone's DNA is different. With the right equipment, detectives can match a person with his spit. They've put criminals in jail that way. They've also freed innocent people.

In this section:

▶ how DNA experts TALK;
▶ where INVESTIGATORS look for DNA evidence;
▶ who else works at the CRIME SCENES.

Discussing DNA

Forensic DNA specialists have their own way of talking.
Find out what their **vocabulary** means.

"We didn't find any fingerprints. But let's take that soda can and the T-shirt. We can check for DNA evidence back at the lab."

DNA

(dee-en-ay) a chemical found in almost every cell of your body. It's a blueprint for the way you look and function. No two people have the same DNA (except identical twins).

DNA profiling

(DEE-en-ay PROH-fyl-ing) a way of processing DNA samples so they can be compared with other samples. The DNA comes from samples of saliva, blood, urine, and other bodily fluids or tissues.

DNA stands for Deoxyribonucleic Acid.

"We need DNA profiling done on this guy. Who has his sample?"

"I'd say that we are looking for a thief with a specific trait: white-blond hair that's really straight."

trait

(trayt) a specific feature of something. For example, your hair color is one of your traits.

"Look, I know this criminal seems like a real monster, but he's got 46 chromosomes in his cells—same as you and me."

chromosomes
(KROH-muh-sohms) thread-like structures in the center of a cell. They're made of DNA and contain all the genetic information in your body.

"Most people in my family are redheads. I guess it's just in my genes."

genes
(jeens) tiny pieces of DNA. Genes determine general stuff, like the fact that you have two eyes, a nose, and a mouth. They also determine specific stuff, like the color of your eyes, hair, and skin.

Say What?

Here's some other lingo a DNA specialist might use on the job.

bag
(bag) take as evidence.

"*Bag* that piece of gum. It might have the perp's DNA."

degrade
(dee-GRADE) to break down into small unusable parts.

"Don't leave those DNA samples out in the hot police car. They'll *degrade*, and then they'll be worthless."

perp
(purp) a person who has committed a crime. It's short for *perpetrator*.

"It always feels good to send a *perp* to jail."

swab
(swahb) to use a thick, cotton tip on a stick—like a Q-tip, only bigger—to get samples of DNA from suspects.

"*Swab* the inside of the suspect's cheek before you question him."

Fast Facts
DNA is the world's smallest instruction manual.

▶ There's a copy of your DNA in almost every cell in your body. That means that every cell has a complete set of instructions for making another you!

▶ If you compared two people's DNA, you'd see that they're 99.9% the same. Only 0.1% is different. That is the part that makes you, you! And that's the part that scientists use to identify a person.

▶ Under the right conditions, DNA can survive a long time! DNA has been found in Egyptian mummies!

A Drop of Evidence

Spit. Blood. Skin. DNA evidence lives in almost every cell of your body.

Think of DNA as your chemical **signature**. No one else's is quite like yours. That makes DNA a great way to identify people.

What's more, almost every cell in your body contains DNA. Almost everywhere you go, you leave a trail of chemical fingerprints. That fact has put many a criminal in jail—and the police know it.

Detectives search crime scenes for **evidence** that might contain DNA. There's DNA in skin, hair, blood, saliva, sweat, and other body fluids. So they look for anything a perp might have touched, licked, bled on, sweated in, or sneezed on. In the bathroom, DNA could be on the handle of a toilet flusher—or in the toilet itself!

Take a look at the photos on this page. These are just some of the places that might hide traces of DNA. They might look like ordinary household items. But any one of them could hold the key to putting a criminal behind bars.

63

The Forensic Team

DNA specialists work as part of a team to help solve crimes and identify victims.

Forensic DNA Analysts

They examine, analyze, and interpret DNA samples in the lab. They determine if these samples could have been left by victims or suspects.

Medical Examiners

They're medical doctors who investigate suspicious deaths. They try to find out when and how someone died.

DETECTIVES OR AGENTS

They direct the crime investigation. They collect information about the crime, interview witnesses, identify suspects—and arrest them if there's enough evidence!

Trace Evidence Specialists

They collect trace evidence at the scene. That includes fibers, tire tracks, shoe prints, and more.

Fingerprint Specialists

They find, photograph, and collect fingerprints at the scene. Then they compare them to prints they have on record.

Forensic Anthropologists

They're called in to identify victims by studying bones.

TRUE-LIFE CASE FILES!

24 hours a day, 7 days a week, 365 days a year, DNA specialists are solving mysteries.

In this section:

▶ how a HALF-EATEN HAMBURGER helped catch a thief;

▶ why police RELIED ON A CAT to find a murderer;

▶ how DNA helped FREE AN INNOCENT MAN.

the Scenes

Here's how forensic DNA specialists get the job done.

What does it take to solve a crime? Good DNA specialists don't just make guesses. They're scientists. They follow a step-by-step process.

As you read the case studies, you can follow along with them. Keep an eye out for the icons below. They'll clue you in to each step along the way.

At the beginning of each case, the DNA specialists identify **one or two main questions** they have to answer.

The specialists' next step is to **gather and analyze evidence**. Specialists gather as much information as they can. Then they study it and figure out what it means.

Along the way, the specialists come up with theories about what may have happened. They test these theories against the evidence. Does the evidence back up the theory? If so, **they've reached a conclusion**.

The Case of the Hungry Burglars

Three men eat a hamburger just before they rob a fast-food restaurant. Will the burger bite them back?

On May 2, 2004, three men robbed a hamburger restaurant in Suffolk, Virginia. The only evidence was trash. But could it put the men behind bars?

Burger Bandits

The burglars escape with cash from the restaurant.
Did they leave any clues?

It was just before closing time at a fast-food restaurant in Suffolk, Virginia. Three hungry men ordered their food and sat down to eat. They shared two burgers, fries, and one drink. They ate most of their food.

The robbers shared a burger and fries before they robbed the restaurant. Could the remains of that meal provide the police with evidence?

The three men waited until five minutes before closing time. They stood up, threw their trash away, and robbed the restaurant at gunpoint.

The burglars demanded money. They forced the scared workers into the restaurant freezer. They then ran out the door. A witness outside the restaurant saw the men sprinting away—and called the police.

Within minutes, officers arrived at the scene. They searched the area for the robbers. But they had disappeared.

The police went inside and started searching the crime scene. They made an important discovery. All

the trash had been taken out just before the robbery. That meant that the only garbage in the restaurant came from the robbers. It could be important evidence. Police radioed for help. This was a job for a DNA **specialist**.

Bag It

A forensic technician collects the evidence. Then she has to keep it from spoiling.

Suffolk County's Forensic Unit supervisor, Joan Jones, got the call at 11:30 P.M. When she arrived at the scene, she was briefed about the situation. The officers told her about the garbage bags.

Did the burglars leave traces of DNA behind on their food? It was Jones's job to find out.

She quickly slipped on her latex gloves and dug in. Jones recovered a half-eaten burger, a tiny portion of another burger, a pack of fries, and a drink with a straw.

Normally, Jones seals evidence in a paper bag. Paper bags keep most things safe from light and **contamination**. But in this case, paper wasn't enough. The food might spoil before it got to the lab. Saliva from the burger, fries, or straw could seep into the paper. It was too big a risk. So Jones collected the evidence in a plastic bag and sealed it. Then she drove it to her office and put it in the freezer.

Jones filled out the paperwork. She signed the **chain-of-custody form**, showing who had handled the evidence. The next morning, she drove the frozen food to the Virginia Department of Forensic Science for analysis.

Joan Jones is the supervisor of the Suffolk County forensic Unit. She carefully collected the evidence from the fast-food restaurant.

Jones examined the remains of a meal like this one.

BAG IT CAREFULLY!

Investigators have to keep a close eye on DNA evidence.

To crime scene investigators, DNA evidence is gold. The right evidence can lock up a murderer or free an innocent man.

Handle with Care

To protect their cases, investigators handle DNA with care. They keep samples out of humidity, direct sunlight, and rain.

These conditions degrade DNA and make it useless. Handlers use gloves so they don't mix their own DNA with the samples. They wear masks so they don't breathe, spit, or sneeze on the evidence.

Chain-of-Custody

Investigators also keep detailed reports to show who handles the evidence. Everyone who touches the evidence signs a chain-of-custody form. At the crime scene, officers make notes about when and where evidence is found. The evidence then gets stored in a safe place.

Only certain people are allowed to handle it. Anyone who examines or tests the evidence adds notes to the chain-of-custody. The chain-of-custody records can be used in court. They help prove that no one has messed up the evidence.

Put to the Test

The crime lab has four pieces of evidence to work with. Can they recover DNA from a half-eaten burger?

At the lab, the bag of frozen food made its way to Ann Pollard. Pollard is a **forensic** scientist trained to work with DNA evidence.

The food had just been tested for fingerprints. The investigator found prints on the paper wrappers, the fry box, and the cup lids. But he couldn't match the prints with a **suspect**.

It was Pollard's turn

Ann Pollard, a DNA scientist for the Virginia Department of Forensic Science. She ran lab tests of DNA she found on the burglars' burgers and fries.

to look at the evidence. Her first task was to get saliva samples from the food. She took a cotton swab and poked around the bitten areas of the burger. The cup and the straw had already been swabbed.

Next, Pollard used a **scalpel** to remove the swabs from their long sticks. She put the swabs in a tube and added chemicals. Then she heated the sample. The chemicals remove everything from the swab except DNA. The heat speeds up the removal process. After half an hour, Pollard had **isolated** the DNA. Now, she was ready to test it.

Cotton swabs are sometimes used to collect DNA information. The evidence is then stored in tubes like this one. Ann Pollard used swabs on the bitten areas of the burger found at the crime scene.

Pollard put the sample into the lab's workstation. This high-tech equipment processes the DNA so it can be X-rayed.

Pollard needed to be sure she had enough information to work with. So she moved the sample to a thermocycler. The thermocycler used a process called **polymerase chain reaction** (PCR) to make millions of copies of the DNA.

Finally, Pollard was ready to make an image of the DNA. She used a machine called an FMBIO. The result was a familiar sight: the DNA bar code.

After a month of testing, Pollard finally had the results in her hand. The samples produced three separate DNA profiles. Each of the burglars had left his mark on the tiny scraps of food.

The challenge now was to find out whom the DNA profiles belonged to.

This film shows a DNA profile that can be compared and studied.

Happy Meal Match-Up

For more information about CODIS, go to page 76.

The testing finds three DNA profiles. The robbers shared a meal; now they will share the punishment.

Pollard went to a computer and logged into the state's **CODIS**. CODIS stands for *Combined DNA Index System*. CODIS is a giant file of DNA profiles. When police charge a suspect with a crime, they take DNA samples. They enter the information into a computer system. Most states have their own CODIS. So does the **FBI**.

Pollard entered her three DNA profiles into the system. The computer tried to match them with profiles already on file. Eventually, she had her answer. CODIS came up with matches.

THE CONCLUSION Suffolk County police now had their suspects. But they still had to check the CODIS results.

An officer visited the men. She collected their DNA by swabbing the inside of their cheeks. The sample was

Using **CODIS** allows police to match DNA samples with suspects.

analyzed to produce a DNA profile. CODIS was right. The DNA matched the samples from the fast-food leftovers.

All three suspects confessed to the crime. Police got the burglars off the streets—thanks to some high-tech science and a little chewed-up food.

In this case, a half-eaten burger led police to some burglars. Can a few hairs help investigators find a murderer?

THE BIG BRAIN
CODIS is a computer database packed with DNA samples.

Say you're a police investigator. You go to a crime scene and find some evidence. You take it back to the lab. The DNA **experts** tell you you've got a great sample of someone's DNA.

They just don't know **who** that someone is. You've still got to find a suspect. Wouldn't it be great if there were an easier way?

DNA Database
In fact, there is. The FBI has created a DNA database. It's called CODIS. That stands for *Combined DNA Index System*.

CODIS contains DNA samples of more than 300,000 people. Some states enter only convicted criminals. Other states enter people when they are arrested.

Who's in CODIS?
These days, laws in all 50 states support CODIS. Anyone convicted of a sex offense or murder must have his or her DNA entered into the system.

Sure, investigators still have to look for perps. But CODIS sometimes gives them a break.

A Hair of Evidence

Prince Edward Island, Canada
October 3, 1994

A woman disappears. Can a few cat hairs help solve the mystery?

Missing Without a Trace

People don't just disappear. Or do they?

It was the morning of October 3, 1994. Off the east coast of Canada, winter was coming to Prince Edward Island. The ground was dotted with fallen leaves. A chill hung in the air. Cold waves pounded the base of the island's huge cliffs.

Shirley Duguay left home that day—and didn't return. She was 32. She cared for five children as a single mom. When friends realized she was missing, they figured she was visiting relatives. But when they called the relatives, Duguay wasn't there.

Shirley Duguay at her home on Prince Edward Island, in Canada. Soon after this photo was taken, she disappeared.

Relatives soon arrived at Duguay's house. They decided not to call the police. Duguay's ex-husband, Douglas Beamish, lived nearby with his parents. He was known to have a bad temper. Duguay's relatives were afraid he might get the children. Or they could be sent to foster care.

Besides, they felt certain that Shirley Duguay would walk in the door any minute. She never did.

In the fall of 1994, a woman from Prince Edward Island, Canada, seemed to disappear into thin air. It turned out that the main clue to her disappearance was invisible to the naked eye.

Strange Clues

The police find Shirley Duguay's car. But where is she?

Four days after Shirley Duguay disappeared, police found her car. It was empty, but there were bloodstains on the windows. Clearly, someone had been hurt—maybe even killed.

Police traced the car to Duguay. They questioned her family. Her relatives admitted that they hadn't seen her in four days.

The police launched a massive search. Hundreds of people joined in.

Three weeks later, a clue turned up. Fifteen miles (24 km) from Duguay's car, police discovered a man's leather jacket and running shoes stuffed in a plastic bag. The jacket was covered with blood.

Members of Canadas top police force, the Royal Canadian Mounted Police, arrived in Prince Edward Island to search for Shirley Duguay.

The police examined the jacket carefully. They tested the blood on the jacket. It was the same blood type as Duguay.

They also found short, white hairs stuck to the jacket. But there was still no sign of Duguay.

Soon, the island was covered in snow. Police were forced to give up the search. All winter, Duguay's disappearance remained a mystery.

Then, the following May, a fisherman found Shirley Duguay's body in the woods. She was dead, and it was clear that she had been murdered.

The police built a tent over the spot where Shirley Duguay's body was found.

WHAT'S YOUR TYPE?

All blood looks alike. But it's not.

Blood comes in different types. There are two things that determine your blood type. First, each person's blood is Type A, B, AB, or O. Second, your blood can be RH+ or RH-, depending on whether or not it has stuff in it called the **RH factor**.

If you lose a lot of blood, you'll need more. But you can't get blood from just anyone. The donor must have the right blood type.

If Your Blood Type Is	You Can Get Blood From
A+	A+, A-, O+, O-
A-	A-, O-
B+	B+, B-, O+, O-
B-	B-, O-
AB+	anyone
AB-	AB-, A-, B-, O-
O+	O+, O-
O-	O-

O- is the universal donor. Anyone can use O-blood.

AB+ is the universal receiver. An AB+ can get blood from anyone.

Snowball's Chance

The police can't crack the case. Can a cat possibly help?

Police now knew they had a murder case on their hands. They also had a suspect: Duguay's ex-husband, Douglas Beamish.

Detectives looked into Beamish's background. They didn't like what they found. Beamish had a history of violence.

Police questioned Beamish. He had an **alibi** for the day Duguay disappeared. He told police he had been working on a house he was building. But witnesses had spotted his car near Duguay's house. Other people saw cuts on his hands that day.

"His story just didn't add up," says Inspector Alphonse MacNeil, who was in charge of the investigation.

But MacNeil couldn't prove a thing. Beamish denied he was involved in Duguay's murder. And no one had seen it happen.

The police had to rely on the physical evidence. They went back to the clue the killer left behind—the jacket. Beamish had owned a jacket like it. And there was blood on it that was the same type as Duguay's. But that wasn't enough evidence. How could they link Beamish to the jacket?

One of the detectives, Roger Savoie, remembered the white hairs on the jacket. He also remembered that Beamish's parents had a white cat named Snowball.

THE QUESTION Could it be that the hairs belonged to Snowball? If they did, a **jury** might believe that Beamish killed Shirley.

This cat, Snowball, belonged to Douglas Beamish's parents. Had those white hairs on the leather jacket come from this cat?

A Purrfect Match?

Sometimes scientists are the best detectives.

How could the police prove that the hairs came from Snowball? To the naked eye, all white cat hair looks alike. Even a microscope wouldn't yield an answer. Proof would have to come from Snowball's DNA.

The idea was new to everyone involved. Animal DNA had never been used in court. Could it be done? And would a judge allow **prosecutors** to use the evidence?

Investigators decided to take a chance. They used the Internet to search for an expert in cat genetics. They found what they were looking for at a lab in Maryland. The police took a sample of Snowball's blood. They sent it to Stephen O'Brien, director of the lab. Included in the package were the white hairs from the jacket.

At the lab, scientists began the complicated process of creating a DNA profile. First, they separated the DNA from cells in the hair and the blood. Then they added chemicals to each sample to process the DNA. Finally, they took an X-ray of each sample. The end result was a set of images. Each image looked like a profile for the blood and for the hair.

O'Brien had one result for the hair from the jacket and one for Snowball's blood. He compared the two results. They matched. Detective Savoie's hunch was right. The hair from the jacket contained the same DNA as the blood from Snowball.

The police took a sample of Snowball's blood and stored it in a container like this one. The DNA in Snowball's blood was compared to the DNA in the cat hair.

Case Closed

Will the jury think Beamish is guilty?

The police arrested Douglas Beamish for murder. During the trial, prosecutors questioned Beamish's brother. He told the jury about a letter Beamish sent to Duguay. There was "no point in living" if he and Duguay couldn't be together, Beamish had written. Then he signed the letter in blood! Prosecutors argued that Beamish killed Duguay because she had decided to end their marriage.

Next, the prosecutors presented the physical evidence. They showed the jacket they had found in the woods. It was identical to one Beamish owned, they told the jury.

But the most damaging evidence came from Snowball. Dr. O'Brien said that the cat hairs found on the bloody jacket were Snowball's. The scientist explained to the jury how the DNA match had been made. In his opinion, Snowball and the cat hair had the same DNA profile.

Finally, it was time for the jury to decide the case. After 12 hours, they reached a **verdict**. On July 19, 1996, they found Douglas Beamish guilty of murder. He was sentenced to 18 years in jail.

Snowball had made history! The Shirley Duguay case was the first time DNA from an animal had been used

Douglas Beamish (left) and his lawyer leave the courtroom. Beamish will spend 18 years in jail for the murder of Shirley Duguay.

to solve a murder. In fact, Snowball's hair had been "the most **significant** piece of evidence against Beamish," said Inspector MacNeil. You might say that a cat had caught a killer.

In this case a few cat hairs helped catch a murderer. But DNA has also helped free innocent people. Read the next case and find out how.

A Second Look at the Evidence

A man goes to jail for shooting a policeman. But did the police get the right man?

Jailed!

Stephan Cowans is convicted of attempted murder. Have the police found the right man?

In July 1998, Stephan Cowans sat in a Boston courtroom. The prosecutor called witness after witness. Each one told the jury a piece of the story. Cowans, they said, had shot a policeman. If the jury believed them, Cowans could go to jail for 50 years.

On May 30, 1997, Sergeant Gregory Gallagher was on patrol in Roxbury, Massachusetts. In the backyard of a house, a man jumped him. They wrestled, and the attacker grabbed the policeman's gun. He shot Gallagher twice in the back. He also shot at an **eyewitness** who was watching from a nearby window.

The attacker ran from the scene, leaving only a baseball cap behind. He broke into a nearby home. For a

In May 1997, a police officer in Roxbury, Massachusetts, was shot. A year later, a man was sent to jail for 30–50 years for the crime. But six years later, new DNA evidence put his guilt in question.

Fingerprints usually show up well on smooth surfaces like glass. Gallagher's attacker drank from a glass just after the shooting. Investigators dusted it and found a fingerprint.

minute, he held the residents **hostage**. He demanded a drink of water. He took off his sweatshirt and put down the gun. After he drank his water, he left the home and disappeared.

Two weeks later, Gallagher identified Cowans from a set of eight photographs. Police arrested Cowans. They thought they had enough evidence to charge him with attempted murder. Both Gallagher and the witness from the window picked Cowans out of a **lineup**. The final piece of evidence was a fingerprint. Police found it on the water glass used by the attacker. Experts claimed that the print matched Cowans's left thumb.

In court, the evidence seemed strong. On July 6, a jury found Cowans guilty. He was sentenced to 35–50 years in jail.

Like many convicted criminals, Cowans insisted he was innocent. Could it be he was telling the truth?

Holes in the Case

The case against Cowans has some holes in it. Can DNA evidence break it wide open?

From inside his jail cell, Cowans was determined to prove his innocence. He got in touch with the Innocence Project. Lawyers at the project work with prisoners who claim they are innocent. Eventually, Cowans's case landed on the desk of Robert N. Feldman from the New England Innocence Project.

Feldman's team of lawyers looked at his case. They found several holes. First, not all witnesses identified Cowans as the attacker. The people in the house Cowans entered got the best look at him. They failed to pick him out of a lineup.

Second, the items left behind at the crime scene were never tested. Police relied on two eyewitnesses and a

The founders of the Innocence Project are Barry Scheck (left) and Peter Neufeld.

A printout from some DNA samples.

Kirk Bloodsworth (right), the first person freed by the Innocence Project, sits with Senator Patrick Leahy from Vermont.

single fingerprint. Eyewitnesses often make mistakes, especially when identifying people who are racially different than themselves. Cowans is black. Gallagher and the man in the window are white. The fingerprint, too, may have been unreliable. It was only a partial print.

Feldman and his staff decided to take the case. The lawyers had two questions to answer. Did the attacker leave any DNA evidence at the scene? If so, did it match Cowans?

Feldman got the court to release the evidence from the case. He asked for the glass mug, the fingerprint, the sweatshirt, the gun, and the baseball cap. The team sent the items to a lab where forensic scientists got to work.

SAVED IN THE NICK OF TIME

The Innocence Project uses DNA evidence to free innocent prisoners.

Sometimes, people go to jail for crimes they didn't commit. That's why Barry Scheck and Peter Neufeld formed the Innocence Project in 1992. Police had just started using DNA evidence to convict criminals. Scheck and Neufeld wanted to use DNA to free innocent people.

The Innocence Project has helped to clear the names of more than 180 people who served time for crimes they didn't commit. Here's a look at just four of them.

name: David Shepard
convicted: 1984
charge: rape, robbery, weapons violations, terrorist threats
release: 1994
time served: 10 years

▶

◀

name: Kirk Bloodsworth
convicted: 1985
charge: murder, rape
release: 1993 (first person released due to DNA evidence)
time served: 8 years

◀

name: Gene Bibbins
convicted: 1987
charge: rape, robbery
release: 2003
time served: 16 years

▶

name: Brandon Moon
convicted: 1987
charge: sexual assault
release: 2004
time served: 17 years

No Match

The defense finds DNA on the hat and the glass. Does it belong to Cowans?

The court didn't release the evidence immediately. By the time they did, it was May 2003. Cowans had been in jail for nearly six years.

But DNA evidence doesn't spoil easily. Scientists at the lab found evidence on the inside of the baseball hat. They also swabbed the glass for saliva. Both samples produced enough DNA to test. Scientists then created a DNA profile from each sample. They also processed a sample of saliva from Cowans.

Now it was time to compare the samples. Scientists lined up the profiles. The DNA profiles from the cap and the glass were the same. But they did not match Cowans's DNA profile.

To make sure, the court had the white sweatshirt tested. The DNA from it matched the DNA from the cap and glass exactly. But none of the samples matched Cowans's DNA profile.

THE CONCLUSION The lawyers had proved what they suspected all along. Cowans could not have shot Gallagher.

Sergeant Gallagher's attacker left a baseball cap like this one at the scene. Six years later, it was tested for DNA evidence. DNA from the cap did not match Cowans's profile.

Faulty Fingerprint

The print doesn't match after all. Cowans walks away a free man.

Cowans's lawyer presented the DNA evidence to a judge. The lawyer asked for a new trial. The county **district attorney**, David E. Meier, did not argue. The judge scheduled the trial for January 21, 2004.

In the meantime, Meier got an expert to look again at the fingerprint. This time, the expert said the print did not match Cowans's thumb. Two days later, prosecutors admitted their mistake.

The judge decided there was no need for a new trial. He freed Cowans that day.

On January 23, Stephan Cowans walked out of prison to join his family. "I don't think there are any words in the dictionary to describe what that's like," he said.

Cowans had spent six and a half years in jail for a crime he did not commit.

The Boston police commissioner publicly apologized to Cowans. "Our error contributed to Mr. Cowans's conviction," he said. "For this we offer him and his family our sincere apology."

The Boston police began investigating the fingerprinting mistake. By 2006, the police still hadn't found a suspect.

FORENSIC

DOWNLOAD

DNA is in every cell of your body. And information about it is on every page of this section.

In this section:

▶ how James Watson found the SECRET OF LIFE;

▶ why DNA testing is MAKING HEADLINES;

▶ information about the tools FORENSIC SCIENTISTS use to analyze DNA;

▶ whether DNA analysis might be in YOUR FUTURE.

1953 "The Secret of Life"

American scientist James Watson identifies the **double helix**. Watson *(left)* shares a lab in England with Francis Crick *(right)*. The pair know that DNA exists. But no one knows how it works.

One night Watson has a brainstorm. DNA is shaped like a twisted ladder. The rungs are made of chemicals called **bases**. The rails are made of another kind of chemical. Watson walks into a bar and shouts, "We have found the secret of life!"

Key Dates in the Study

1984 Genetic ID Cards

Sir Alec Jeffreys is the first person to find a way to identify people by their DNA. Jeffreys *(below)* is part of a team studying seal genes when he makes this discovery. He creates a way to take X-rays of DNA. He uses it on human samples. As he develops the film, he sees patterns in the X-rays. He realizes that the patterns change from person to person.

1986 DNA Nabs a Killer

British courts accept DNA as evidence. A 15-year-old is murdered and the killer leaves a trace of blood behind. Police call in Sir Alec Jeffreys to help them catch the killer.

Jeffreys starts the world's first large-scale DNA testing. He takes blood or saliva samples from 5,000 local men. At one point, a man who is not guilty confesses to the crime. But his sample does not match.

The search continues until police find a match, and the killer goes to jail. DNA analysis helps catch a killer. And for the first time it also **exonerates** an innocent man.

1988 DNA Testing Comes to the United States

DNA evidence is used for the first time in a U.S. court. On May 9, 1986, a 27-year-old woman is attacked in her Florida home. Two years later, she identifies Tommy Lee Andrews as her attacker. Andrews tells a jury he was home on May 9. His DNA, however, tells a different story. It matches the DNA from body fluids found at the crime scene. Andrews goes to jail for 115 years.

1990 DNA Database

Virginia becomes the first state to collect DNA from criminals. Police enter the evidence into a computer database.

of DNA

1992 Genes for Justice

The Innocence Project is founded by Barry Scheck *(below)* and Peter Neufeld. Its goal is to use DNA evidence to free innocent people from jail.

How did scientists unlock the secrets of DNA? It didn't happen overnight.

1998 DNA Database Goes National

The FBI sets up its first DNA database. It's called CODIS. The system allows states to work together to link suspects to crimes.

In the News

Forensic DNA analysis is front-page news.

DNA Tests Could Reunite Families of Holocaust Victims

JERUSALEM, ISRAEL—June 12, 2006

During the Holocaust, thousands of Jewish children lost their parents. Many were also separated from brothers or sisters at a very young age. They have no idea who their parents were. They may have relatives somewhere in the world. But until now, they have had no way of identifying their family members.

Now, according to an American scientist, DNA testing could help bring these families together. Mary-Claire King does genetic research at the University of Washington. She plans to take blood samples from Jews who don't know their roots. She will then also take samples from families who think they have living relatives. Tests could reveal which people come from the same extended families.

Above: Women and children from a prison camp in Austria in 1945. The death rate at the camp was about 200 to 300 a day. *Left:* Children after they had been freed from a prison camp in Poland.

Scientists get blood samples from a pair of jeans and a T-shirt for a criminal investigation. The scientists will then determine the DNA profile of the blood.

Police Need Help Processing DNA Cases

INDIANAPOLIS, INDIANA—June 13, 2006

Twenty years ago, barely anyone had heard of DNA profiling. Today, police can't get along without it. In fact, some labs can't keep up with the work. These forensic scientists work at the state police lab in Indiana. They have 1,100 DNA cases waiting to be tested. That means many criminal suspects have to wait months for their cases to go to trial.

The state is hiring 20 new scientists. But they still need more help. Police are now sending several hundred cases out to private labs.

A worker in a lab prepares a sample for the thermocycler. That's part of the process of creating a DNA profile.

It's All Genetic

Have a look at the tools and equipment used to collect DNA samples—and then to analyze them.

AT THE CRIME SCENE

swab kit Police use a swab to collect saliva from the inside of a person's cheek. Then they seal the swab in a paper envelope. This photo shows three swab samples in tubes. The tubes have been placed in a plastic evidence bag.

Tyvek suit Protects investigators from dangerous material. Here, investigators look for clues and evidence at the burial site of a murder victim in England.

MAKING THE SCENE

Here's how to get DNA evidence from a crime scene.

Barry A. J. Fisher is the director of the crime lab for the Los Angeles County Sheriff's Department. He's been investigating crimes for more than 35 years. Getting DNA evidence from a crime scene isn't easy. Here are his tips for doing it right:

1. Do a walk-through. See everything before you collect any evidence. Look for how the criminal may have gotten in and out of the area.

2. Protect the crime scene. Lots of people work at a crime scene. Photographers, police, medical examiners, sketch artists, firefighters, reporters, you name it. Make sure they don't touch important evidence.

3. Pick a path. Choose one path in and out of a crime scene. Make sure everyone uses it. This helps protect any possible evidence.

4. Record it. Take pictures of the scene. Videotape it. Sketch it if you have to. And be sure to measure bloodstains.

5. Collect fragile stuff first. Fingerprints, footprints, hairs, fibers. These things can get stepped on, blown away, or smudged. It's important to find them and collect them quickly.

6. No flushing. Don't use the toilet or turn on faucets. You could be sending important evidence down the drain.

IN THE LAB

electrophoresis system A machine that separates long strands of DNA from short strands. This helps scientists find the part of the DNA they need to examine.

DNA extraction system This machine extracts DNA from stains, blood, and other fluids. It also turns the DNA into a liquid for further testing.

FMBIO It uses a laser or X-ray to take a picture of the DNA. It produces an image in bar code form.

polymerase chain reaction (PCR) This process allows scientists to duplicate small samples of DNA. It is one of the most important developments in science since the discovery of DNA.

AT THE SCENE AND IN THE LAB

latex gloves Protects the investigator from blood and other samples. Also keeps the investigator from contaminating the evidence.

scalpel A sharp knife to scrape up dried fluids for testing.

DNA: THE INSIDE STORY

What is this stuff, anyway?

When scientists do DNA profiling, they work with the most basic pieces of the body. These pieces are so small you can fit millions of them in the period at the end of this sentence. If you could see them, here's what they would look like.

CHROMOSOMES

Every human has 23 pairs of chromosomes in each cell. Chromosomes contain your genes—about 30,000 of them. Your genes control the way you look and function. You get half your chromosomes from your mother and half from your father. So, you get some of your traits from each of them. You might have your father's black hair and your mother's blue eyes.

DNA

DNA is the chemical that chromosomes and genes are made of. A DNA molecule is shaped like a twisted ladder. The rungs of the ladder hold the information contained in your genes.

WHICH TWIN DID IT?

Identical twins look almost exactly the same. And their DNA is exactly the same, too. So what happens if a twin is a suspect in a crime? DNA evidence can't bail out the innocent one!

Fraternal twins don't have the same problem. They don't look alike, and they don't share the same DNA.

Help Wanted: DNA Scientist

Is DNA in your genes? Here's more information about the field.

Q&A: FORENSIC SCIENTIST

ANN POLLARD

Q How did you decide to become a forensic DNA scientist?

Pollard: I was always interested in science. I was a biology major, and I learned about forensic science in my classes. I was also interested in law enforcement. This career gives me an opportunity to combine the two: science and law.

Ann Pollard is a forensic DNA scientist in Virginia.

Q What kind of training did you go through?

Pollard: I have my bachelor of science degree in biology. I also have a master's degree in criminal justice, with a specialization in forensic science. I took a ten-month training program in forensic biology and DNA analysis.

Q What's a typical day like on the job?

Pollard: When I'm doing case work, I could be working on 15 to 20 cases at a time. I take it one case at a time. I might spend two or three days sitting in the lab. I go through evidence, get samples ready, and stuff like

that. Then, I'll spend another week doing actual DNA analysis. Next, I'll write up all the reports and paperwork. That could take about two or three weeks to complete.

What's the hardest thing for you?

Pollard: I'd have to say interpreting DNA profiles. We have all these mixtures of samples. And we have to figure out whose DNA it is. People's lives depend on it.

What's the coolest part about your job?

Pollard: I get to work on something different all the time. Sometimes, I get basic cases, like finding DNA from a bloodstain or cigarette butt. But every once in a while I get to work on cool stuff, like finding DNA from cans or bottles, guns, hats, clothing, steering wheels—you name it.

What can middle-school and high-school kids do to get started in the field?

Pollard: Look for colleges that offer good forensic science programs. It's also important for the school to offer in-depth lab work in the field you want to work in. That way you can get hands-on experience.

THE STATS

Money
▶ Forensic scientists may earn $40,000 to $85,000.
▶ Lab directors with advanced degrees can earn more than $100,000.

Education
▶ B.S. in a hard science, such as biology or biochemistry
▶ M.S. in criminal justice or another hard science
▶ Career training often includes courses in forensic DNA analysis.

The Numbers
▶ There are close to two million DNA samples on file in U.S. state and federal databanks.
▶ As of 2004, in the United States there were 524,700 crime-scene DNA samples waiting to be tested. Great Britain is the leader in DNA profiles and crime scenes.
▶ British investigators make 3,000 DNA matches each month.

DO YOU HAVE WHAT IT TAKES?

Take this totally unscientific quiz to see if you might have what it takes to be a DNA scientist.

1 How do you feel about handling blood?

a) I'm OK with it. I know it can give me valuable information.

b) I get a little grossed out. But I can handle it.

c) No, thanks!

2 Can you follow step-by-step directions?

a) That's my strength!

b) Most of the time.

c) I don't like following directions.

3 How organized are you?

a) I'm organized and detailed. I keep notes on everything I do.

b) I'm organized when it comes to homework. But my room is a mess.

c) I can't organize anything. And I'm not good at taking notes.

4 How comfortable are you speaking in public?

a) Bring it on! I love talking to an audience.

b) I'm shy. But I can give a speech if I can look at my notes.

c) I wouldn't be caught dead talking to an audience!

5 Can you work independently and also as part of a team?

a) I like working on my own. But I also enjoy working with a team to figure stuff out.

b) I'm best working with a partner or group. But I can sometimes work on my own.

c) I don't like working with a team. I prefer to do it all myself.

YOUR SCORE

Give yourself 3 points for every "**a**" you chose.

Give yourself 2 points for every "**b**" you chose.

Give yourself 1 point for every "**c**" you chose.

If you got **13–15 points**, you'd probably be a good forensic DNA scientist.

If you got **10–12 points**, you might be a good forensic DNA scientist.

If you got **5–9 points**, you might want to look at another career!

HOW TO GET STARTED...NOW!

It's never too early to start working toward your goals.

GET AN EDUCATION

▶ Starting now, take as many math and science courses as you can. Train yourself to ask questions, gather evidence, and draw conclusions the way forensic scientists do.

▶ Work on your public speaking skills. Join the debate team, the speech club, or the drama club. It's good practice for testifying in the courtroom.

▶ Start thinking about college. Look for ones that have good science programs. Call or write to those colleges to get information.

▶ Read the newspapers. Keep up with what's happening in your community.

▶ Read anything you can find about DNA analysis. Learn about cases in which DNA played a vital role. See the books and Web sites in the Resources section on pages 108–111.

▶ Graduate from high school!

NETWORK!

▶ Investigate an investigator. Get in touch with your local police department. Interview a crime scene investigator or DNA analyst. Ask to spend a day with him or her to get a sense of what goes on.

GET AN INTERNSHIP

▶ Call your local crime lab. Staff there might be willing to give you a tour. Or there may be internships available. Don't be afraid to ask!

LEARN ABOUT OTHER JOBS IN THE FIELD

There are certain jobs that relate to DNA analysis. They are:

▶ Forensic chemist
▶ Crime scene analyst
▶ Crime scene technician
▶ Criminalist
▶ Crime lab supervisor

Resources

Looking for more information about forensic fingerprinting and DNA? Here are some resources you don't want to miss.

Professional Organizations

American Academy of Forensic Sciences (AAFS)
www.aafs.org
410 North 21st Street
Colorado Springs, CO 80904-2798
PHONE: 719-636-1100
FAX: 719-636-1993

The AAFS provides education for people interested in working in forensic science and continuing education for experts already in the field. The organization runs workshops and sessions at its annual meeting that are open for students in middle school and up. Its Web site includes a long list of colleges and universities with forensic science programs.

American Society of Crime Laboratory Directors (ASCLD)
www.ascld.org
139K Technology Drive
Garner, NC 27529

The ASCLD is an association of crime laboratory directors and forensic science managers dedicated to providing excellence in forensic science through leadership and innovation.

Canadian Society of Forensic Science (CSFS)
www.csfs.ca
P.O. Box 37040
3332 McCarthy Road
Ottawa, Ontario
Canada K1V 0W0
PHONE: 613-738-0001
EMAIL: csfs@bellnet.ca

This nonprofit organization promotes the study of forensic science. Its Web site has information about careers and schools with forensic science programs.

International Association for Identification (IAI)
www.theiai.org
2535 Pilot Knob Road, Suite 117
Mendota Heights, MN 55120-1120

CLPE means Certified Latent Print Examiner. Fingerprint examiners who have these letters beside their names have been certified by the IAI. IAI-certified print examiners have passed tests that prove they have top-notch skills. Its Web site includes job listings and requirements.

Education and Training

The AAFS Web site (www.aafs.org) has a list of colleges and universities with forensic science programs.

Only a few schools offer a full-fledged undergraduate degree in forensic science. A greater number allow a minor or concentration in forensic science along with a degree in one of the physical sciences. Here is a selection of colleges to consider, and some of these offer master's degree programs as well:

Federal Bureau of Investigation (FBI)
www.fbi.gov/
J. Edgar Hoover Building
935 Pennsylvania Avenue, NW
Washington, DC 20535-0001
PHONE: 210-567-3177
EMAIL: smile@uthscsa.edu

The FBI Web site contains information on its latent print unit. It also gives information on getting a job with the FBI.

Colleges

Albany State University
www.asurams.edu
Forensic Science
Department of Criminal Justice
504 College Drive
Albany, GA 31705
PHONE: 229-430-4864

Buffalo State College
www.buffalostate.edu
Forensic Chemistry
Chemistry Department
313 Science Building
1300 Elmwood Avenue
Buffalo, NY 14222
PHONE: 716-878-5204

George Washington University
www.gwu.edu
Graduate Programs
Department of Forensic Sciences
2036 H Street
Samson Hall
Washington, DC 20052
PHONE: 202-994-7319

John Jay College of Criminal Justice
www.jjay.cuny.edu
Forensic Science
889 Tenth Avenue
New York, NY 10019
PHONE: 212-237-8000

Ohio University
www.ohio.edu
Forensic Chemistry
Athens, OH 45701
PHONE: 740-593-1000

University of Mississippi
www.olemiss.edu
Forensic Chemistry
Department of Chemistry and
 Biochemistry
322 Coulter Hall
University, MS 38677
PHONE: 662-915-7301

Virginia Commonwealth University
www.vcu.edu
Forensic Science
College of Humanities and Sciences
P.O. Box 843079
Richmond, VA 23284
PHONE: 804-828-8420

West Chester University
www.wcupa.edu
Forensic Chemistry
Department of Chemistry
West Chester, PA 19383
PHONE: 610-436-2631

Web sites

Careers in Forensic Science
www.forensicdna.com/careers.htm
An overview of requirements and options for a forensic science career.

truTV's Crime Library
www.crimelibrary.com/index.html
This Web site contains tons of true criminal cases. There's a whole section on fingerprinting.

Crime Lab Project
www.crimelabproject.com
The Crime Lab Project works to increase awareness of the problems facing public forensic science agencies.

FBI Crime Lab DNA Analysis Unit
www.fbi.gov/hq/lab/org/dnau.htm
For information about the DNA Analysis Unit that analyzes body fluids recovered as evidence in violent crimes.

Fingerprint Dictionary
www.fprints.nwlean.net
A long list of terms used by fingerprint experts.

The Fingerprint Society
www.fpsociety.org.uk
News and a journal from fingerprint buffs in England.

Forensic Files
www.forensicfiles.com
Web site for *Forensic Files* on truTV, which features real forensic cases.

Interactive Quiz: What Every Law Enforcement Officer Should Know About DNA Evidence
www.dna.gov/training/letraining/ beg/menu.htm
Learn about DNA and forensics the way that law enforcement officers do!

Latent Print Examination
www.onin.com/fp
There's good info on this site for professionals and for the general public.

Southern California Association of Fingerprint Officers (SCAFO)
www.scafo.org
The Web site for this organization lists job information and useful links.

Books

Camenson, Blythe. *Opportunities in Forensic Science Careers*. New York: McGraw-Hill, 2001.

Fingerprinting (Great Explorations in Math and Science). Berkeley: University of California, 2000.

Fisher, Barry A. J. *Techniques of Crime Scene Investigation*, 7th ed. Boca Raton, Fla.: CRC Press, 2003.

Genge, Ngaire, E. *The Forensic Casebook: The Science of Crime Scene Investigation*. New York: Ballantine, 2002.

Innes, Brian. *The Search for Forensic Evidence*. Milwaukee: Gareth Stevens Publishing, 2005.

Mauro, Paul, and Robin Epstein. *Prints and Impressions.* New York: Scholastic, 2003.

Platt, Richard. *Ultimate Guide to Forensic Science*. New York: DK Publishing, 2003.

Platt, Richard. *Forensics.* Boston: Kingfisher, 2005.

Ramsland, Katherine M. *The Forensic Science of CSI*. New York: Berkley Trade, 2001.

Rudin, Norah, and Keith Inman. *An Introduction to Forensic Analysis*, 2nd ed. Boca Raton, Fla.: CRC Press, 2001.

Silverstein, Herma. *Threads of Evidence: Using Forensic Science to Solve Crimes.* New York: Henry Holt & Company, 1996.

Just for fun, check out these classic novels.
Mark Twain wrote about fingerprinting before fingerprinting was cool!

Life on the Mississippi

Pudd'nhead Wilson

A

absorbent (ab-ZOR-buhnt) *adjective* able to soak up water or other liquid

AFIS (AY-fiss) *noun* a computer database in which police store the prints of arrested suspects. AFIS stands for *Automated Fingerprint Identification System.*

alibi (AL-uh-bye) *noun* a story about where you were when something happened

analyst (AN-ah-list) *noun* someone who is specially trained in studying something

arch (arch) *noun* a fingerprint pattern that is made up of a single raised bump or wave. A *tented arch* fingerprint has a tent shape.

B

bag (bag) *verb* to take as evidence

bases (bayss-ez) *noun* rungs that make up the DNA ladder

busted (BUS-tid) *verb* slang for *caught*

C

carbon paper (CAR-bun pay-pur) *noun* paper containing carbon ink on one side for making copies. It was used with typewriters before computers and copiers were common.

chain-of-custody form (chayn ohv KUST-uh-dee form) *noun* a document used to record the names of people who held evidence gathered at a crime scene

chromosomes (KROH-muh-zohmz) *noun* thread-like structures in the center of a cell. They are made of DNA and contain all the genetic information in your body.

CODIS (KOH-diss) *noun* a database that contains DNA samples of more than 300,000 people. It stands for *Combined DNA Index System*.

contamination (kuhn-TAM-uh-nay-shun) *noun* the process by which something is made dirty or unfit for use

D

dactylography (dac-ti-LOG-rah-fee) *noun* the study of fingerprints as a method of identification

database (DAY-tuh-bayss) *noun* a lot of information organized on a computer

degrade (dee-GRADE) *verb* to break down into small unusable parts

district attorney (DISS-trikt uh-TUR-nee) *noun* a lawyer who represents a certain city or town in criminal trials

DNA (DEE-en-ay) *noun* stuff in almost every cell of your body that has tons of information about you

DNA profiling (DEE-en-ay PROH-fyl-ing) *noun* a way of processing DNA samples so they can be compared with other samples

double helix (DUH-buhl HEE-lix) *noun* the pair of strands that make up DNA

duct (duhkt) *noun* a passage that allows air to move around in a building

dusted (DUS-ted) *verb* brushed with a dark powder on a surface at a crime scene. The dust sticks to the sweat and oils in the latent prints, which makes invisible prints visible.

E

evidence (EV-uh-duhnss) *noun* information or clues that might help solve a crime

exonerate (ig-ZAH-nuh-rayte) *verb* to clear a person from blame or guilt

expert (EX-purt) *noun* a person who has a great deal of knowledge and experience in a certain field. See pages 14 and 64 to learn about forensic experts.

eyewitness (eye-WIT-ness) *noun* a person who saw a crime being committed

F

FBI (EF-bee-eye) *noun* a U.S. government agency that investigates major crimes. It stands for *Federal Bureau of Investigation*.

fingerprint (FIN-ger-print) *noun* the pattern of skin ridges at the tips of your finger. These patterns include arches, loops, and whorls.

forensic (fuh-REN-zik) *adjective* describing the science used to investigate and solve crimes

fuming (FEW-ming) *verb* a process that makes latent prints visible

G

genes (jeenz) *noun* tiny pieces of DNA that determine traits in every person

groove (groov) *noun* the area between the ridges of your fingerprint

H

hit (hit) *noun* a match. A hit on AFIS means the computer found a match.

hostage (HOSS-tij) *noun* a person who is taken and held prisoner as a way for someone to demand money or other terms

I

identify (eye-DEN-tuh-fye) *verb* to figure out who someone is

impressed print (im-PRESD print) *noun* a print made when you touch something like gum, which leaves a clear impression

isolate (EYE-suh-layt) *verb* to find something; to separate it from everything around it

J

jury (JU-ree) *noun* a group of people at a trial who listen to a court case and decide if a person is guilty or innocent

L

latent print (LAY-tuhnt print) *noun* a fingerprint or footprint that you can't see. When you touch stuff, the sweat and oils on your skin leave a mark. That means that every time you touch a hard, shiny surface, you're leaving an invisible fingerprint.

lift (lift) *verb* to pick up a fingerprint, using sticky tape

lineup (LYNE-uhp) *noun* a group of people lined up for inspection by police or witnesses

loop (loop) *noun* a fingerprint pattern in which the ridges form a series of half-circles, one inside the other. There are *accidental, central pocket, double, radial,* and *ulnar loop* fingerprints.

N

Ninhydrin (NIN-hy-drihn) *noun* a chemical used to get fingerprints from soft, absorbent surfaces like paper and clothing

P

partial (PAR-shul) *noun* part of a fingerprint

patent print (PAT-uhnt print) *noun* a print that is clearly visible. It's made when you touch something like paint or blood and then touch other surfaces.

perp (purp) *noun* a person who has committed a crime. It's short for *perpetrator*.

polymerase chain reaction (puh-LIM-uh-rase chayn ree-AK-shun) *noun* a process that allows scientists to duplicate small amounts of DNA. Also known as PCR.

prints (prints) *noun* short for *fingerprints*

process (PRAH-ses) *verb* to gather information (such as fingerprint evidence) at a crime scene

prosecutor (PROSS-uh-kyoo-tur) *noun* a lawyer who represents the government in criminal trials

R

RH factor (ahr-aych FAK-tur) *noun* a specific trait that occurs in some red blood cells

ridges (RI-jez) *noun* raised lines on the tips of your finger that create your fingerprint. The area between the ridges is called a groove.

S

scalpel (SKAL-puhl) *noun* a small, sharp knife used by surgeons

signature (SIG-nuh-chur) *noun* a characteristic mark

significant (sig-NIF-uh-kuhnt) *adjective* important or having great meaning

specialist (SPE-shuh-list) *noun* someone who has specific knowledge about a given subject

suspect (SUS-pekt) *noun* a person law enforcement officials think might be guilty of a crime

swab (swahb) *verb* to use a thick cotton tip on a stick—like a Q-tip, only bigger—to get samples of DNA

T

trace evidence (trayss EV-uh-duhnss) *noun* fibers, tire tracks, shoe prints, and other stuff left behind at the scene of the crime and used to help catch the criminal

trait (trayt) *noun* a specific feature of something or someone

V

verdict (VUR-dikt) *noun* a decision from a jury about whether someone is guilty or innocent

W

whorl (whirl) *noun* a fingerprint pattern in which the ridges form a series of circles, one inside the other

Index

Photo Credits

Alamy Images: 25 top, 109 (Mikael Karlsson), 16 top (SHOUT), 20 (Stephen Vowles), 93 (Oote Boe), 75, 102 top left (Mikael Karlsson), 91 left (Martin Shields), 102 top right (Stockfolio); AP/Wide World Photos: 48 top (Angel Rowlings), 52 center left (Toby Talbot), 40 (Tom Warren/Middletown Press); Armor Forensics: 12 (22), 110; Chattanooga Area Convention & Visitor's Bureau/David Andrews: 17; Corbis Images: 46 bottom (Bettmann), 5 bottom (Jonathan Blair), 23 (Muriel Dovic), 12 (14) (Randy Faris), 47 top (Hulton-Deutsch Collection), 12 (7) (Thom Lang), 16 bottom (Dylan Matinez/Reuters), 12 (2) (Royalty-Free), 26 (Alex Silva-AE/Reuters); DK Images: 46 top, 50 center, 100 bottom (Ashely Cooper), 103 bottom (Peter M. Fisher), 87 (Kevin Fleming), 62 (Klaus Hackenberg/zefa), 98 top (Sgt. Robert Holliway), 98 bottom (Lainsward/Hulton-Deutsch Collection), 99 bottom (Jerry McCrea/Star Ledger), 90, 97 top (Ed Quinn/ SABA), 66 bottom (Michaela Rehle/Reuters), 63 (Benjamin Rondel), 62 (Royalty-Free); Ethicom Advertising, City of Suffolk, Virginia and the Riverfront Community: 67; Getty Images: 6 right (Alan Abramowitz), 49 top (Jim Bourg), 18 (Ron Chapple), 57 (George Doyle and Ciaran Griffin), 5 top (Baldomero Fernandez), 25 bottom (Stockdisc), 62 (Blue Mountain/Amana Images), 101 bottom right (Roy Botterell), 89 bottom (Steve Cole), 84 (Davies & Starr), 66 top (Peter Dazeley), 62 (Peter Dazeley), 8 bottom, 63, 102 bottom right (Nicholas Eveleigh), 77 (Grant Faint), 62 (Lenora Gim), 62 (Aaron Graubart), 63 (Thomas Jackson), 7 top (Zigy Kaluzny), 62 (Raimund Koch), 63 (Lund-Diephuis), 101 bottom left (Peter Miller), 62 (Bryan Mullennix), 111 (Steven Puetzer), 62 (Gabrielle Revere), 62 (Alexandra Rowley), 74 bottom (Stephen Simpson), 62 (Christopher Stevenson), 6 center, 63 (Christopher Stevenson), 62 (Toledano), 63 (Eric Von Weber), 97 bottom (Mark Wilson); Index Stock Imagery/David Burch: 69; Index Stock Imagery/Timothy O'Keefe: 27; iStockphoto/ Jim Jurica: 21 right; James Levin Studios: 4 bottom, 10, 29; JupiterImages/Laurent Hamels: 53 top left; Los Angeles County Sheriff's Dept./Courtesy of Barry Fisher: 101 top right; NEWSCOM/PictureArts: 39, 94 (Alex Garcia/Chicago Tribune), 91 right (Chris Kleponis/AFP); On Scene Photography/Seth Gottfried: 34; Photo Researchers, NY: 48 bottom (Mauro Fermariello), 5 center, 30 (Pascal Goetghluck); Photo Researchers, NY/SPL: 96 top (A. Barrington Brown), 72 bottom left, 100 top (Michael Donne), 101 center right (Mauro Fermariello), 103 right (Carlyn Iverson), 102 bottom left (Will & Deni McIntyre), 99 top (Peter Menzel), 96 bottom (David Parker), 8 center (Prof. K. Seddon & T. Evans/Queen's University Belfast), 6 bottom, 7 bottom, 60, 72 top, 74 top (Tek Image); PhotoEdit/Dana White: 12 (8); photolibrary.com: 52 bottom (Creatas), 49 bottom (Nonstock); Reprinted from "Prints and Impressions," Scholastic, Inc., 2003: 50 top, 50 bottom, 51 all; ShutterStock, Inc.: 103 left (sgame), 72 bottom right (Michael Thompson); Sirchie Fingerprint Laboratories: 6 left, 12 (3, 13, 18), 13 (15), 52 top, 52 center right, 53 top right, 108, 106; Suffolk Police Department/Andre Washington: 71 top; Superstock, Inc./Tom Brakefield: 37; Tennessee Bureau of Investigation: 24, 53 bottom, 54; Courtesy of The Guardian, Charlottetown, PEI: 7 center, 78, 80, 81, 83, 86; The Innocence Project: 92; VEER: 13 (25) (Digital Vision), 47 bottom (Photodisc); Virginia Department of Forensic Science/Jennifer Bertelsen: 73, 104; Visuals Unlimited/ Dave Olson: 13 (20). Maps by David Lindroth, Inc.

When I started researching this book, all I knew about fingerprinting was what I saw on TV crime shows. But as latent print specialist Oakley McKinney told me, "The TV shows make it look like magic. But it's really science."

I learned tons about the history and science of fingerprinting. I learned so much I couldn't fit it all in this book. I started with Web sites. So if you're into finding out more, hop on your computer. Check out the Web sites listed in the Resources section. If you like reading about cases, try the truTV site. The IAI and FBI Web sites give valuable info on getting a job in the field.

There are textbooks on fingerprinting that really show how to compare prints. You can find them at large bookstores. They zero in on the details of what experts look for. But they're pretty complex, so have your dictionary handy!

Of course, the best way to learn is to talk to those who do it. I contacted the public relations/public affairs departments of the FBI and TBI. The PR person put me in touch with Agent McKinney. So try calling your local law enforcement office—the police or sheriff's department—and ask for the public information officer or the public relations person. Find out if you can interview a print specialist about his or her job. It won't hurt to try!

Here's to catching the bad guys!

—D. B. Beres

After more than 250 pages of research about DNA and crime, I became intrigued with every case—especially unsolved cases. I'd search the Internet for clues to the case, hoping to find information that would help solve a crime.

But as the book's deadline approached, I snapped back to reality. I'm not a DNA analyst or crime scene investigator. I'm an author! My job is to write about crimes, not solve them.

If you're interested in a career in forensic science, start with your own neighborhood. Dial the number of the county medical examiner's office. When you call the ME's office, explain who you are and what you need. Say something like, "Hi, my name is (fill in the blank!). I'm a student at (fill in the blank with your school name and town). I'm seriously considering a career in forensic science. I was wondering if there's a (choose one) DNA scientist, blood spatter specialist, forensic anthropologist, or fingerprint specialist who could take a few minutes to talk to me?"

You'll likely be connected to someone who can help. Talk to the person about his or her job. Ask what a typical day is like. Most people chose a career in forensic science because it's an opportunity to help society. So they'll be more than happy to help you—just be aware that they may be crunched for time because they're working on a case!

—Anna Prokos

Acknowledgments

I would like to thank Agent Oakley McKinney for teaching me the nitty-gritty about fingerprint analysis. Thanks also to the TBI for their cooperation, and to the American Academy of Forensic Sciences.

—D.B.B.

Many thanks to the following people for their expertise: Jan Burke, Barry A. J. Fisher, David Vidal, Joan Jones, and Ann Pollard.

—A.P.

CONTENT ADVISERS: King C. Brown, MS, CSCSA, CFPH, CLPE, Crime Scene Supervisor, West Palm Beach (Florida) Police Department; Norah Rudin, PhD, Forensic DNA Consultant

NOTES